Byzantine Art

Text : Charles Bayet
Translation: Anne Haugen and Jessica Wagner
Coffeehouse Translations, LLC

Layout :
Baseline Co Ltd,
33 Ter - 33 Bis Mac Dinh Chi St.
Star Building, 6th Floor
District 1, Ho Chi Minh City, Vietnam

© 2009 Parkstone Press International, New York, USA
© 2009 Confidential Concepts, Worldwide, USA

ISBN : 978-1-84484-620-7

Printed in India

Charles Bayet

Byzantine Art

PARKSTONE
INTERNATIONAL

Contents

Introduction 7

I. Early Byzantine Art (306–843) 9

II. The Renaissance of Byzantine Art (843–1204) 79

III. Late Byzantine Art (1204–1453) 157

Conclusion 189

Chronology 190

Glossary 194

Bibliography 196

List of Illustrations 197

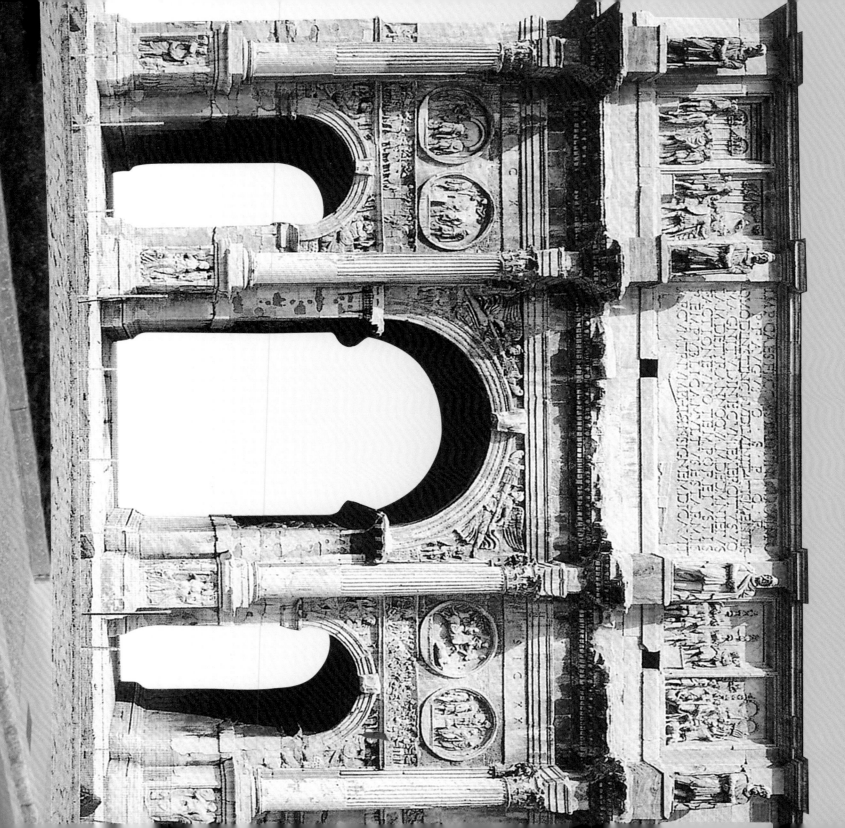

Introduction

Byzantine art has been alternately strongly attacked and strongly advocated. For many years, critics' only references to the movement produced the most unflattering epithets. The word itself, Byzantine, which refers to both painting and politics, used to arouse immediate ire in the elite artistic circles of the nineteenth century. It had become established that this term was used to refer to a type of art that had created nothing but unsightly, unpleasing works and which, condemned to stagnation from its very conception, had neither progressed nor changed.

Later on, those who attempted to defend the unappreciated era often did its reputation harm with their excessive zeal. Before it had even been clearly defined what was to be understood by the term "Byzantine", these overly active panegyrists claimed to recognise its influence in nearly every country and on every monument in the West. Losing its contemptuous nuance, the term "Byzantine" was becoming very vague and, above all, very elastic. Everyone believed himself to have the right to use it according to his own fancy. The term thus accompanied half of the works of the Middle Ages; as for the others, experts strained to recognise at the very least the influence of the Greek masters. In this way, other works were assimilated under the Byzantine banner and declared its vassals.

These invasions of style provoked some resistance. In France, Italy, and Germany, art historians affirm that, before even the twelfth or thirteenth century, the West had produced its own local schools whose existence must not be forgotten. This reaction to the older civilisation's artistic style was quite strong, at times excessive. In Italy, one encountered scholars who refused to see Byzantine influence anywhere. Some, unfamiliar with the history and monuments of the East, even claimed that the artistic principles that developed in the Mediterranean during the fourth century were actually bequeathed to the Byzantine Empire by the Italians.

One point is worth noting: detractors and apologists have often followed the same method. Before speaking of the relationship between Byzantine art and other styles, many do not take the pains to study it in its context and in its works. Perhaps it would have been better to reject the word "Byzantine", which is not precise and which was exploited to such a degree, and rather to discuss neo-Hellenistic art or Greek art of the Middle Ages; however it seems useless to go against convention, words take on the value, above all, by the meaning given them.

Arch of Constantine, 312-315. Marble, 21 x 25.7 x 7.4 m. Rome.

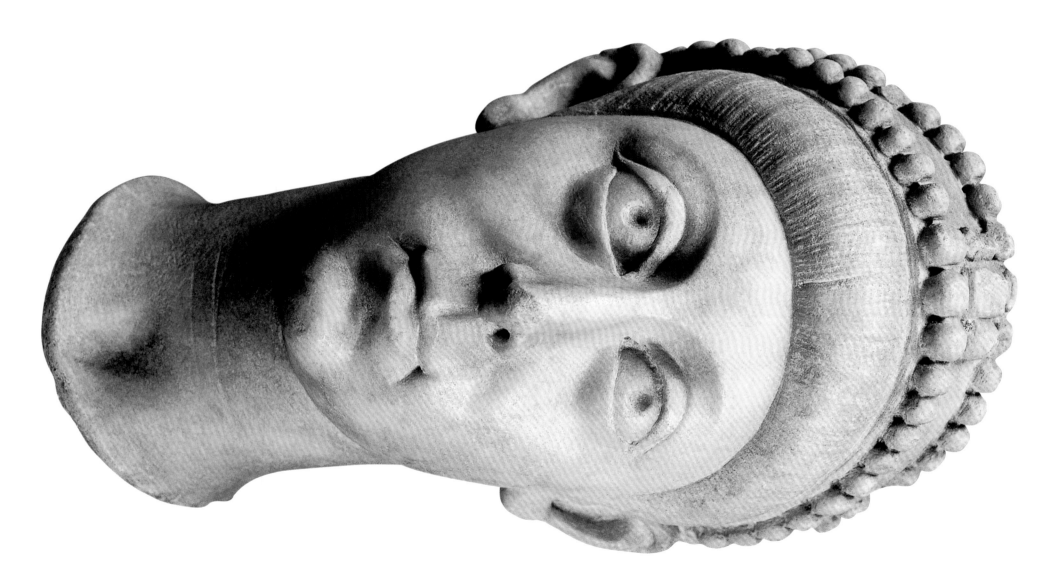

I. Early Byzantine Art (306-843)

A. The Birth of a New Style (306-527)

At the beginning of the fourth century, under the reign of Constantine, a great revolution transpired in Christian history; in the wake of persecution, Christianity suddenly found itself in imperial favor. This development exerted a profound influence on the development of Christian art. It blossomed openly in new and richer forms. Churches were erected everywhere. "In each city," wrote the contemporary ecclesiastical historian Eusebius, "celebrations take place for the consecration of churches and newly constructed oratories. On this occasion, the bishops assemble, pilgrims come rushing in from distant lands; one sees the sudden outpouring of affection behind this movement and, in order to increase the number of holy structures, put the riches of the State at the disposal of the Christians.

The transformation of ancient Byzantium into Constantinople is a milestone in history. A consequence of this change was the division of the former Roman Empire into two parts, which were fated to meet different ends. Constantinople became the axis of a brilliant civilisation, where eastern influences were mixed with Hellenism. From this viewpoint, its geographic situation is indeed enviable: Constantinople was connected with both Europe and Asia; its vessels could harbour within its vast and secure port, keeping the city in continuous contact on one side with the regions of the Black Sea and on the other, with all the peoples of the Mediterranean. Thence came the immense influence that the city exerted during the Middle Ages, as well as its splendour and wealth.

It was in 324 that Constantine chose Byzantium. In Antiquity, certain religious rites were followed to found a city. In the well-known story, Romulus traced the first outline of Rome with the blade of a plow. A fourth century historian recounts that Constantine himself also traced the outline of the new capital with the point of his lance. He said that he was following the indications of an angel, who was walking in front of him. Work on the city was accelerated to such a degree that, according to one chronicler, the consecration supposedly took place only nine months later. It is true that a city can be consecrated, just as with a church, long before termination. The ceremonial consecration date for Constantinople is recorded: it took place on the eleventh of May, 330. The circumstances surrounding this event are indicative of the role assigned to Constantinople by the emperor: it was to be a Christian capital, and he entrusted the blessing of his city to the bishops. In addition, "he ordered by law," writes the historian Socrates Scholasticus, "that she would be called the second Rome. This law was carved on a marble table placed in the Strategeion, near the equestrian statue of the emperor."

In planning the new capital, Constantine was preoccupied with imitating Rome. Like Rome, Constantinople had seven hills and was divided into fourteen regions; there was

Bust of Arcadius Wearing the Imperial Diadem, early fifth century. Marble. Archaeological Museum, Istanbul.

Christ in Majesty Giving a Blessing,
fourth century.
Opus sectile.
Ostia Museum, Ostia, Italy.

Baptistry of Neon, 458.
Marble.
Ravenna, Italy.

even a Capitoline Hill. The main Forum, known as the Augustaeum, remained famous throughout the entire Middle Ages. It may have predated Constantine, who was content simply to embellish it. A portico dominated all four sides, and statues were placed underneath. Among these was a group representing Constantine and his mother, Helena, standing to either side of the cross. This archetype has remained traditional in the East and can still be found reproduced on frescos and engravings.

The period extending from Constantine to Justinian was a formative age for Byzantine art. Christian architecture was the progeny of Greco-roman architecture but in certain regions of the East, especially in Syria, it had already undergone drastic changes, made more complex by foreign elements. Today, it can be experienced through the ruins of Palmyra and Baalbek by the layout, the appearance of the principal lines, and the decoration. These constructions have an original appearance; what is especially remarkable is the tendency to substitute curves for straight lines, archways for shouldered flat arches. The new trend spread rapidly. Already at the beginning of the fourth century, there was a palace in Dalmatia that had roots in this Asiatic architecture, that of Diocletian who had resided in Asia during his entire reign and then retired to Solin after abdicating.

The Byzantine Empire, such as it were after the death of Theodosius, must have exerted its new influence with a certain degree of force, as the Asian provinces were bringing their prosperity and the luster of their civilisation to the European provinces, and it was there that Hellenistic thought proved to be more active and creative. Even during the time of Constantine, Christian architects in Asia seem to have already proven to be more

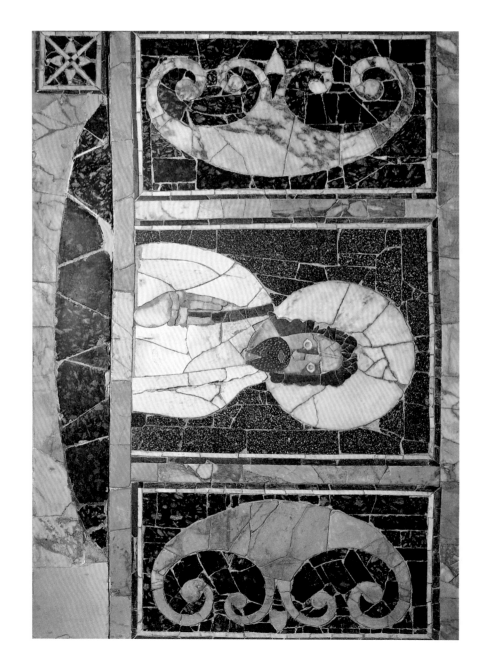

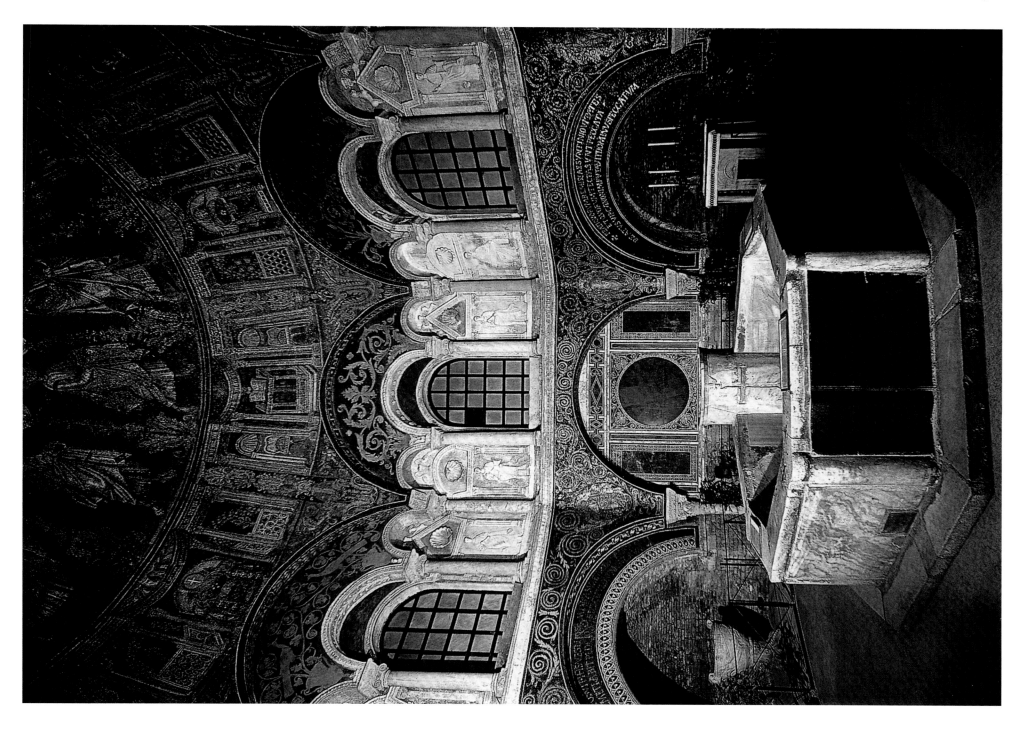

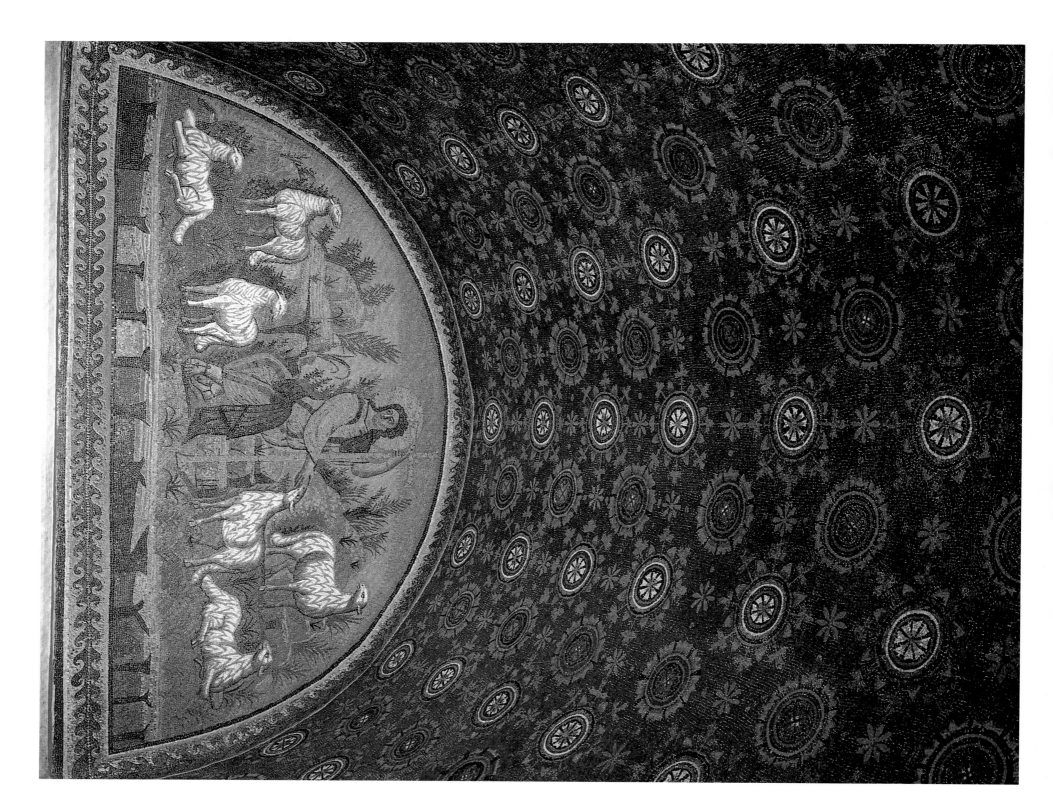

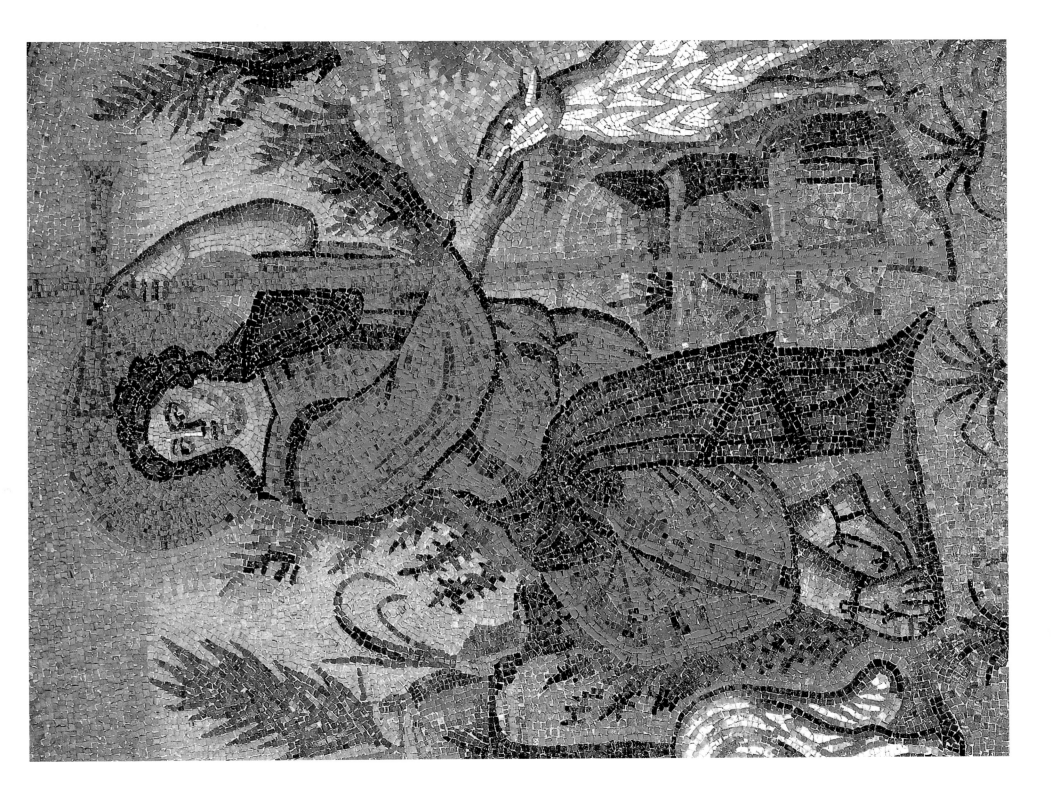

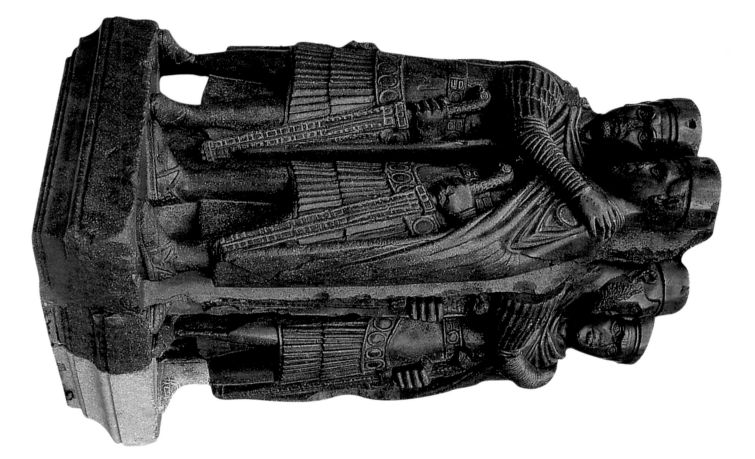

innovative. If circular churches were found in the West, in the East they seem to have been of a bolder design: the church in Antioch was especially astonishing to people of the time. This type of structure is no longer seen in the ancient Byzantine Empire, save as one well preserved monument, and it is true that it is not found in Asia at all save in Thessaloniki: it is a vast rotunda, measuring 24 metres in diameter. Within the thickness of the walls, seven vaulted chapels are housed; an eighth, situated on the axis of the main door, is farther inward and forms a long apse of 19.37 metres, which stands apart within the walls. This church had probably served previously as the mausoleum of the emperor Galerius.

One can quietly observe the attempts leading up to the development of the cupola atop pendentives. In Seleucia and Ctesiphon, the cupola can be found used over a square design. The trail of this innovative spirit is found in the monuments that can still be appreciated, such as the church of St. Demetrios in Thessaloniki. The basic layout is of a basilica with an atrium, narthex, and partial double walls, but inside, there are two levels, and the upper encircles the church, reaching even over the narthex. The capitals, the heads of columns, already take on distinctive shapes. They are generally still connected with antique forms, though altered. They are made of two parts, and it is not the main section that receives the most acute pressure from the arches; it weighs on the headboards, which form a sort of upper capital. It is a small jump from this innovation to the superposition of two genuine capitals. Additionally, in two places, one is struck by even more creative forms: classical examples were abandoned completely for bell-shaped capitals, sculpted in the contemporary style, that is to say as a sort of cubic mass around which ornamentation winds its way, which simulates an additional sculpture.

In Constantinople itself, from Constantine to Justinian, the construction of thirty-eight new churches or monasteries has been noted, according to a Byzantine chronicler. Hardly any details are available on their architectonic characteristics; it seems, however, that after a fire, the Hagia Sophia was reconstructed "with cylindrical vaults". There, as in Asia, the architects, who were called upon incessantly to produce new works, had to compete zealously. It fell to them to discover ingenious and original combinations. While in the West the misfortunes of the empire distracted people from artistic matters, in the East, a generally more positive situation favored their development. Rather than reproduce the same models over and over, with less intelligence and less care, Greek architects were constantly modifying and perfecting them.

From this time on, the mosaic was more and more the preferred decorative style. In St. George of Thessaloniki, the cupola covering the church was decorated entirely in mosaics. Today, only a portion of it remains; there are large compartments where saints are located standing upright, in an orant posture, amid a rich architectural framework. The craftsmanship of these mosaics is extremely beautiful, and, despite the mutilations they have suffered and their faded colours, they give off a very grand effect. The slightest ornamental details bear witness to a fine and delicate taste; arabesques and palmette bands are elegantly designed.

The mosaics of the fifth century, which decorate the churches of Ravenna in Italy, must also be attributed to Byzantine art. Before this city became the residence of the

The Good Shepherd and the Starry Sky, fifth century.
Mosaic.
Galla Placidia Mausoleum, Ravenna, Italy.

The Good Shepherd (detail), fifth century.
Mosaic.
Galla Placidia Mausoleum, Ravenna, Italy.

The Tetrarchs: Diocletian, Maximian, Constantius Chlorus, and Galerius, fourth century.
Porphyry.
South façade of St. Mark's Basilica, Venice.

Theodosian Walls, 412-413. Istanbul.

Great Palace Mosaic Museum, Istanbul. Mosaic.

Great Palace Mosaic, late fifth to early sixth century.

Byzantine governor of Italy under Justinian, it was already artistically linked to the East. The mosaics of the Orthodox Baptistery and the Galla Placidia Mausoleum are distinguished by the rich craftsmanship and the pleasing harmony of the decor. [See p. 34]

At the Baptistery, the Baptism of Christ is portrayed on a large medallion, forming the center of the cupola. In curious contrast, the Jordan River is present in this scene in the guise of a fluvial god, which is striking evidence of the persistent influence of ancient art. Along the outer edge of the medallion winds a circular band with full length images of the twelve apostles. Although they all give the same general impression, the artist avoided too high a level of monotony by slightly varying positions and giving individual characteristics to each face. Farther down still, a second band is decorated in architectonic patterns. Finally, near to the ground, among the golden arabesques, the faces of eight saints stand out. In the Galla Placidia Mausoleum, the decor remains intact. Above the door, immediately within the entrance, a mosaic representing the Good Shepherd recalls classical works with its free style. Seated amid his flock, the Shepherd caresses a ewe with his right hand, while in his left he holds a cross with a long descending arm; the face, surrounded by blond curls, radiates a calm and uniform beauty. [See p. 12-13]

Throughout the rest of the chapel are other figures in ancient dress. The ornamentation is elegant in design and rich in colour; amid the arabesques, which couple green with gold, two stags drink from a spring. This motif is one found in the illuminations of manuscripts up through the final days of Byzantine art.

During this time a taste for metalwork was already spreading, which would subsequently continue to develop. It was a response to a love of luxury which, as previously seen, is one of the characteristics of Constantinian art. Constantine introduced the diadem and adorned his clothes with pearls and precious stones — the pomposity of his wealth seemed to him to be an exterior symbol of his power; the attitude of the emperor contributed to the penetration of these ideas into the artistic realm. It was considered better to honour religion and to increase the beauty of Christian monuments than to attempt to decorate them with the rarest of materials. To the churches of Rome, Constantine donated five foot tall reproductions, in gold and silver, of the Savior, the apostles, and angels. His generosity was no less in the East. After describing the Church of the Holy Sepulchre, Eusebius adds, "One wouldn't know how to say how many adornments and gifts of gold, silver, and precious stones with which Constantine enriched it. These works were crafted with art." In Constantinople, he also mentions golden bas-reliefs. In the palace and in many public squares in the city towered golden crosses, decorated with fine stones.

Nothing of these works done in precious materials remains today. One could guess the style of the figures and ornamentation that adorned them based on a lead font, intended for holy water, whose Greek inscription is indicative of its origin. Diverse characters are displayed: next to the Good Shepherd, a gladiator is depicted at the moment just after seizing the crown laid on a cippus. Next to these subjects are found bands of pampres, palms, and peacocks drinking from a bowl; the four rivers of terrestrial paradise spill from a butte surmounted by a cross, with stags present, drinking. In one corner, a Nereid sits astride a seahorse. This peculiar mélange of paganism and Christianity was very common in the fourth century.

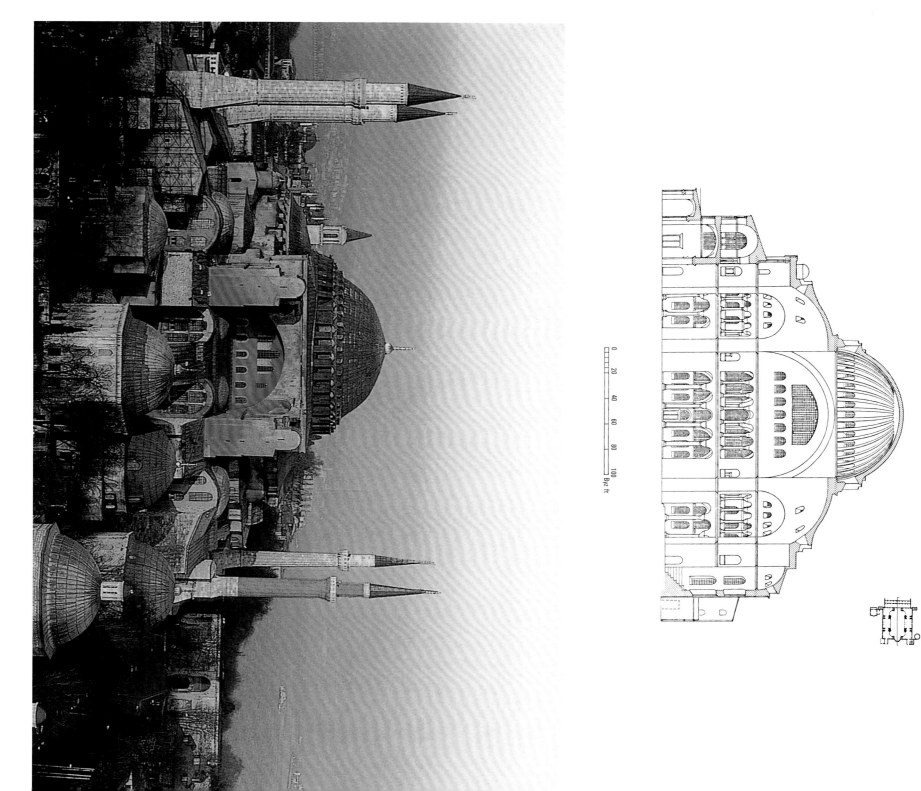

0
20
40
60
80
100
Byz ft

B. Art under Justinian and His Successors (527-726)

1. Architecture

At the debut of the sixth century, Justinian had already been partially directing affairs during the reign of his uncle Justin (518-527); he was then himself the sole emperor for nearly forty years (527-565). He encouraged artistic development throughout his empire. Justinian was a great builder. His historiographer Procopius dedicated an entire work to the structures, built by order of the emperor.

The most famous of all is the Hagia Sophia in Constantinople, which, it can be said, was the epitome of Byzantine art, for both its decoration and its architecture. No church in the history of Christian art holds more significance: even Notre Dame-de-Paris had its equals in the neighboring provinces. The Hagia Sophia has the double advantage of marking the advent of a new style and of achieving, in one fell swoop, proportions, such as have never been surpassed in the East. [See p. 20]

A church already existed in the main Forum, which was consecrated to Divine Wisdom. Built under Constantine, it had been partially destroyed by flames in 404, during a public riot on behalf of St. John Chrysostom. Theodosius had it repaired but in 532, during a terrible sedition, which nearly caused Justinian to lose his throne, the Hagia Sophia fell prey to a new bout of arson. Victorious over the rebels, the emperor reconstructed it, attempting to surpass in splendour all the most famous ancient structures ever described, the temple of Solomon in particular.

Rarely had the folly of extravagance been pushed so far. The most elaborate of materials – gold, silver, ivory, and precious stones – were used with an incredible abundance, even to the point of offending good taste: it seems that Justinian had less an appreciation for beauty than for costliness, and that his vision was to dazzle onlookers with the spectacle of enchanting luxury. He wanted gold and silver everywhere. The labours on the Hagia Sophia thus absorbed immense sums of money. In order for there to be sufficient funds, new taxes had to be levied and drastic measures taken. The ambo alone, with the altar, cost a year's revenue from Egypt; Justinian was also writing to governors and government officials to send already worked materials, which the desecration of old monuments. The praetor Constantine had ordered from Ephesus eight columns in antique green. They came from Cyzicus, Troas, the Cyclades, and Athens. A Roman widow, Marcia, had sent eight columns of porphyry, removed from a temple to the Sun. There was a wild array of marbles and stones of every colour, but within the natural polychromy, there was nothing displeasing, with the knowledge of tastefully combining the many shades. Even the land was very costly. Justinian was hardly content with the placement of the old Constantinian church and therefore had to purchase the surrounding houses, in the most affluent district of the city.

The names of the two principal architects who directed the labour are known – Anthemius of Tralles and Isidore of Miletus. Their contemporaries praised their knowledge, but it is Anthemius who was first acknowledged, by general consensus.

Plan of the Hagia Sophia, sectional view, 537. Hagia Sophia, Istanbul.

Hagia Sophia, southern view, 537. Hagia Sophia, Istanbul.

Hagia Sophia, interior view facing west, 537.
Hagia Sophia, Istanbul.

These two artists came from those Asian provinces where the architecture in the fourth and fifth centuries had developed with more originality. Under their orders, one hundred masters or chiefs of the building sites had been assigned, each of whom commanded one hundred workers. Once the terrain had been cleared and the foundation laid, the patriarch Eutychius recited prayers for the success of the enterprise, and the emperor himself placed the first stone. He immediately had an oratory constructed and some rooms from which he supervised the progress. Later, people would entertain themselves telling a mass of miraculous stories that supposedly occurred during the construction: an angel had described to the slumbering emperor the plan he was to adopt; another revealed to him hidden treasures, at a time when funds were lacking; yet another was supposed to have indicated to him that three apses were necessary for the completion of the cathedral. All these legends prove how much this mammoth enterprise had inspired the popular imagination.

The labour had begun shortly after the **arson**; the dedication took place the seventh of December 537. The emperor left his palace for the Augustaeum, mounted on a four-horse chariot; then, arriving at the church, he descended, ran from the great entrance gate up to the ambo, and there, with hands extended, he cried, "Glory to God who judged me worthy to complete such a work! Solomon, I have conquered you." This audacious exclamation well proves that in his eyes this temple was the epitome of the new law that he had just promulgated. He saw to the organisation and the maintenance of the church with the same pomp: three hundred sixty-five estates were ascribed to the areas surrounding Constantinople and one thousand clerics were charged with their service. From the exterior, the Hagia Sophia gives an impression of mediocrity, and the cupola itself, bold as its construction may be, seems depressing. One must enter the church in order to fully comprehend the originality and splendour. [See p. 23-25]

Before the temple stretches the atrium. A double narthex is found adjoining the church through nine doors. Apart from the eastern apse, the church is contained within a rectangular space 77 metres in length by 76.70 metres in width, including the thickness of the walls. The interior is divided into a central section, the nave, and two lateral sections. In the center of the structure, a cupola rises, with a 31 metre diameter, inscribed within a square. It rests on four large arches, with an opening equal to the diameter, which, in turn, rest on four wide pillars. Immense spherical pendentives jut out into the open air, filling the space between the large arches, and come out to meet the cupola. On the two arches perpendicular to the nave, the eastern and western arches, rest two semicircular domes; by contrast, to the north and at the median of the main cupola, the large arches are closed off by a solid wall, supported with colonnades. Around the semicircle, which is covered by the large, eastern half-dome, three apses are carved out: the principal apse, in the center, which extends to the east and terminates with a vault in the shape in a quarter sphere and two secondary apses to the right and left of the principal apse. The bottom of the two secondary apses is opened on the shoulders, and their archway is supported in this section by two columns. The perimeter of the western semicircle is sculpted in the same manner, but the central archway does not end in a quarter sphere. The arch extends to the facing wall, into which are cut the three doors joining the narthex.

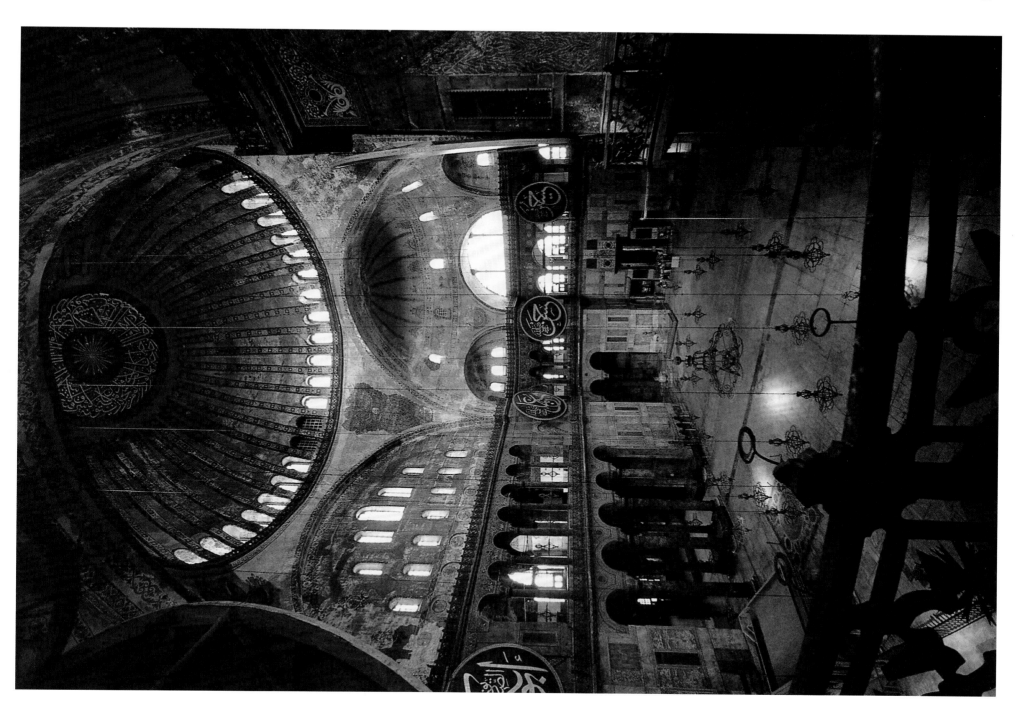

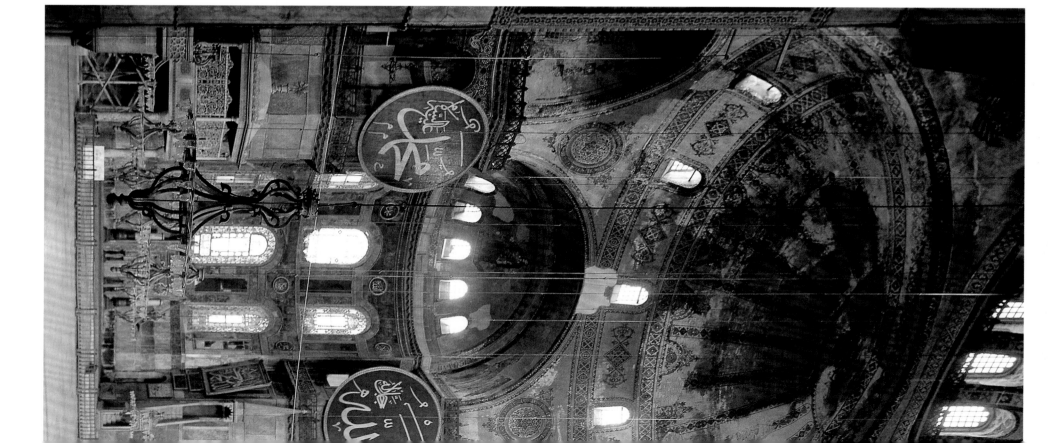

Hagia Sophia, interior view, 537.
Hagia Sophia, Istanbul.

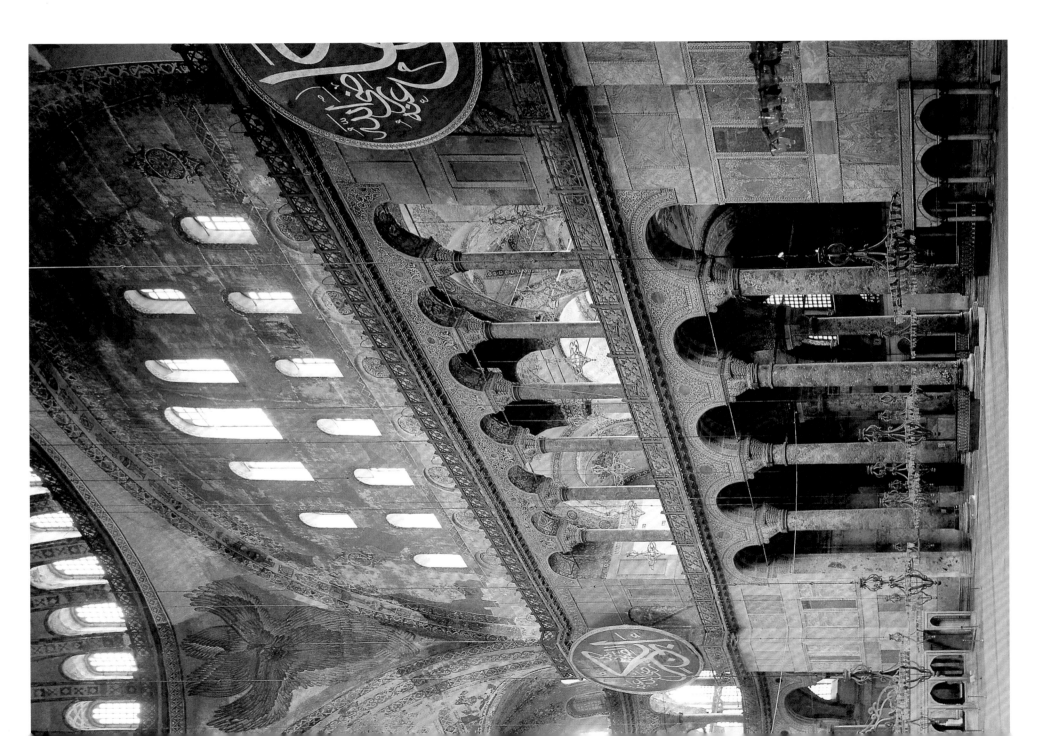

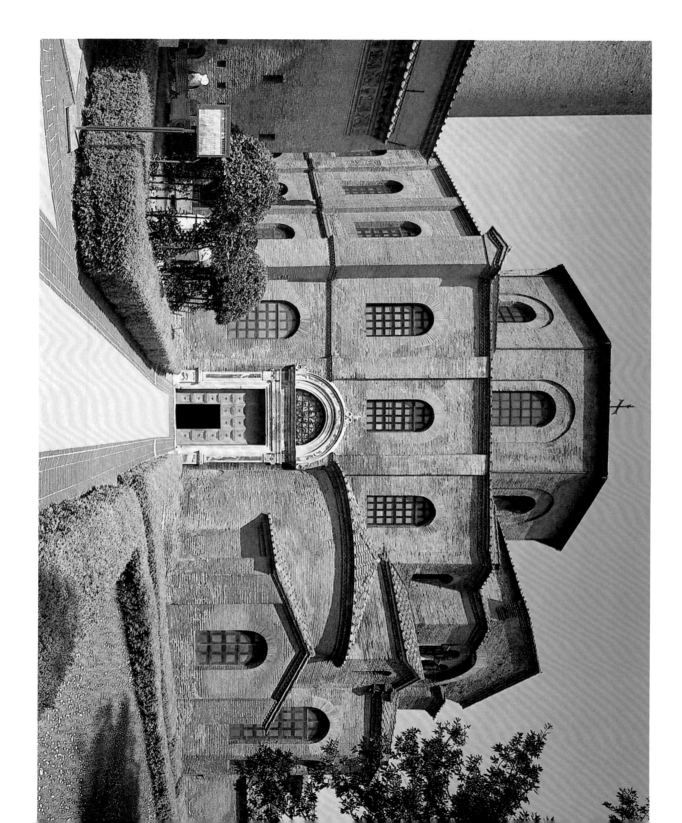

The shoulders, from the ground up to the cradle of the arches, are divided into two levels, the upper bearing the name of gynaeceum. The light penetrates throughout the entire structure through a large number of bays: forty windows open at the base of the cupola, and others are cut into the walls of the north and median arches, in the half-domes and in the apses.

The construction of the central cupola had been a difficult problem to resolve because of the immense proportions that had been desired for it. Massive pillars had been allocated as points of support, carved with great care to prevent them from giving way or splitting under the pressure they were to support. Nevertheless, for a while there was concern for the cupola itself: the architects who had had the audacity to build it were challenged by their own work. They therefore employed particular materials, notably white, spongy tiles, manufactured in Rhodes, and so light that five were needed to equal the weight of one regular tile.

Despite these precautions, it was not before they recognised how well founded were their fears. The following years were riddled with earthquakes that were sometimes extremely violent: there was one in 553 that lasted forty days, another in 557 that razed a portion of the city. The cupola of the Hagia Sophia felt the effect of these repeated tremors, fissures formed, and on the seventh of May 558, it collapsed. According to some authors, the architects charged with researching the cause of the accident declared that it had been erroneous to remove the wooden scaffolding too quickly in order to work on the mosaics. Justinian had the cupola rebuilt. Anthemius and Isidore had died, but the latter had left a nephew, who was charged with this project. He increased yet again the elevation of the cupola, but at the same time he gave more solidity to the great arches. This time, the curves and the scaffolding were left in place longer, and then the lower part of the church was flooded so that the falling wooden pieces would not weaken the new construction.

Everything in the furnishings and decoration of the church bespoke the vision of magnificence with which Justinian's mind was saturated. Toward the center of the structure, the ambo was a large stand topped with a cross and a dome: the magnificence of gold and precious stones was combined with that of the most beautiful marble. The sanctuary was separated from the rest of the church by a railing of pure silver. On the columns, images of Christ, the Virgin, angels, apostles, and prophets stood out on medallions. The altar was golden and from this dazzling background gleamed gems and enamels. Stretched above, in the form of a ciborium, was a dome with a golden cross at its apex; four columns of gilded silver supported it. "Who would not be astonished," said a poet of the time, "by the appearance of the splendour of the holy table? Who could comprehend her provenance, when she scintillates with varied colours and when one sees her at times reflecting the brilliance of gold and silver, at others shining like a sapphire, casting…multiple rays, following the colouration of fine stones, pearls, and metals of all sorts, of which she is comprised?" At night, during the great celebrations, the church was lighted up like a beacon for, according to Byzantine writers, there were no fewer than 6000 gilded candelabras.

Basilica of San Vitale, 527-548.
Ravenna, Italy.

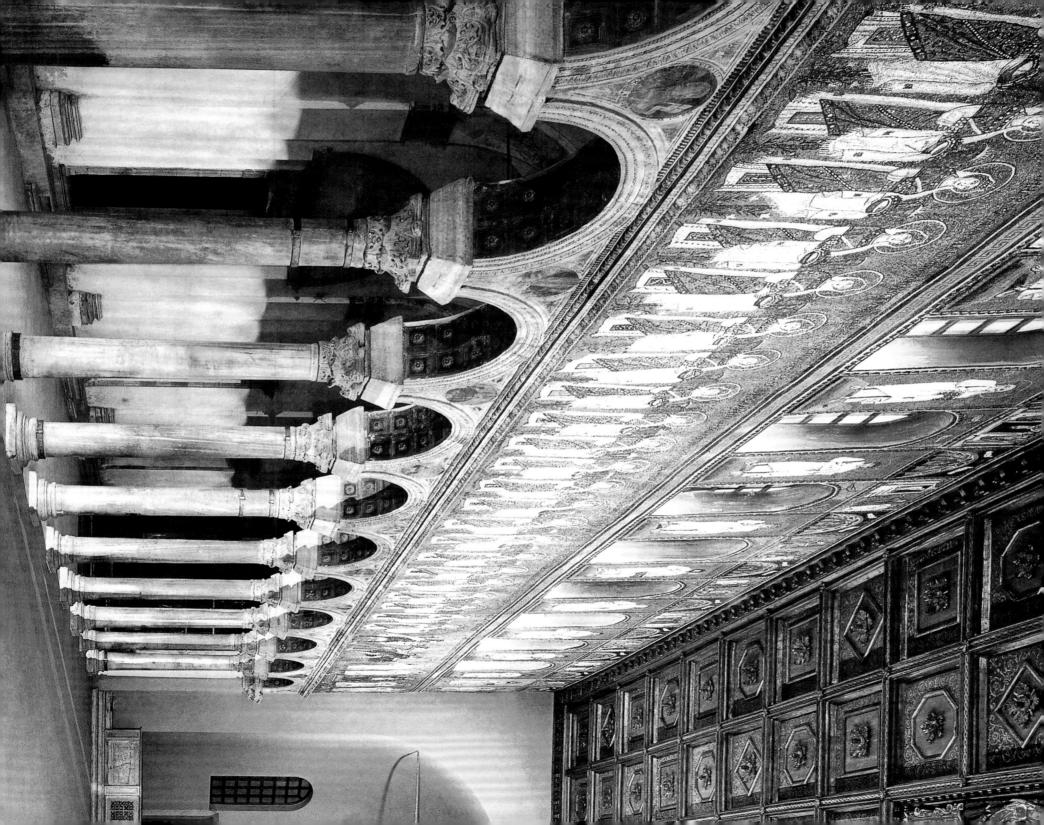

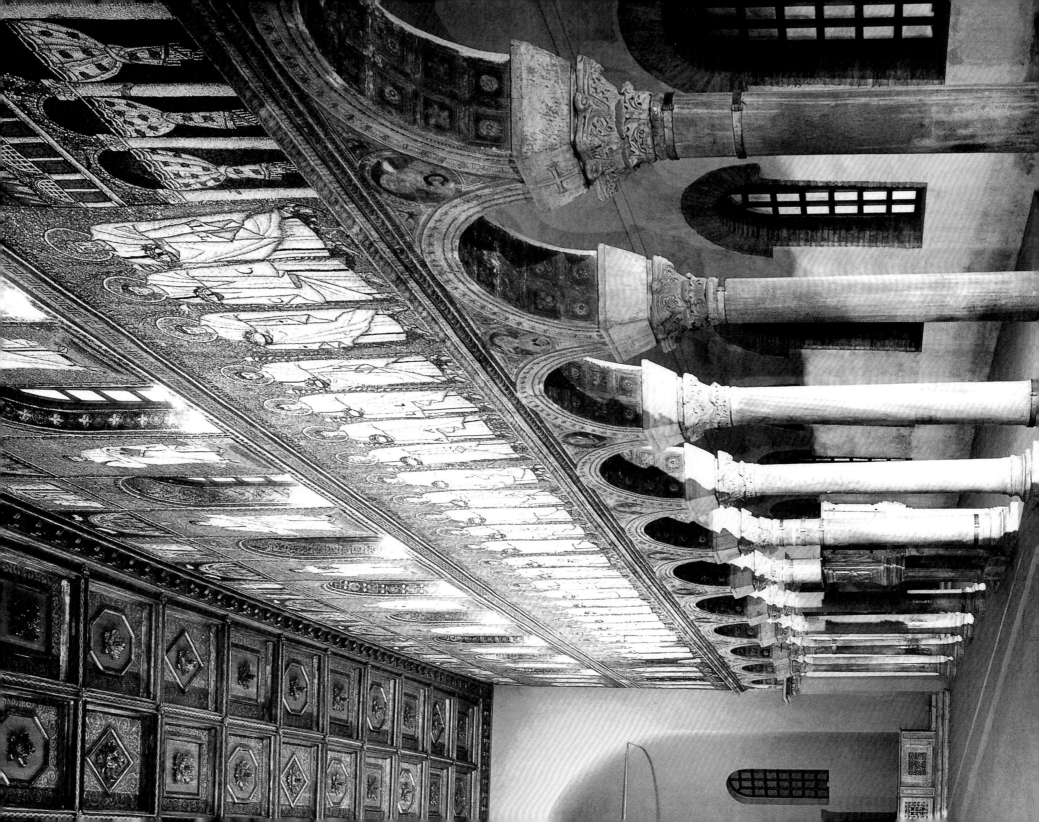

Basilica of San Vitale, interior view, 527-548. Ravenna, Italy.

Monastery of St. Catherine, 527-565. Mount Sinai, Egypt.

In other places, saints and prophets stood out beneath archways. Only small fragments remain, but they furnish some idea of what was once the Hagia Sophia, when she shone brightly, draped entirely in this rich garment of mosaics. Rarely in the history of art can one encounter an ensemble that is so imposing, an accord of architecture and adornment so perfect.

The Hagia Sophia is the apogee of Byzantine art, as it was developed under Justinian and his successors. Contemporaries admired it, artists have been inspired by it, yet it must not be believed that it was imposed as a model from which one dare not stray.

In architecture, the use of the cupola was spreading more and more. From a technical standpoint, the construction of the Hagia Sophia had drawn architects to study this form of their art with more care and to better realise the effect it produced, the use that could be made of it, and the rules that needed to be applied. From that time on, Latinate basilicas became the exception in the East, but in the new churches with cupolas, hardly anyone was content to copy the layout of the Hagia Sophia. The cupola served as the theme around which numerous variations were created, and in Constantinople itself, in the vicinity of the Hagia Sophia, other churches were raised in the same style under Justinian, but in a very different layout. More than one had even been started and finished before the Hagia Sophia.

The church of the Hagia Sophia at Thessaloniki seems also to belong to the reign of Justinian, although Procopius makes no mention of it. Several travellers have noted that the architect seems to have imitated the Hagia Sophia of Constantinople. The great central cupola is indeed present, resting on four pillars, but it is no longer accompanied by two large half-domes, as at Constantinople, and consequently, alongside remarkable similarities, some essential differences must be distinguished. In Asia, in the region of Antioch, the church of Dana displays no cupola and is closer to the standard basilica; on the other hand, one curious example of a horseshoe arch may be highlighted, which would pass from Byzantine to Arabic architecture. The Byzantines themselves had borrowed this form from the architects of central Asia.

Let us now move on to Italy, which had just been partially re-conquered by Justinian's forces. Ravenna, where the exarchs resided, was like a miniature of Constantinople. In this city, famous for some centuries, the monuments of the time crowd in on each other and are quite well preserved.

Among the churches of Ravenna, the most famous and most important is that of San Vitale. [See p. 26] Its construction had begun before the Byzantine conquest, in the year 526, but it was only completed in 546, and the decoration of the structure attests to the fact that Justinian and Theodora enriched it with their gifts. According to various inscriptions, the labour of San Vitale, as well as that of several other churches of Ravenna, was allegedly directed by a man named of Julian, who fulfilled the duties of treasurer (*argentarius*). San Vitale is in the shape of an octagon; on the interior, eight wide pillars are connected by arches from which soars a high cupola. The circular base

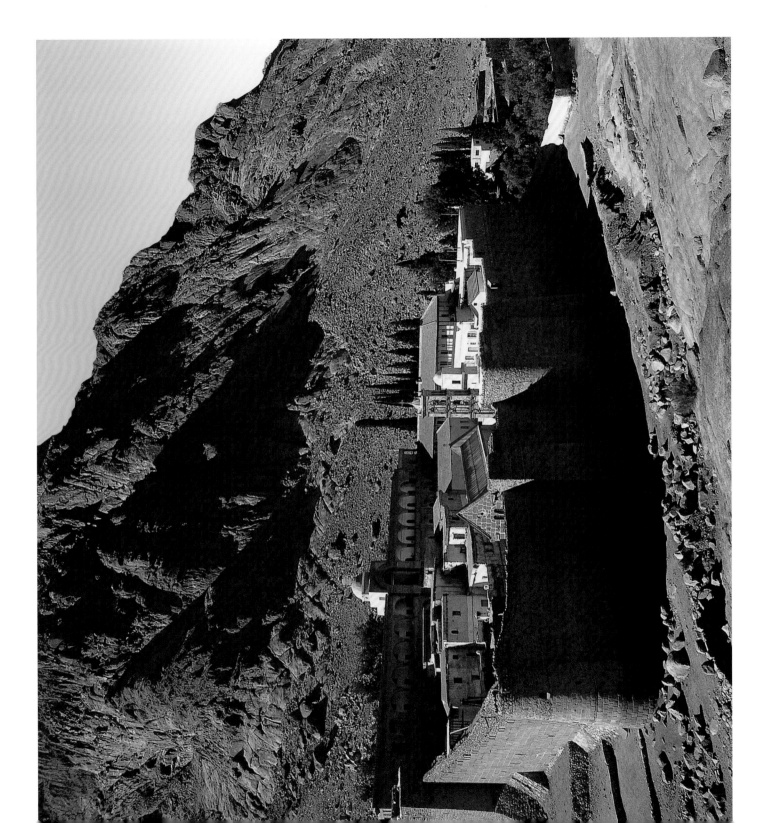

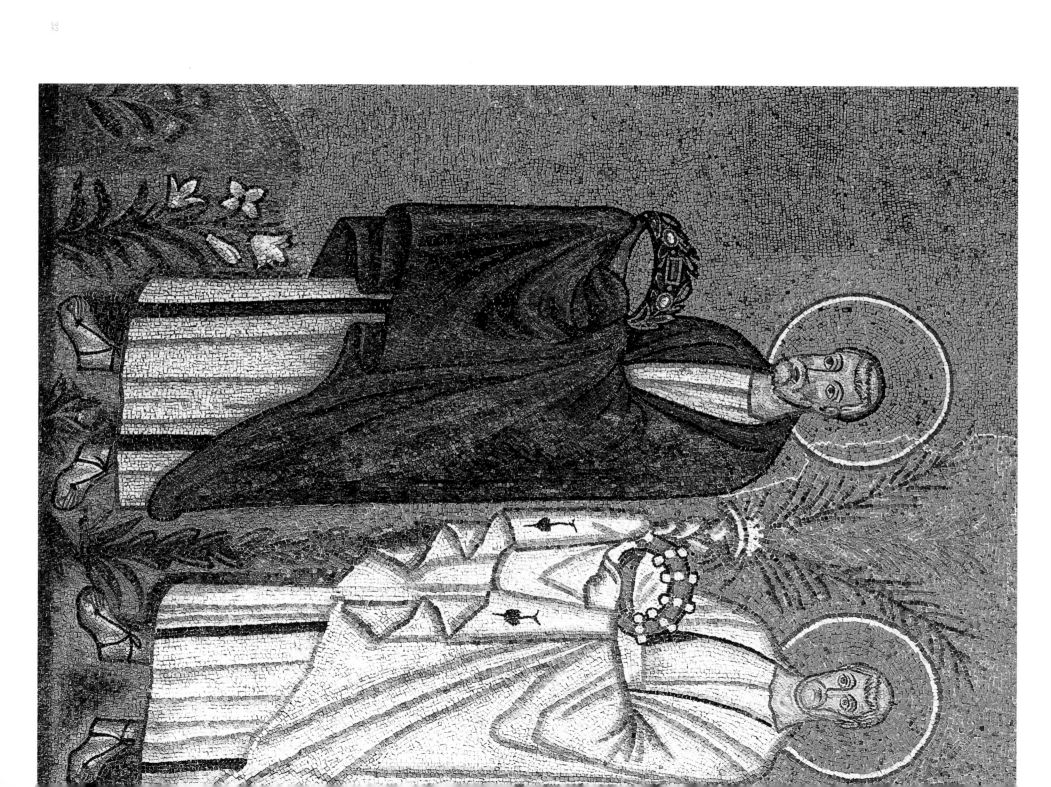

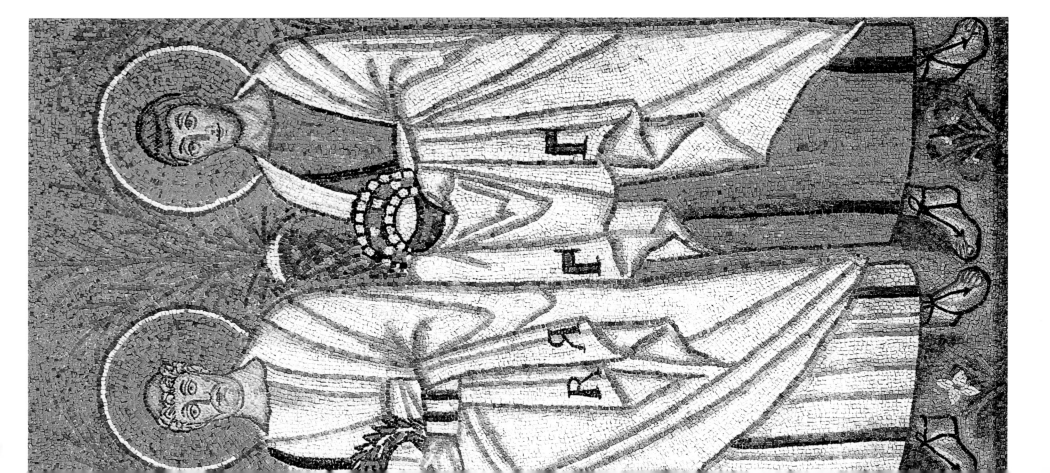

Procession of Martyrs, 493-526.
Mosaic.
Basilica of Sant'Apollinare Nuovo,
Ravenna, Italy.

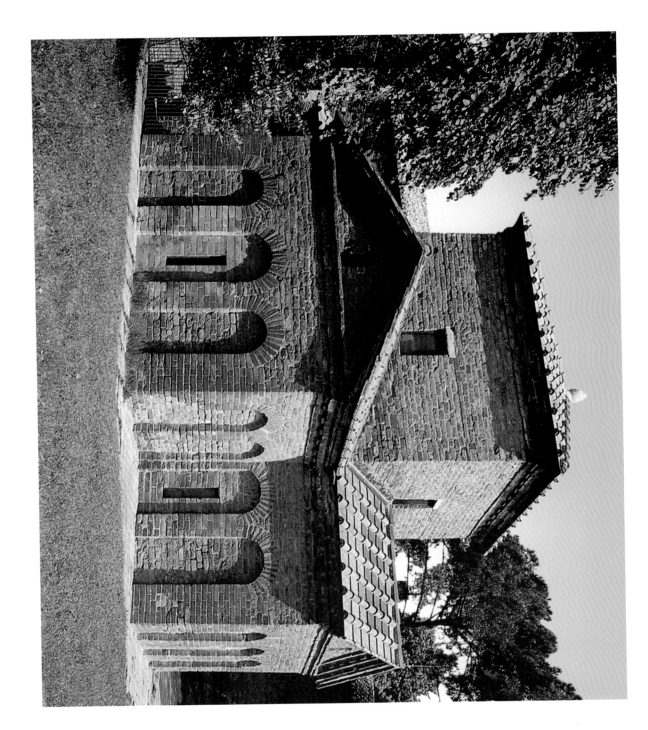

of the cupola attaches to the octagonal layout by eight small pendentives. In order to minimise the weight of the vault and to ensure its solidity, the architects built it with clay pipe, nestled one inside the next. The shape of the cupola is not evident from without, as it is in the churches of the East; it is hidden under a pyramid-shaped roof. Begun prior to the Hagia Sophia, San Vitale is distinguished from it by certain essential characteristics. It has consequently been proposed to recognise not Byzantine influence, but that of a school of architecture that existed in Milan during the fourth and fifth centuries. Yet whether in the ornamental sculpture or the splendid mosaic decoration, everything betrays collaboration, or at least an education of Greek artists. It is difficult to believe that this influence does not extend to the very plan of the structure, considering that it was primarily in the East that the polygonal form had been applied to churches.

On the other hand, in other religious structures in Ravenna dating from the same time, the architects preserved the layout of the ancient Latin basilica. Among the most interesting, the church of Sant'Apollinare in Classe is situated outside the walls of the city.

Byzantine architects mostly used brick, and they generally retained the form given to the material by the Romans. Manufactured with care and often created with markings that allowed for the identification of the date and character of the structures, these bricks were connected by a mortar of a very heavy consistency. The core of the walls was ordinarily made of concrete, and the bricks formed only a façade. Byzantine constructions were therefore extremely solid; in many places, the city walls have resisted the attacks of time and man and have been preserved nearly intact for centuries.

On the interior, ornamental sculpture developed in the most original and curious forms. It is thus that the capitals of Byzantine churches present a marvelous array of appearances: in some places the most finely detailed tapestry seems to be cast upon a cubic stone mass, while in other places, there are foliated bell capitals. Images of animals, birds, and vessels at times further complicate the decoration. These ancient examples of Greek and Roman architecture have been neglected or profoundly altered; as time advances, fewer traces of them are found. However the Byzantines did not invent all these ornamental combinations from which they drew such pleasing result; once again they borrowed from the East, and some of the models, by which they were often inspired, are found in the monuments of Persia.

As elaborate and varied as the decoration of Byzantine capitals may be a decline in the sculpting process must be acknowledged. Those who had worked on them did not know how to add depth to their ornamentation, scouring the stone on the surface rather than cutting it with more profound layers, and their works often came closer to the style of metalworking than to that of sculpture.

Galla Placidia Mausoleum, fifth century. Ravenna, Italy.

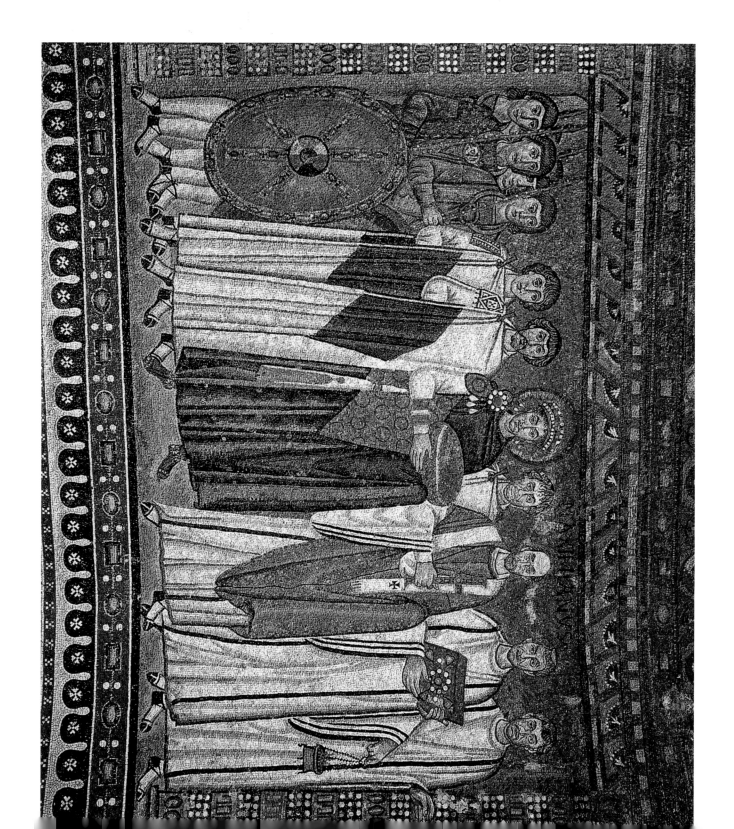

Justinian and His Retinue, c. 546.
Mosaic.
Basilica of San Vitale, Ravenna, Italy.

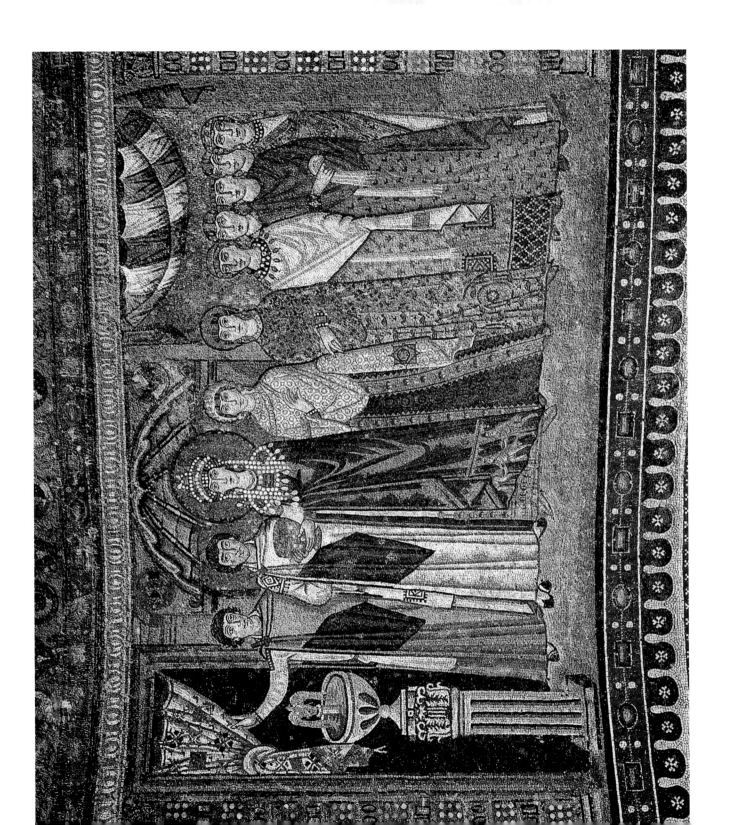

Theodora and Her Retinue, c. 546.
Mosaic.
Basilica of San Vitale, Ravenna, Italy.

2. Painting, Mosaics, and Illuminations

In a large number of churches from the sixth and seventh centuries, such as the Hagia Sophia, mosaics pour out the wealth of their adornments and are displayed as brilliant works. Byzantine artists loved to depict huge compositions whose details were all distinct; they avoided subjects that involved a large number of figures mingled with one another; they gave preference to those with almost no action, the postures calm and regular, in which the characters could be arranged without at all disturbing the uniformed arrangement of the ensemble. At times they would place the same number on one side as on the other, so as not to disturb the compositional equilibrium. This principle of symmetry had to be maintained in Byzantine art. The painters' mentality was so imbued with it that it was applied assiduously, even in the smallest works. For this reason this art, even while losing at times something on the side of authenticity and artistic freedom, was so well suited for the decoration of huge structures.

From a technical perspective, Byzantine tile setters had no less understood the demands of their art. While, during the Middle Ages, the number of shades was increased so as to attain the appearance of a fresco, the Byzantine artists only used them in small numbers, juxtaposing contrasting colours, neglecting intermediate shades. Since the mosaic is made to be seen from afar, the harshness of these contrasts is lost within the overall harmony of the work; but on the other hand, everything stands out with an incomparable vigor and brilliance. The figures leap out of a background of blue or intense gold; the vibrant and clear colours of the clothing form a powerful contrast with this uniform shade of the background. Often, a black line traces the outline of the body and facial features to better enhance the picture. Everything in the process contributes therefore to giving the work the look of a well composed piece that captures the attention through striving to create the illusion of poignant definition.

Some mosaics from this time can still be found in the East. In a church in Thessaloniki, which bore the same name and today has been transformed into a mosque, the Ascension of Christ is portrayed on the vault of the cupola, while on the apse, the Virgin, seated on a gem-encrusted throne, bears the Baby Jesus in her arms. One of the famous monasteries of Mt. Sinai preserves some mosaics that have been attributed to the same era, which reenact various episodes from the life of Moses and the Transfiguration of Christ.

Moreover, in Constantinople itself, this genre of decoration was used in more than just the churches: Procopius describes one mosaic found at the Great Palace. "The artists," he says, "have depicted the wars and battles of the realm, the cities taken in Italy and Africa. Justinian is victorious, thanks to Belisarius, who, returning with his army brought him the loot of kings, kingdoms, and treasures. In the middle, Justinian and Theodora, filled with exultation, celebrate this triumph, while the kings of the Goths and the Vandals beg for clemency. Around them, the senators display their joy."

Once again, it is to Ravenna that one must go to find the most beautiful Byzantine mosaics of the era. Of this genre, nothing is equal to the decoration of the apse of San Vitale. Immediately upon entering, the gaze is drawn to two large compositions of

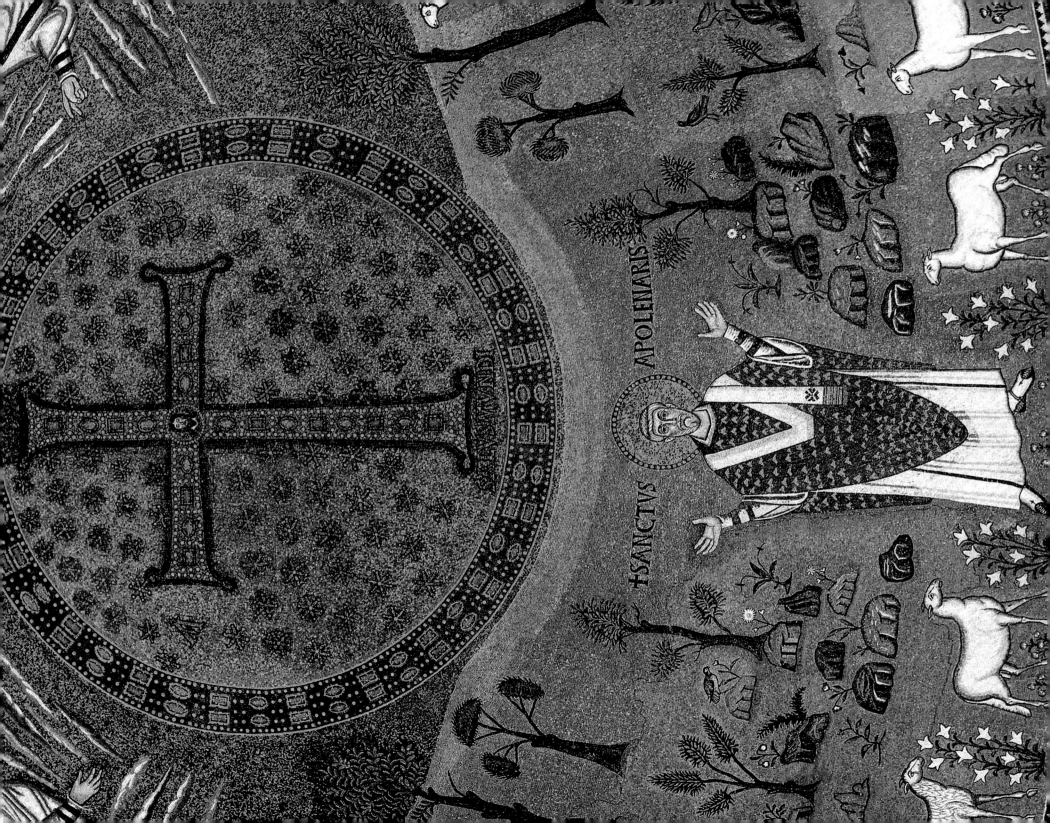

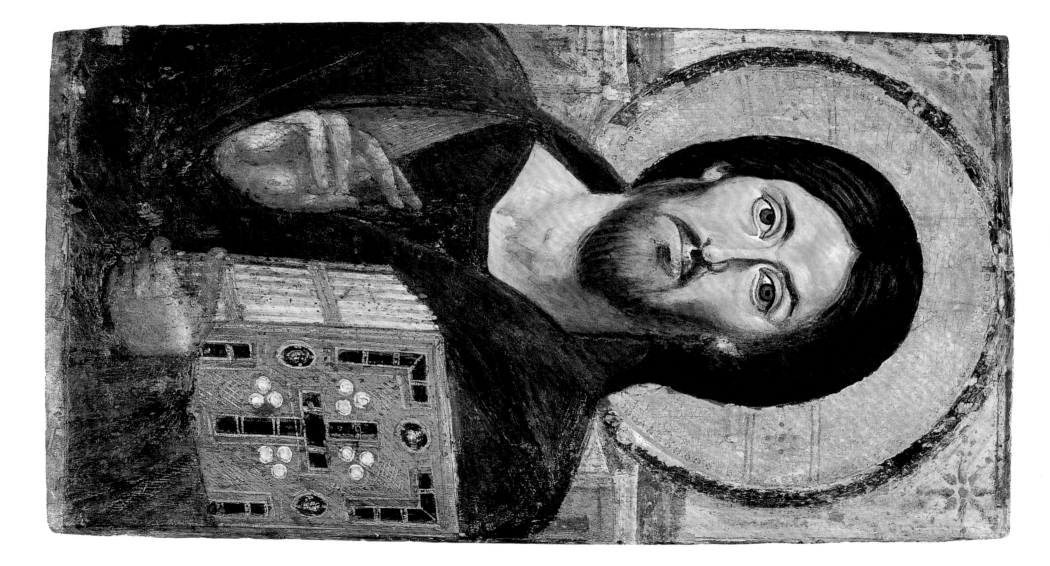

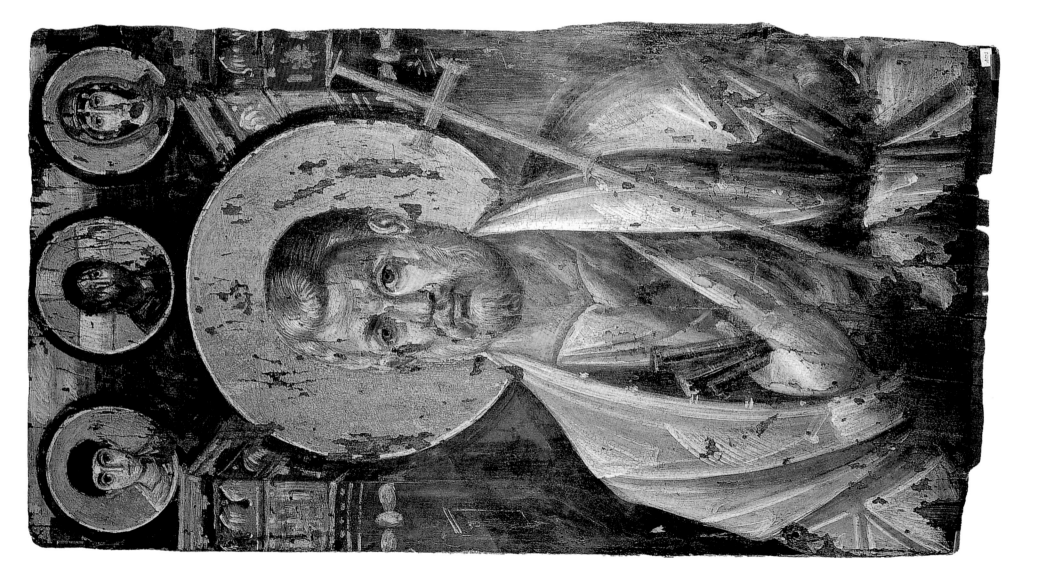

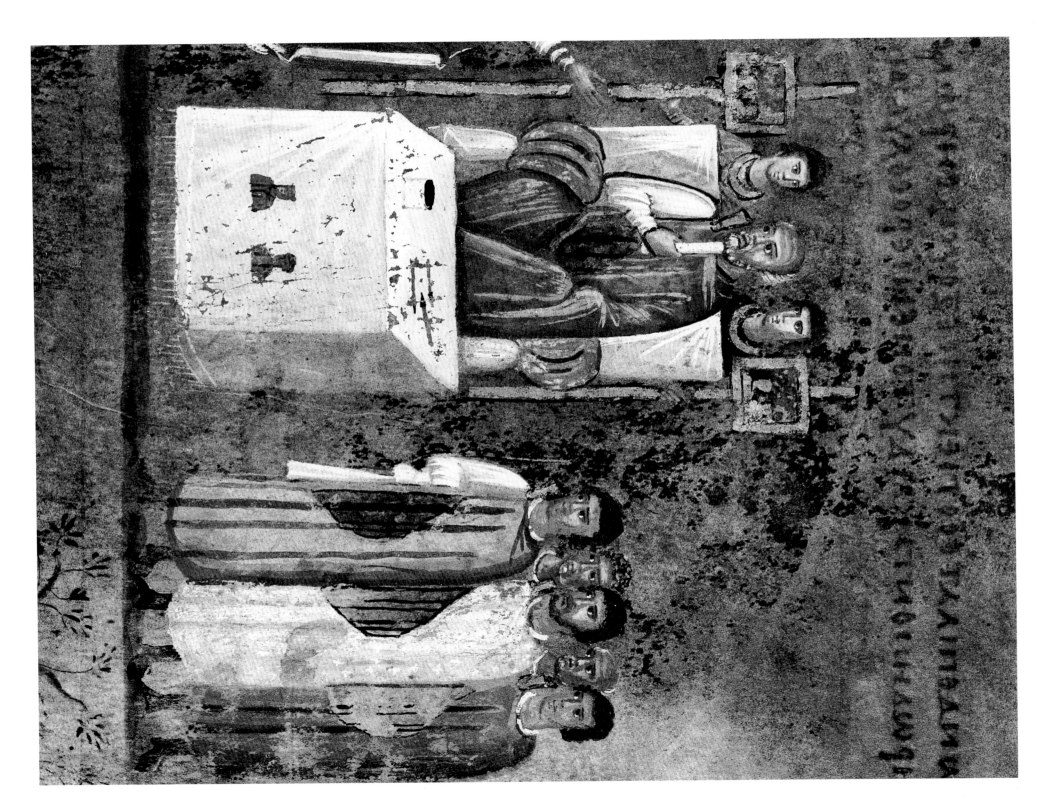

Christ Pantocrator, sixth century. Icon. Monastery of St. Catherine, Mount Sinai, Egypt.

St. Peter, sixth century. Icon. Monastery of St. Catherine, Mount Sinai, Egypt.

Codex Purpureus Rossanensis (Rossano Gospels), the Judgement of Pilate, sixth century. Painting on parchment, 30 x 25 cm. Cathedral Treasury, Rossano, Italy.

Genesis, Rebecca and Eliezer, sixth century. Painting on parchment, 31 x 25 cm. Österreichische Nationalbibliothek, Vienna.

historical interest. On one side, Justinian surrounded by dignitaries and guards, and on the other side, Theodora attended by her retinue, offer gifts to the church: the empress crosses the atrium, where the holy fountain is located, while a servant raises before her the veils hung at the door of the temple. Her costume is splendid: large embroidery, depicting the Adoration of the Magi, adorns the hem of her cloak; jewels cover her chest; from her hair, coils of pearls and gems hang to her shoulders; a tall diadem crowns her haloed head. This is a vibrant evocation of the past: these symmetrically arranged figures, who are presented full-face, these women with their regular features, their large, fixed eyes, their uniformed posture, the splendour of their costumes, all this offers, finally, a glimpse of the court of Byzantium, which is impossible to forget, so rich and so elegant, and where a meticulous etiquette ruled. [See p. 36-37]

It would be impossible to describe all the mosaics of San Vitale and the other buildings of Ravenna. However, one of the most remarkable is the long procession of female saints that unfolds atop the arcades of one nave in Sant'Apollinare Nuovo; they bear crowns to the Virgin; their attire is rich, their heads are adorned with mitres, but the regularity of their features, a slight and gracious incline of the head, gives them a particular charm. One involuntarily muses on classical Antiquity and certain works of incomparable perfection, where this idea of order and harmony dominates. Since this beautiful epoque of Greek art, many qualities have been lost; yet in these mosaics, one regains a sense of the relationship between the past and the present.

Basilica of San Vitale, north wall, 527-548. Mosaic. Ravenna, Italy.

It is thus no less interesting to study the illuminated manuscripts from this era, which have preserved for us a smaller image of the big picture. One of the oldest, the manuscript of Genesis, kept in the National Library at Vienna, offers well-conceived compositions in which the artist discovered how to introduce life and grace into the illuminations and illustrations. The women in them are draped with an arrangement of elegantly simple folds, reminiscent of Antiquity. [See p. 43]

A manuscript of the Gospel, found at Rossano in the south of Italy and dated to around the sixth century, contains an entire series of paintings whose subjects are borrowed from the New Testament. [See p. 42]

A manuscript of the works of the doctor Dioscurides, also kept in Vienna, bears its date: it was written for a princess of the imperial family, Juliana Anicia, who lived in Constantinople at the end of the fifth century and the beginning of the sixth. It is not about religious events, and the painter seems to have been especially inspired by secular works. On the first sheet, Anicia is portrayed seated between two personifications, Magnanimity and Wisdom, while a prostrate woman kisses her feet and a winged genie presents her with an open book. Their posture is simple and natural, and the well drawn figures pleasantly stand out from a dark blue background. The framing is particularly exquisite – small Cupids engage in the artistic work, some painting, others sculpting or building. It is correct to say that these figures recall certain paintings from Pompeii and Herculaneum; the resemblance is, in fact, surprising, and the technique is as free and as gracious. [See p. 47]

The Laurentian Library in Florence possesses a Syriac manuscript, produced in 586 in a Mesopotamian convent, by a monk named Rabbula. Nearly every page is framed with a large architectural drawing, tall porticos, supported by fragile and elegant colonnettes. [See p. 48]

On the façade or surrounding these delicate constructions, groups of birds, animals, and trees, treated in a graceful and researched style, then little scenes whose subjects are borrowed from the sacred texts. Toward the end of the volume are some compositions of greater proportions: one is famous because it displays one of the first examples of the Crucifixion. [See p. 48]

The subjects treated in manuscripts are numerous: many belong to the Old Testament, some to the history of Christianity, such as the Lapidation of St. Peter and the Conversion of St. Paul. At the end of the manuscript is placed a large and beautiful illumination that occupies an entire page; at the top, two medallions contain images of Saints Anne and Simeon; beneath, Christ, the Virgin, St. John the Baptist, the great priest Zacharias, and St. Elizabeth are arranged beside each other. The posture of the characters, the religious serenity on their faces, the gold that gleams behind their halos and on their clothing all combine to give this painting an arresting appearance. It seems copied from some mosaic and, furthermore, is not of the same style as the preceding illuminations.

46

St. Demetrios, seventh century.
Mosaic
Thessaloniki, Greece.

Dioscorides, Princess Anicia Juliana,
De Materia Medica, 512.
Painting on parchment, 36.5 x 26.6 cm.
Österreichische Nationalbibliothek,
Vienna.

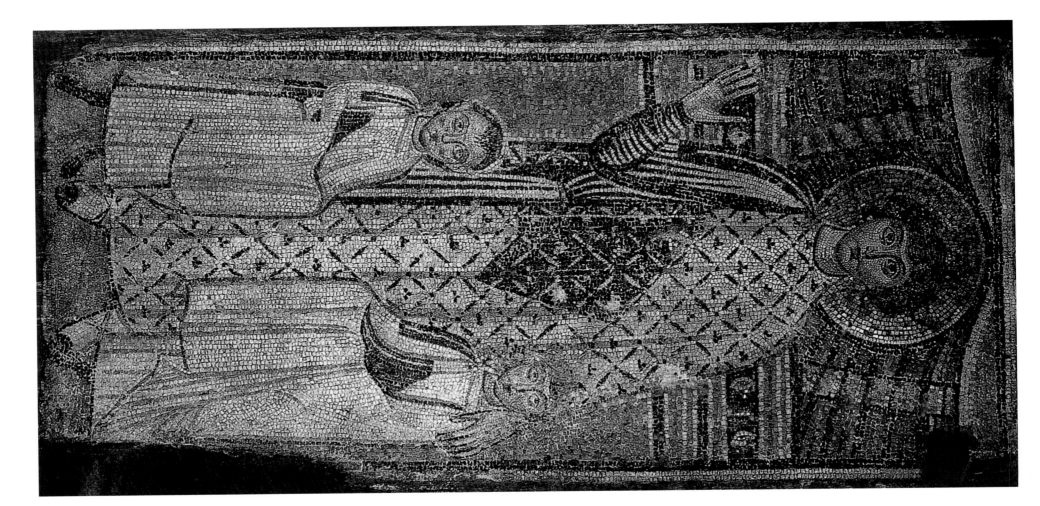

Rabbula Gospels, the Crucifixion and the Resurrection, 586. Manuscript, 33 x 25.5 cm. Biblioteca Mediceo Laurenziana, Florence.

Rabbula Gospels, the Ascension, 586. Manuscript, 33 x 25.2 cm. Biblioteca Mediceo Laurenziana, Florence.

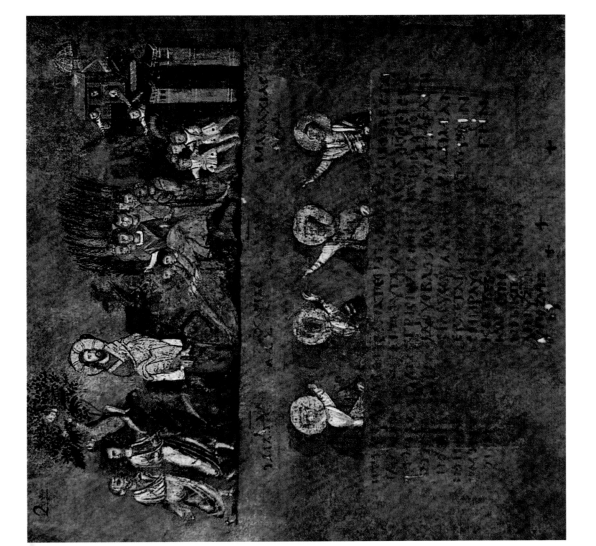

Codex Purpureus Rossanensis (Rossano Gospels), The Entry into Jerusalem, sixth century.
Manuscript, 31 x 26 cm.
Cathedral Treasury, Rossano, Italy.

These few observations are indicative of how complex the decoration of these manuscripts is. Sometimes they take us further into the past: even in the eighth or ninth century, painters had used ancient manuscripts whose images they repeated. But the artists whose works were being reproduced had by no means themselves created all these compositions: more akin to the third and fourth centuries, they knew those monuments, were inspired by them, so certain illuminations of the more recent edge of the Byzantine Empire can give a sense of the frescos that had decorated the most ancient churches. Previously, the well-known work of a famous artist would become a model that was copied almost exactly; this is why some illuminations appear to be reproductions of mosaics. On this point, one can give clear proof: thus the angel head framed in a medallion located at the Hagia Sophia reappeared many times and is seen again in a manuscript from the twelfth century.

As for mural painting, though the works themselves have been lost, the texts of contemporary writers make some examples known. The mosaic was a mode of decoration that was too extravagant to use always; so they often had to resort to the fresco. A rhetorician, Choricius, described at length those adorning a church in Gaza from the sixth century.

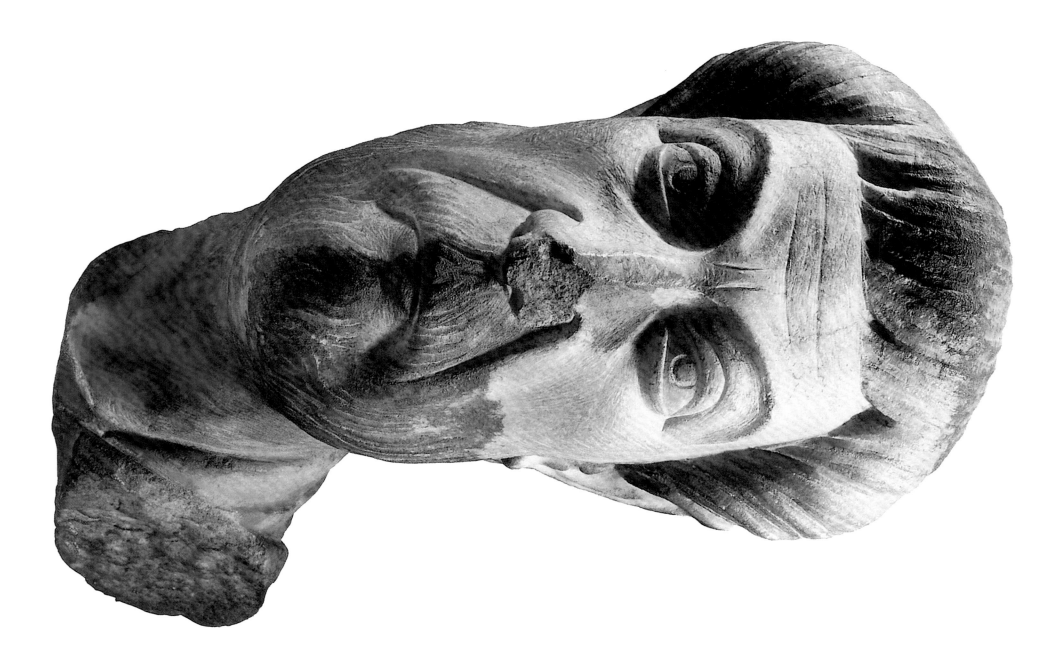

All the subjects were borrowed from the New Testament. The cycle of paintings begins with the Annunciation: the angel, descending from the heavens, approaches the Virgin who is occupied with her spinning; he speaks to her, and his words seem almost to reach the viewer. The Virgin is astonished by this unexpected sight, and the crimson she is weaving nearly escapes from her hands. The Visitation follows, and Elizabeth is seen rushing toward the Virgin, whose knees she desires to embrace, while the latter impedes her from doing so. Later, the Nativity is depicted, the donkey and the ox are near the manger where the newborn rests; the Virgin is reclining, half leaning on her right arm. Then a celestial voice informs the shepherds, diverting them from their flocks; they leave them in the pasture, near a spring, under the guard of a watchdog, and stand to the call. Some carry their staffs, others lean on theirs. The angel appears to them, pointing the way to the Child; the flocks, who are not in the least suspicious of the apparition, graze or drink, but the dog, being more intelligent, seems to comprehend that something extraordinary is taking place.

The following painting depicts the old man Simeon, greeting the divine Child, who is carried in the arms of his mother. Such are the scenes treated from the childhood of Christ. Those that follow illustrate the principal miracles of the Savior. First, we attend the wedding at Cana: Christ, accompanied by his mother, transforms the water into wine; one of the servants pours the water from a vase into the amphorae; another, after having filled the basin, circulates it around the table; the wine seems to have a pleasant bouquet, for the delighted face of the one drinking shows the pleasure he finds in it. Here is the mother-in-law of Peter, healed by the Savior at the request of the apostle; there, the paralytic and the slave of the centurion, delivered from their sufferings. Further on, we follow the body of the widow's son into the tomb, dead in the flower of his youth; women follow behind in mourning, but their sorrow changes to joy at the sight of the miracle brought about by Christ. The repentance of the adulterous woman, the calming of the storm, Christ walking on water and saving Peter, the healing of the demon-possessed man and the lame man, and the resurrection of Lazarus are figured into this second series of subjects, as well.

Finally come episodes borrowed from the last days of Christ: the Last Supper, the betrayal of Judas, the judgment and sufferings of Christ, Pilate washing his hands, the Crucifixion, the soldiers guarding the tomb, the Ascension. Unfortunately, Choricius, at first generous with his details on the composition of these paintings, then becomes more sparing after the episode of the wedding at Cana, and some of the last scenes are scarcely mentioned.

Nevertheless, his descriptions clearly show the spirit that presided over the order and composition of these paintings; nowhere near all the subjects of the Gospel were addressed, but those present were divided into three chronological series: childhood scenes, miracles, and the Passion. Thus was the development of the system of decoration whose origins have been indicated.

Bust portrait of Eutropius, late fifth century. Marble, height: 32 cm. Kunsthistorisches Museum, Vienna.

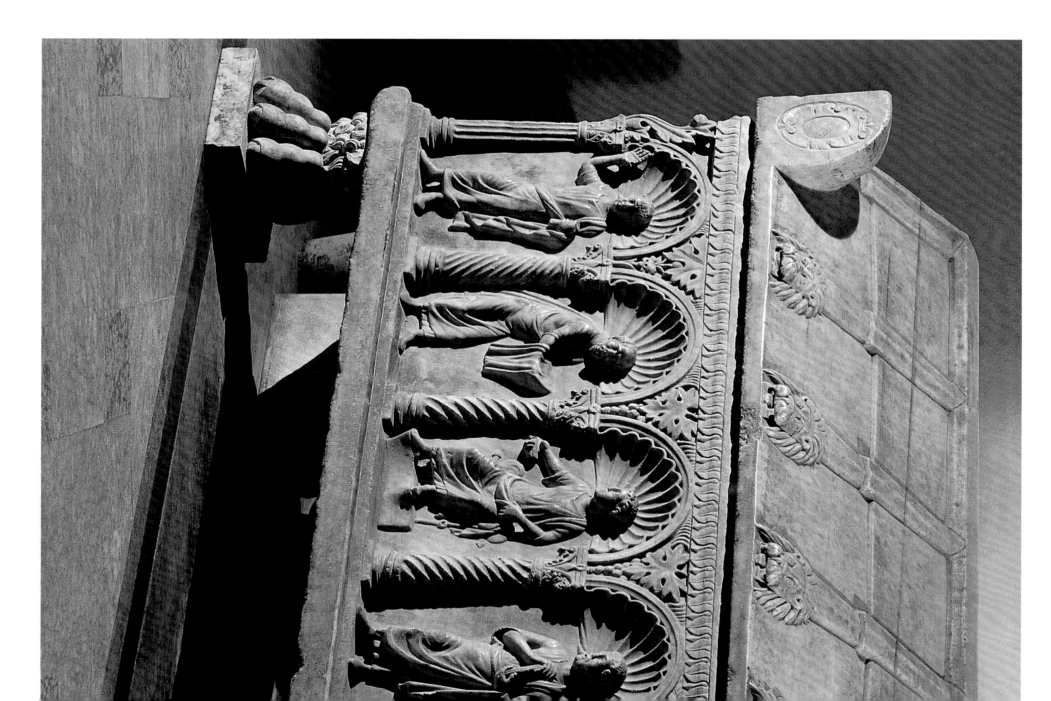

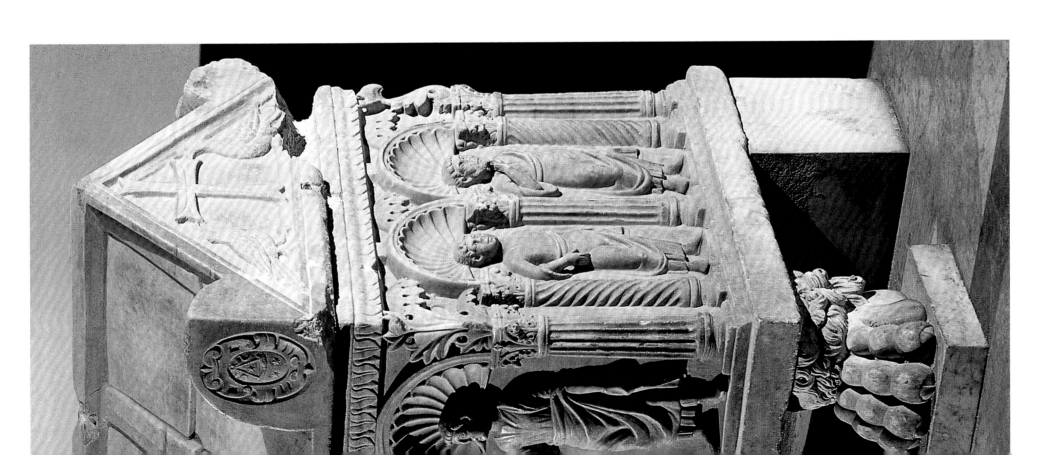

Christy Restoring the Law, fourth or fifth
century.
Marble.
St. Francis Basilica, Ravenna, Italy.

3. Sculpture and Metalworking

While architecture and painting blossomed in the most original of forms, sculpture was on a decline. It is true that the sculptures of emperors continued to be erected; Procopius describes the statue of Justinian, which stands in the Augustaeum across from the Hagia Sophia and remained there until around the time of the capture of Constantinople by the Turks. "On a horse of bronze is seated the statue of the emperor, remarkable in his dress, which is that of Achilles." Elsewhere he speaks of statues so skillfully crafted that they were believed to be of the hand of Phidias, Lysippus, and Praxiteles. These bombastic praises are without foundation and it is difficult to form a meritorious idea of these works. There remain, nevertheless, two works that display the splendour of statuary throughout the course of the fifth century, the head of Arcadias and the famous bust of Eutropius in the Kunsthistorisches Museum in Vienna. [See p. 8 and 50]

Sculpture would have been redeveloped with radiance if the Church had tried to protect it, but it was never able to overcome the mistrust of which sculpture had been the object; the Church remembered that sculpture had given the most attractive and perfect forms to idolatry, and, if it was not exactly banned, it was hardly encouraged.

Moreover, some monuments of this era show how much this sense of sculpture is innate to Greek genius. In place of the heavy figures of Roman decadence, more skillful works abound, and in Constantinople, the bas-reliefs on the obelisk of Theodosius at the Hippodrome, though still rather mediocre, attest to a progression. [See p. 54]

Theodosius Receiving Tribute from the Barbarians, detail from the base of the Obelisk of Theodosius, 390-393. Marble, height: 430 cm. Hippodrome, Istanbul.

Sarcophagus, reputedly of Archbishop Theodorus, late fifth to early sixth century. Marble. Basilica of Sant'Apollinare in Classe, Ravenna, Italy.

Sarcophagus, reputedly of St. Barbatian, 425-450. Marble. Cathedral, Ravenna, Italy.

Sarcophagus with Stylistic Decoration, c. 500. Marble. Basilica of Sant'Apollinare in Classe, Ravenna, Italy.

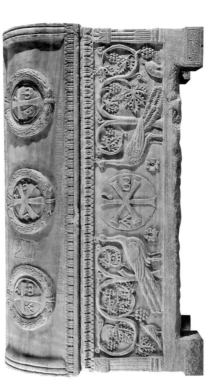

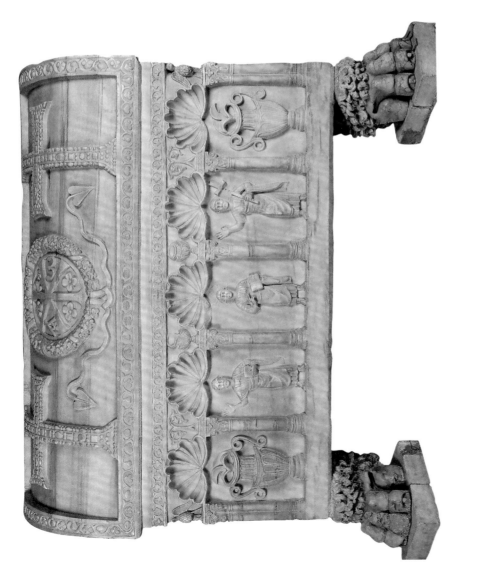

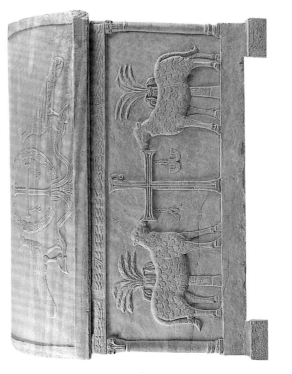

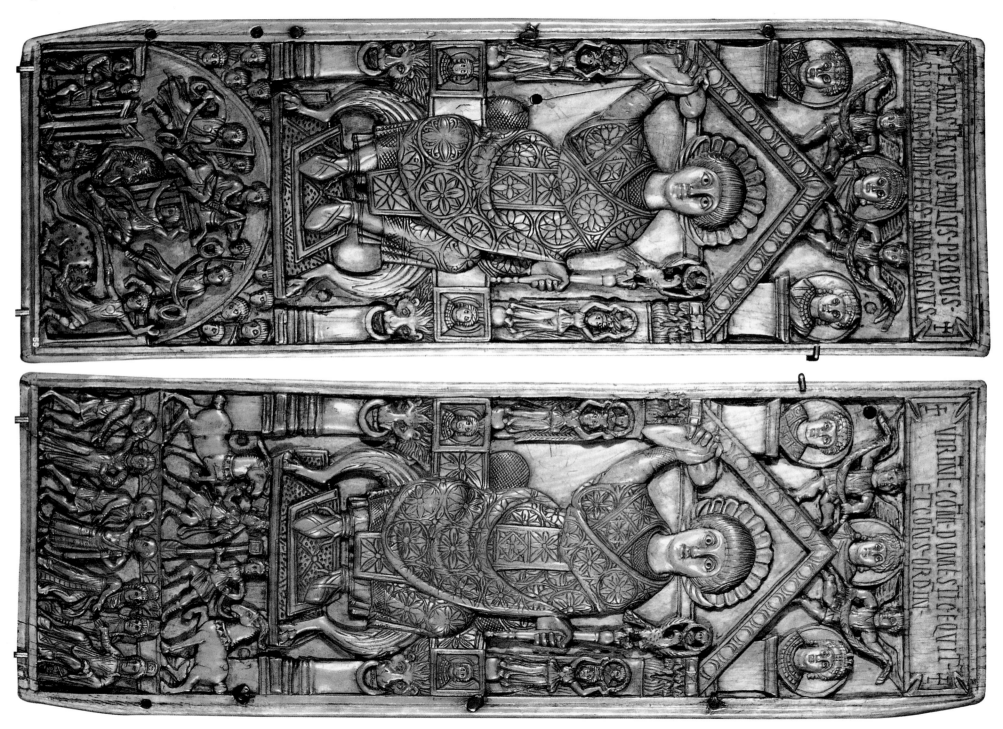

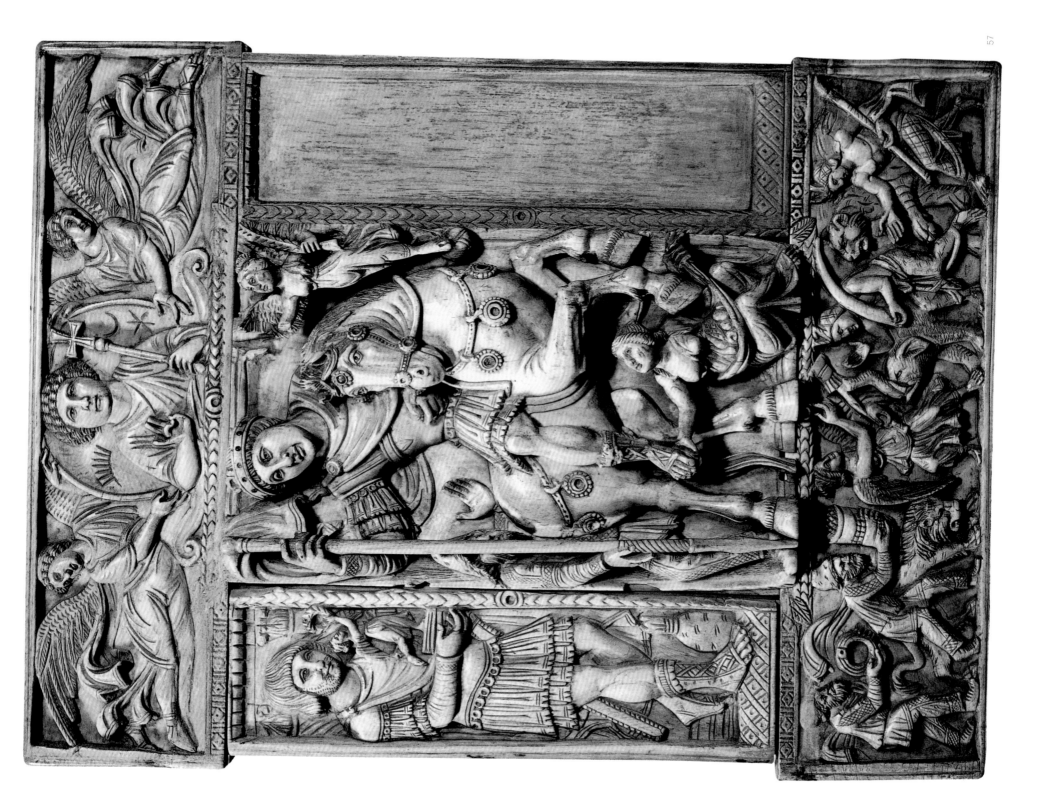

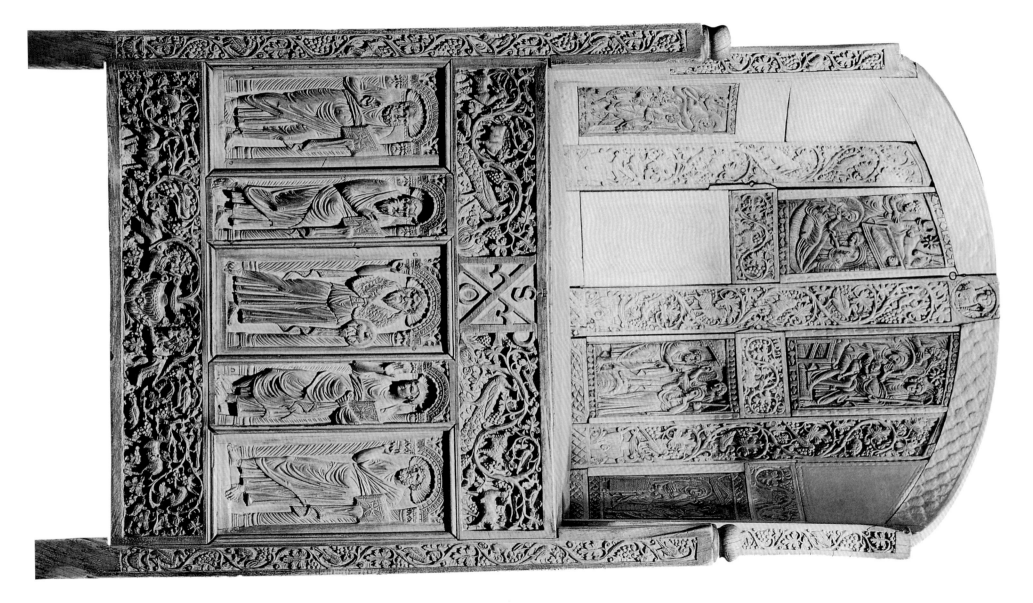

In Thessaloniki the debris of an ambo that dates to around the end of the fourth century still exists. The bas-reliefs demonstrate the story of the Magi. A characteristic of slightly stiff majesty is already expressed there, and the Virgin holding the Child is depicted seated in a hieratic position, in which the naïve and familiar grace of older Christian compositions is no longer present. In Ravenna, some of the sarcophagi of the time that are scattered throughout the churches and in the streets are the works of Greek artists. [See p. 55]

In Ravenna, very early on, sculptors had the same tendency to neglect the portrayal of human character. Most common on their bas-reliefs are sheep, doves, peacocks, vases from which vines burst forth, monograms, and crosses, all in a variety of groupings, but always with a great love for symmetry.

Even in secular art, it seems that metalworking was taking the place of sculpture. Already in the fifth century, statues in gold and silver could be seen standing in public areas, like that of Eudokia, the wife of Arcadius, and of Theodosius II. In the Augustaeum a silver statue of Theodosius the Great had been placed. This search for grandeur was dangerous for sculpture: it was customary to give more attention to the splendour of the material than to the style of the figures. However, when it came to casting the metal, whether precious metals or bronze, the Byzantines retained great technical skill.

Their superiority was no less great in their work with ivory. Throughout the Middle Ages, the East had famous ivory carving guilds, which primarily sculpted diptychs, covers for Evangeliaria, and caskets. Among the works remaining, several have a historical quality and portray the princes and characters of the time.

One of the most famous works in the history of Byzantine art is the Barberini ivory. It depicts an emperor on a rearing horse, exulting over his enemies. It symbolises his imperial power and his claim to terrestrial domination. This magnificent ivory embodies the quintessential skill of Byzantine artists. [See p. 57]

Another example, the diptych preserved at Monza, was the subject of much debate, and one may recognise Galla Placidia and Valentinian III, accompanied by a warrior, who was taken in turns to be Theodosius II and Aëtius. The diptych of the consul Anastasius (517), nephew to the emperor of the same name, is all the more interesting because it shows the state of the official attire of important Byzantine government officials in the sixth century. Dressed in richly embroidered fabrics, whose fit is no longer reminiscent of the toga, the consul presides over the games; he shakes the cloth that signals the commencement of the games; underneath, the finish of the races and the gladiatorial fights against ferocious beasts are depicted. The diptych of Areobindus, consul in 506, portrays the same theme. [See p. 62]

Religious ivory carvings are often of a better style and are distinguishable by their elegant qualities and a delicacy of craftsmanship that is truly extraordinary. In this genre, one of the most beautiful works that might be cited from the sixth century is half

Diptych of the Consul Anastasius, 517.
Ivory, height: 36 cm.
French National Library, Cabinet des Médailles, Paris.

The Triumphant Emperor, Barberini Ivory, early sixth century.
Ivory, 34.2 x 26.8 cm.
Louvre Museum, Paris.

Throne of Bishop Maximianus, 546-554.
Ivory.
Archepiscopal Museum, Ravenna, Italy.

Jewelry from the Mersinsky Treasure,
sixth or seventh century.
Gold, 5.7 cm.
Hermitage Museum, Saint Petersburg.

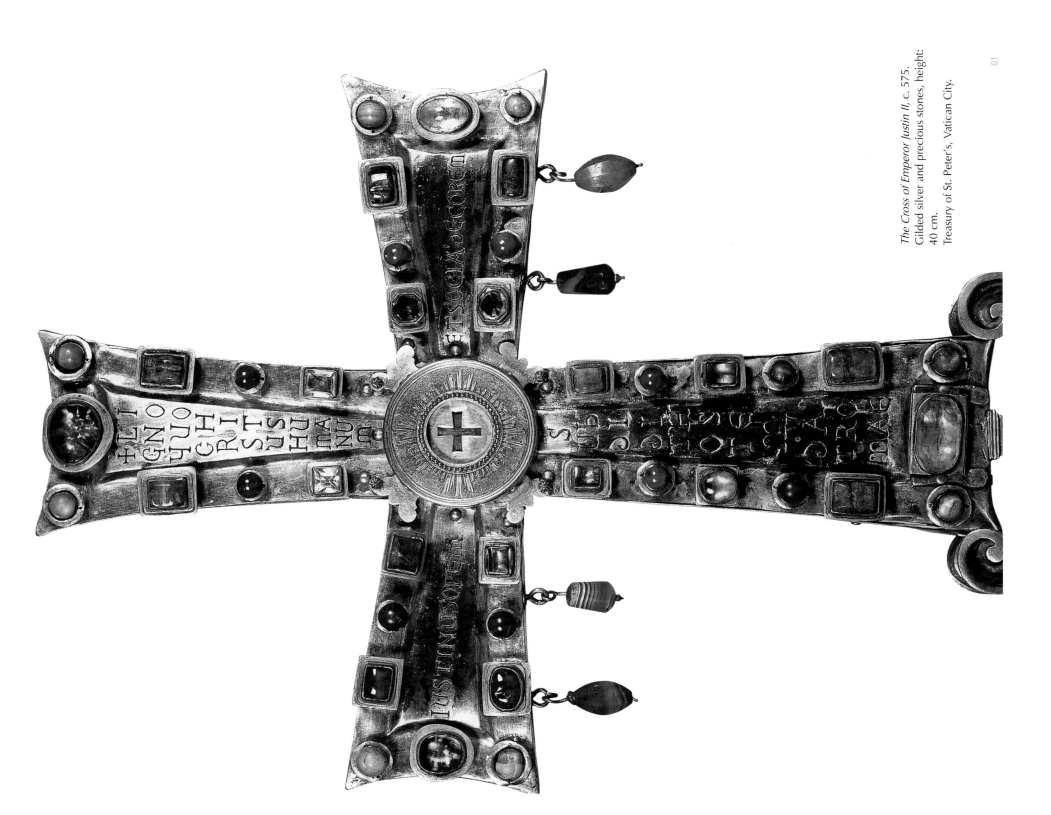

The Cross of Emperor Justin II, c. 575.
Gilded silver and precious stones, height:
40 cm.
Treasury of St. Peter's, Vatican City.

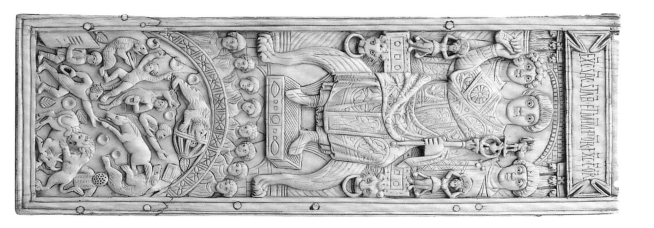

Panel of a Diptych of the Consul Areobindus, 506.
Ivory, 39 x 13 cm.
Musée National du Moyen Âge -
Thermes et Hôtel de Cluny, Paris.

of a diptych representing an angel standing upright under a richly decorated arcade. A few steps separate him from the ground; with one hand, he leans on a long scepter and with the other, he holds a globe, surmounted by a cross. His wings, widely spread, are painstakingly crafted; his raiment, consisting of a tunic and an outer cloak, displays a drapery of excellent taste and rare elegance. As for his head, framed in thick curls, it is an exemplary representation of perfect regularity. The eyes, open wide, give his face a vivacious expression; his posture is noble and imposing without stiffness. Those who have dealt with this ivory have been correct to note that the artist must have been familiar with and have taken as models artwork from Antiquity. However, it would be incorrect to see here a mere imitation of a pagan example. Along with the influence of the past, a realistic originality must also be noted in the overall ensemble of the figure, as well as great skill in the details of its execution.

In the sacristy of the cathedral in Ravenna, the throne of Bishop Maximianus, dated to the same time, is completely decorated with bas-reliefs in ivory. The most striking feature is found on the front of the throne: St. John the Baptist and the four evangelists occupy five arcades. Above and below run wide boarders whose decoration is exquisitely delicate and rich: vine branches grow gracefully, and within the coils frolic crowds of birds and animals of all types. [See p. 58]

And so ivory sculpture progressed, while marble sculpture degenerated. As the fourth century fades, it seems that the practice of cutting deeply into stone and exacting from it lifelike scenes was lost. At least on works of limited dimensions, such as the aforementioned, some of the master qualities of great sculpture still appear.

In the form of non-enameled metalwork, nothing remains but a few pieces dating from this era. There is a cross in gilded silver, encrusted with gems, which is preserved at the Vatican and was given to Emperor Justin II around 575. [See p. 61] Some repoussé medallions display images of Christ, the lamb, the emperor and the empress. Another cross in silver, located in Ravenna, would be of great interest, but it has been subjected to too many restorations. The Monza treasury contains metal Greek ampoules whose dates and origins are certain. They were brought from Palestine in the seventh century. Decorated with episodes from the New Testament, such as the Nativity, the Resurrection and the Ascension, they are of great iconographic importance; but the low value of the metal that comprises them hardly allows them to be classified as true metalwork.

The vase from Emesa dates, for all practical purposes, from the beginning of the seventh century. It was fashioned from a sheet of hammered silver. A band encircling the vase depicts eight characters from the Gospels: Christ between two apostles, the Virgin between two angels, and St. Peter and St. Paul. [See p. 63]

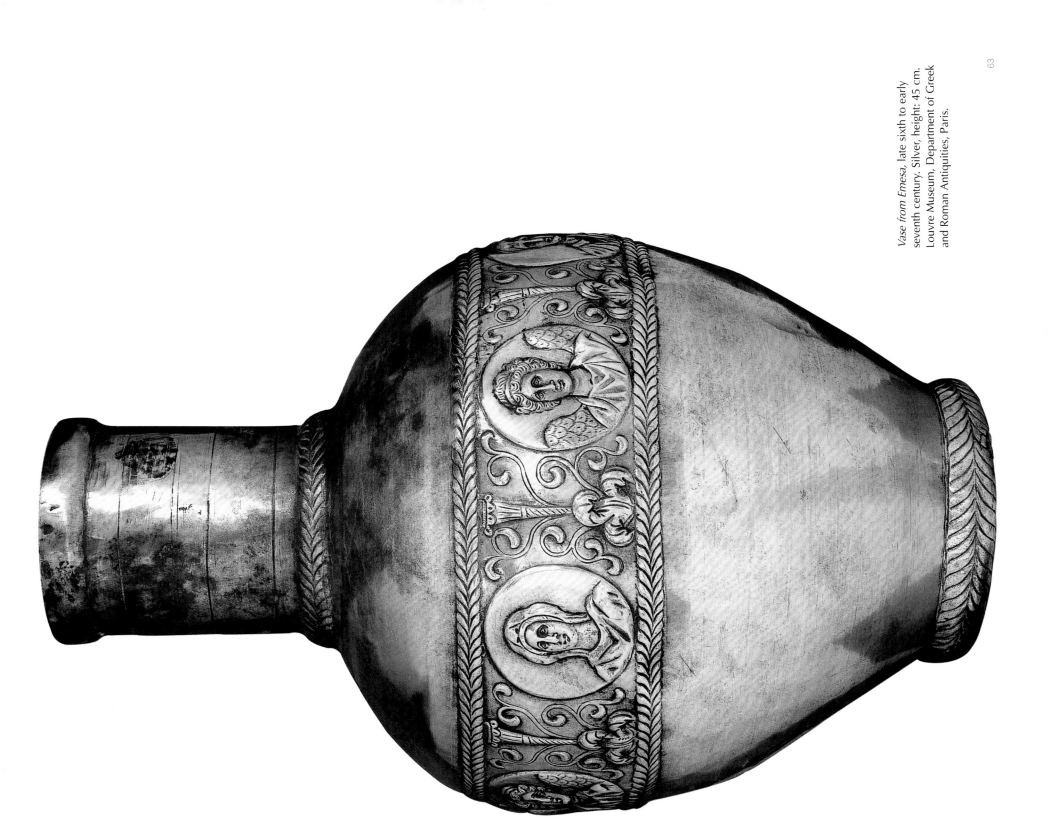

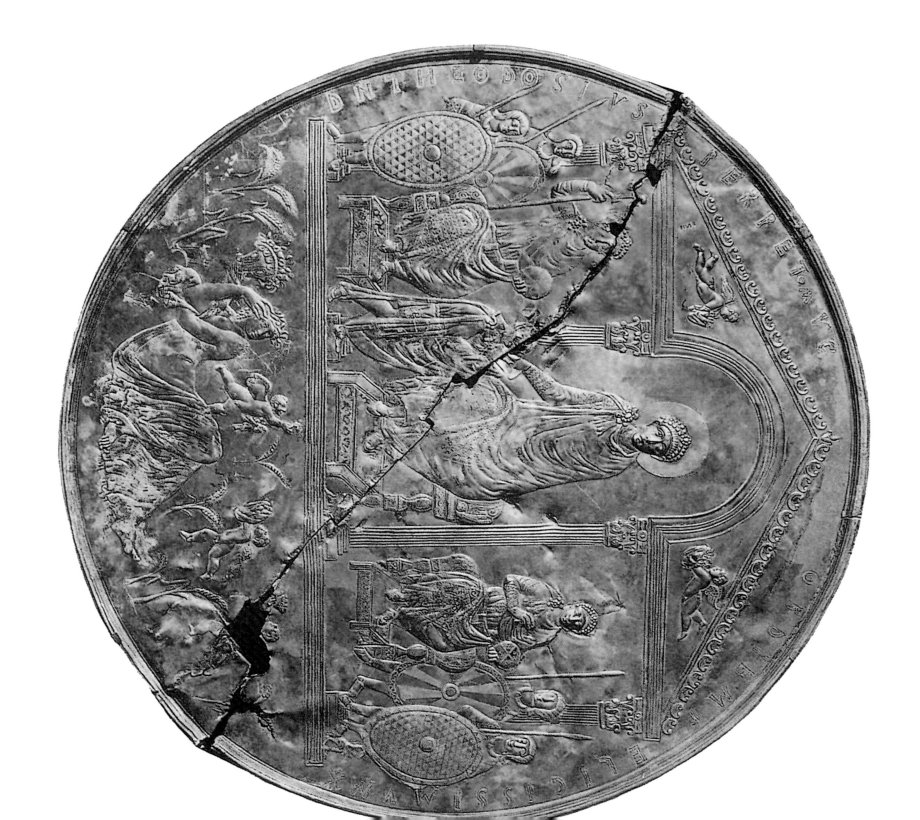

The missorium of Theodosius I is a large ceremonial silver dish, preserved in the Real Academia de Historia in Madrid. Most likely completed in Constantinople in celebration of the tenth anniversary of the reign of Emperor Theodosius I, it is considered one of the masterpieces of goldsmith work. [See p. 64]

Among the numismatic monuments, some are of artistic interest. From the end of the sixth century, the fabrication of Byzantine money became particularly crude; however, in the preceding era, certain specimens are outstanding for their precision and finesse. [See front cover]

The previous pages have presented an overview of Byzantine art from the sixth and seventh centuries. A summary of the resulting impression is in order before going on to study the changes that took place during the following centuries.

It is an undisputable fact that Byzantine art, such as it were, stems in part from the art of Antiquity. The force of tradition had always been great in the Hellenistic East. Still today, the old mythological legends have not disappeared from Greece's countryside; in the narratives, the songs, and the uses of quotidian life, the memory of the divinities of Olympus are constantly relived. Some are confused for the saints of modern religion; however, behind the façade of borrowing, their traits can be discerned, half-erased. Even where the Christian faith replaced pagan sanctuaries with its own churches, the old gods were not entirely driven out, and something of their name was preserved in the places where they reigned long ago.

But along with these elements of Greek origin were mixed other influences, some of which came from the Far East. Among its most beautiful possessions, the Eastern Empire then included the wealthy provinces of Syria, which served as an intermediate zone between central Asia and Greece. Constantinople was connected to these countries by its very location – a large portion of its population originated there – the customs and art could not help but be affected by it. It was in constant commercial and political contact with the most powerful monarchies of the East, particularly with Persia. In architecture, these influences are very appreciable; but the same can be said for decoration, where patterns are found borrowed from the East at every turn, treated in the same vein and style. It is especially here that Byzantine artists drew on the taste for magnificence and luxury, which appeared in all of their works; from this also came their tendency to render all ornamental details in a conventional manner. Art, in the knowledge it required of flora and fauna, now faithfully reproduced nature, then altered and imagined artificial specimens, ceaselessly repeated, and the imitation of realistic forms disappeared almost entirely. The Byzantines followed the latter path and often they adopted models long established in the East. One can see in their works complicated, interlacing, bizarre flowers and fantastical animals so frequently found on the monuments of India or Persia.

Missorium of Theodosius I, 387-388. Partially gilded silver, diameter: 74 cm. Royal Academy of History, Madrid.

Plaque of St. Simeon Stylites, sixth century. Silver repoussé with gold, height: 29.6; length: 26 cm. Louvre Museum, Department of Greek and Roman Antiquities, Paris.

Hercules and the Nemean Lion (missorium), sixth century. Silver, diameter: 40 cm. French National Library, Cabinet des Médailles, Paris.

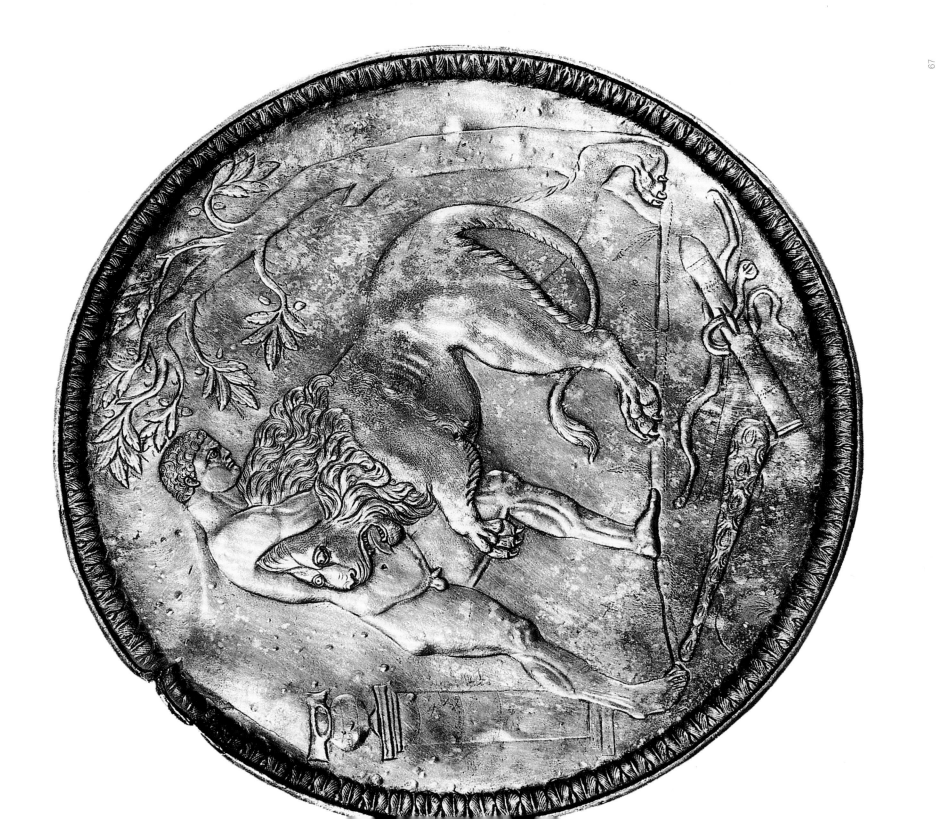

Aquamanile, seventh century.
Sard, height: 17.8 cm.
Louvre Museum, Department of
Decorative Arts, Paris.

Aquamanile, seventh century.
Agate, gold, height: 20.7 cm.
Louvre Museum, Department of
Decorative Arts, Paris.

Belt, seventh century.
Gold, 6.3 x 3.4 cm.
National Archaeology Museum, Saint-
Germain-en-Laye.

However, Byzantine art was hardly satisfied with combining elements of diverse origins: it proved to be truly innovative. Credit is due to it for having given a true individual physiognomy to Christian concepts. In fact, it is especially in the religious domain that it is manifested with all its originality and brilliance: one should not be surprised if one considers how powerful religion was, and how much it was incorporated into everything for the Greeks of the Middle Ages. Artists had been especially enamored of certain dominant characteristics of Christianity — the splendour of triumphant religion, divine majesty, the protective role of the saints — and they set about expressing them with vigor.

In this respect, the Byzantines were great masters; whether referring to the concept or the execution, they understood the veritable rules of religious decoration, and it may be noted that, in our time, painters who have tried to revive this genre of art have at times been inspired by their works. Moreover, as will be seen later on, this general uniformity did not remotely lead to a sterile immobility, and Byzantine art came to know the transformative power of diverse schools.

C. Art under Iconoclasm (726-843)

From the death of Justinian to the debut of the eighth century, the Byzantine Empire was subjected to many disasters. Arabic conquests consumed some of its wealthiest provinces in Asia, while in the north, Slavic invasions spread devastation through the countries between the Danube and the Mediterranean. Internally, the uncertain transmission of imperial power was an incessant cause of trouble and disorder; in erudition and customs, signs of decadence and ruin were apparent. However, thanks to the domination of the Church, religious art continued to develop when a revolution erupted that threatened its existence. Kindled and supported by fervent emperors, the iconoclasts, or "breakers of images", furiously attacked the works they considered to be a remnant of the old idolatry.

Truth be told, it was not only the fate of the images that was made uncertain in this famous battle. Although the iconoclasts are known mostly through the accounts of their adversaries, recent research has demonstrated that they had enormous plans and dreamed of a general reorganisation of the State.

When they attacked religious art, it was because in it the monks found one of their most powerful means of action. In their hands, Christianity was transformed; they had made of it a material religion, an offspring of paganism, which no longer related to the everyday except on the surface. From the fourth century on, these dangerous tendencies had continued to develop; among the chroniclers and hagiographers it was no longer a question of icons and relics, but rather of the miraculous power attributed to them. They were no longer merely venerated but worshipped as true divinities. Already many had been disquieted by these aberrations and had preached the return to a more primitive Christianity, but the *vox populae* of the monks suffocated their protestations. These crude superstitions had nothing to do with art, though they altered and demeaned it along with religion. Thus the iconoclasts did not proclaim themselves hostile in principle to all artistic manifestations; only icons incited their wrath, and, to justify their doctrine, they recalled that God himself had prohibited them in the Bible.

In 726, Emperor Leo the Isaurian promulgated the first edict against the iconodules. He contented himself with ordering that they be suspended higher in the churches, so that they could not be kissed and thus lavished with the signs of material adoration. In 728, he went further and removed them. These measures brought about revolts in Greece and Italy, where Pope Gregory II placed himself at the head of the resistance. In Constantinople, the opposition was especially heated on the part of the monks and common people; riots broke out. On the door of the imperial palace, an image of Christ was raised that was the object of special veneration; Leo attempted to remove it. The women who were present rushed up and knocked over the imperial officer; the crowd had to be dissipated, which brought about several deaths, arrests, and executions. The battle became harsher yet under the reign of Constantine V, the son of Leo the Isaurian, who acceded power in 741. The resistance that the emperor faced led him devastatingly to excess: religious art had its martyrs. In 754, Constantine convened in council the bishops on his side. "We are convinced," they

Chludov Psalter, Christ on the Cross, Iconoclasts Destroying an Icon of Christ, ninth century. Manuscript, 16.2 x 10.8 cm. Museum of History, Moscow.

Griffon on a Medallion, eighth to
ninth century.
Gold, diameter: 4.2 cm.
Louvre Museum, Department of
Decorative Arts, Paris.

Hagia Irene, eighth century.
Istanbul.

said, "that the shameful art of painting is a blaspheme against the fundamental dogma of our salvation, that is, the incarnation of Christ... What is the ignorant artist doing who, in a sacrilegious spirit of avarice, depicts what must not be depicted and wants, with his soiled hands, to give form to what must not be believed save in the heart? He makes an image, and he calls it Christ. The name of Christ signifies God and man. Consequently, if there is an image of both God and man, then the artist has foolishly attempted to depict the divine, which is impossible, and married in his work the divine with created flesh, a mixture that must never take place... If some say that we are correct on the subject of the images of Christ, but we are erroneous on the subject of the images of Mary, the prophets, the apostles, and the martyrs, who were mere men and were not made up of two natures, we will reply that they must all be rejected equally. Christianity has completely overturned paganism, not only pagan sacrifices, but pagan images."

General measures followed these declarations, and, in the churches, mural paintings and mosaics were covered in lime. However, such was the power of decorative art that people recoiled before the sad impression of the white and naked walls. Religious scenes were substituted with landscapes and totally secular compositions. As with Muslims mosques, where the same prohibitions apply, decorative art still finds a place, and at times charms the eyes with a thousand ingenious combinations of drawings and colours.

From this council on, the persecutions of the monks and the iconodules became more severe. Many were thrown in prison, beaten, and put to death. Constantine V even succeeded in his pursuit of the complete ruin of monasticism in the Empire. This violence incited a reaction. The successor of Constantine V, Leo IV (775-780), already showed himself to be less rabid; after his death, Empress Irene attempted to reestablish icon veneration and to impose the authority of a new council upon the decisions of the council of 754. Her first attempts were not successful. The iconoclasts counted many supporters within the army; the imperial guards drove off the assembled bishops, threatening them with death. Irene, however, managed to break down this resistance, and in 787, the council reconvened at Nicaea. The acts that underline these deliberations concerns the history of art, for the bishops worked to gather all historical and theological arguments, in favor of the veneration of icons. The work of the council of 754 was abolished. "We decree the restoration of the holy images," the Fathers said. "They will be restored in the churches, on objects of worship, on vestments, on the walls, on individual works of art, in houses, and on the streets; for, the more they are seen, the more is brought to mind the respectful memory due to the figures they represent."

Quadriga, from the reliquary of Charlemagne at Aix-la-Chapelle, eighth century.
Silk, 75 x 72.5 cm.
Musée National du Moyen Age - Thermes et Hôtel de Cluny, Paris.

The Crucifixion, early ninth century.
Cloisonné enamel.
Metropolitan Museum of Art,
New York.

In the first half of the ninth century, the iconoclasts again held the advantage. Leo the Armenian (813–820) and Theophilus (829–842) favored them. Once again the images disappeared and Theophilus ordered the closure of all monasteries in the cities and villages. However, the cause of the iconoclasts would definitively give way. At the death of Theophilus, his son being only three years of age, it was his widow Theodora who exercised power. Even during the life of her husband, she never ceased secretly to champion the cause of the images. Immediately, from all corners of the empire, monks rushed to stand by her and her family; they easily triumphed, and it was even decided that each year, a great celebration, the Day of Orthodoxy, would be held in honor of the restoration of the veneration of icons.

Such was this famous quarrel that troubled the empire for more than a century. It holds interest both for the history of art and of political institutions. Even before it ended, it had resulted in the withdrawal of Byzantine domination from most of Italy; by contrast, however, it had infused into the Hellenistic civilisation a new life that would ensure several more centuries of power and glory.

As for art, it can be said that it did something in the midst of these battles. The painters who were associated with monasticism, far from allowing themselves to become discouraged by threats and persecutions, worked with more obstinacy. From this era date the rendering of a quadriga on silk. This image is of a victorious charioteer at the Hippodrome in Constantinople. According to tradition, this fabric possibly served to cover the remains of the body of Charlemagne. [See p. 74]

However, at the same time, a more independent school was forming that seemed to draw its inspiration from ancient models with new fervor. These diverse elements would combine to producea true renaissance after the dispute over the images. Moreover, the iconoclastic emperors had hardly been, as their enemies would have had others believe, crude barbarians, attempting to snuff out all of civilisation. Surrounded by scholars and literati, they had even encouraged the arts, all the while robbing them of their religious characteristics. One of the most ardent among them, Theophilus, was noted for the beautiful constructions he undertook. He expanded and embellished the great imperial palace, and he commissioned splendid mosaics. Churches were erected under his orders, and, even though examples were sparse, they were lavished with all the wealth of ornamental decoration without treatment of religious themes.

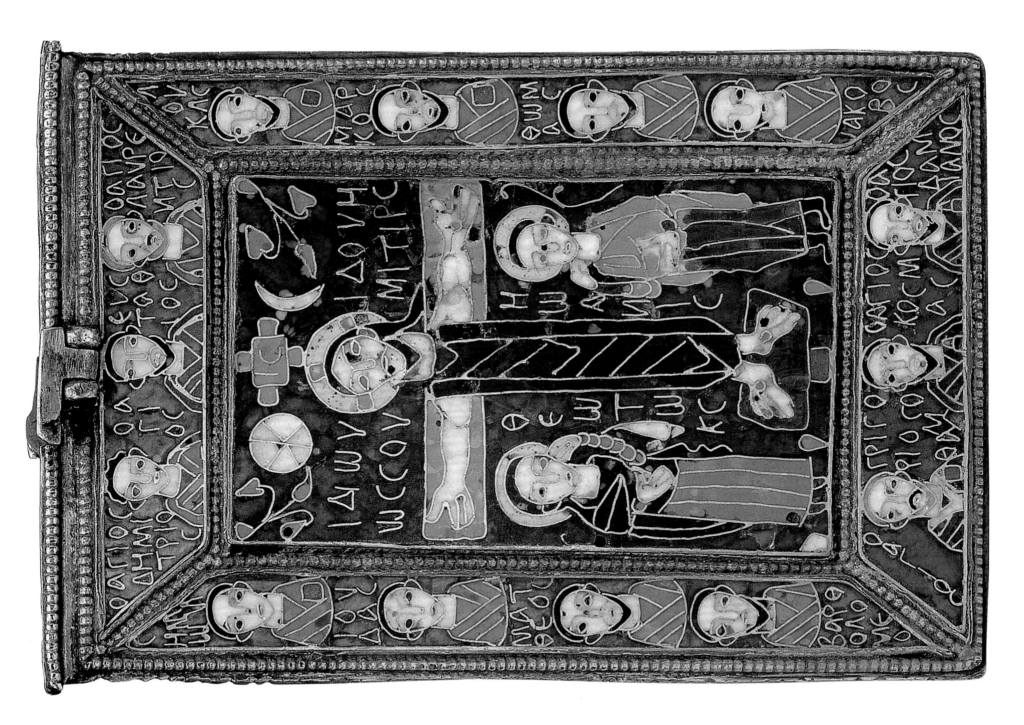

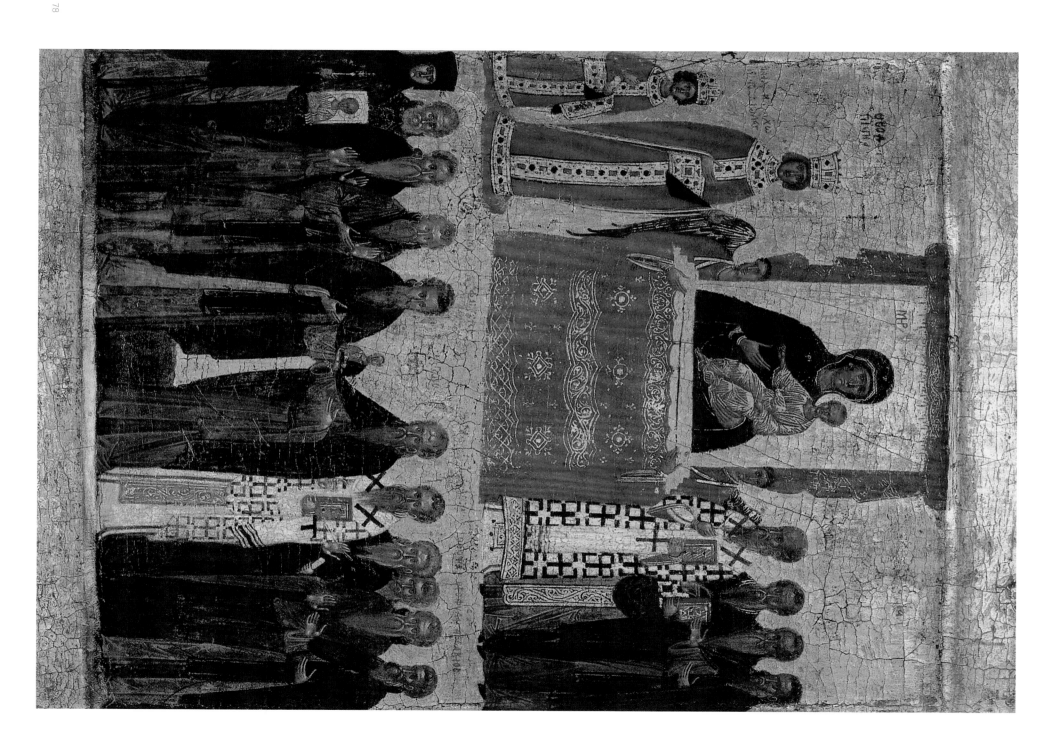

II. The Renaissance of Byzantine Art (843-1204)

A. Art under the Macedonians and the Komnenoi

1. Architecture

Never was the Byzantine Empire more powerful and more prosperous than in the ninth and tenth centuries, under the rule of the Macedonians (867-1057). The great princes of that era were of a sounder intelligence and grander energy than Justinian; they better understood the interests of Hellenistic civilisation. Intrepid warriors and skilled administrators, they discovered how to make use of all intellectual and material resources in the Eastern Empire.

The founder of the dynasty, Basil the Macedonian (867-886), forged the way later followed by Nicephorus Phokas, John Tzimiskes, and Basil II. The Empire defended itself valiantly against the invasions that flowed into their provinces from the north and the south: the Slaves were pushed back, the Bulgars stopped dead, Cyprus, Crete, and Cilicia were reconquered from the Arabs; from all sides, Hellenism regained a portion of the territories it had lost.

Internally, modified legislation preserved a part of the reforms of the iconoclasts, the administration was reorganised and in the larger cities industry and trade led to a truly marvelous increase in wealth. Constantinople was at that time the center of world commerce, serving as the port city between the East and the West: Arab, French, Italian, and Asian merchants would flock there. Constantinople was the intermediary of their exchanges, at the same time that its merchants sold them silks, embroideries, carpets, ivories, and all the precious objects that, gained at great cost, propagated Byzantine influence in the most distant countries. At that time in the Middle Ages, the customs and wares of Byzantium played approximately the same role as the those of Paris do in our time. Constantinople was not the only city to prosper at the expense of the rest of the Empire: in many other cities such as Thessaloniki, Thebes, Corinth, this activity was taking place, this convergence of foreign merchants.

This development of industrial and commercial life also corresponded to a new flowering of intellectual life. Constantinople had a university where philosophy, rhetoric, and mathematics were taught; the emperor chose from there those he judged to be meritorious of the highest government positions. The schools of Athens were erected: student came all the way from France and England. And one should not believe that the teaching received there was always narrow and base. The famous patriarch Photius, who fought with Rome, was familiar with all secular antiquity and all Christian literature, and he summarised it in his *Myriobiblion*; but he was also an original thinker, often very bold. He was by no means isolated in the society of his time; among the literati, many contemplated and reasoned. The efforts of the iconoclasts had as a consequence opened many minds, which broke free of monastic tyranny to reconcile the Christian faith with a return to ancient Greek culture. The Byzantine Empire even had its popular epics;

Icon of the Triumph of Orthodoxy, late fourteenth century,
Painting on wood, 39 x 31 cm.
British Museum, London.

Digenis Akritas was one of the heroes in the battle against the Arabs in Asia Minor.

The renaissance extended to the arts. The emperors favored it; Basil the Macedonian set the example and one of his descendents, Constantine Porphyrogenitus, obligingly described the edifices that he had had built and decorated.

From the point of view of architectural history and Byzantine decoration, it may be noted that analogies existed among those buildings and the churches from the same time period. Secular and religious architecture were subject to the same principles, and they offered the same combinations. In palace layouts, whether it were in rooms, atriums, even peristyles, the circular form, the cupola, and the apse were present. The Chrysotriclinium bears the same plan as a church. These facts prove the unity with which Byzantine architecture was simultaneously applied in very different structures, and yet this is one of the characteristics of a truly original art. When one studies the works of the ancient Greek architects or the French architects of the thirteenth century, one recognises that they also obeyed this principle, that they always reproduced the same essential forms, all the while accommodating the various uses of the monuments. On the contrary, at other times, this unity disappears, and the structures are only more or less pleasing compilations of all forms and styles. From that comparison, is one not correct to conclude that Byzantine art is no accident, the fortuitous result ill-combined of individual fancies and foreign elements, but rather on the contrary, well-organised, lively, and responsive to the people's own genius?

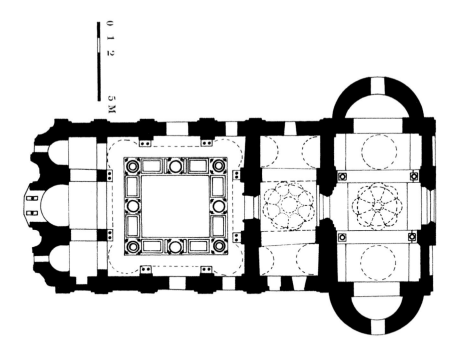

Plan of the Monastery of Nea Moni, 1042.
Monastery of Nea Moni, Chios, Greece.

Monastery of Nea Moni, 1042.
Mosaic.
Monastery of Nea Moni, Chios, Greece.

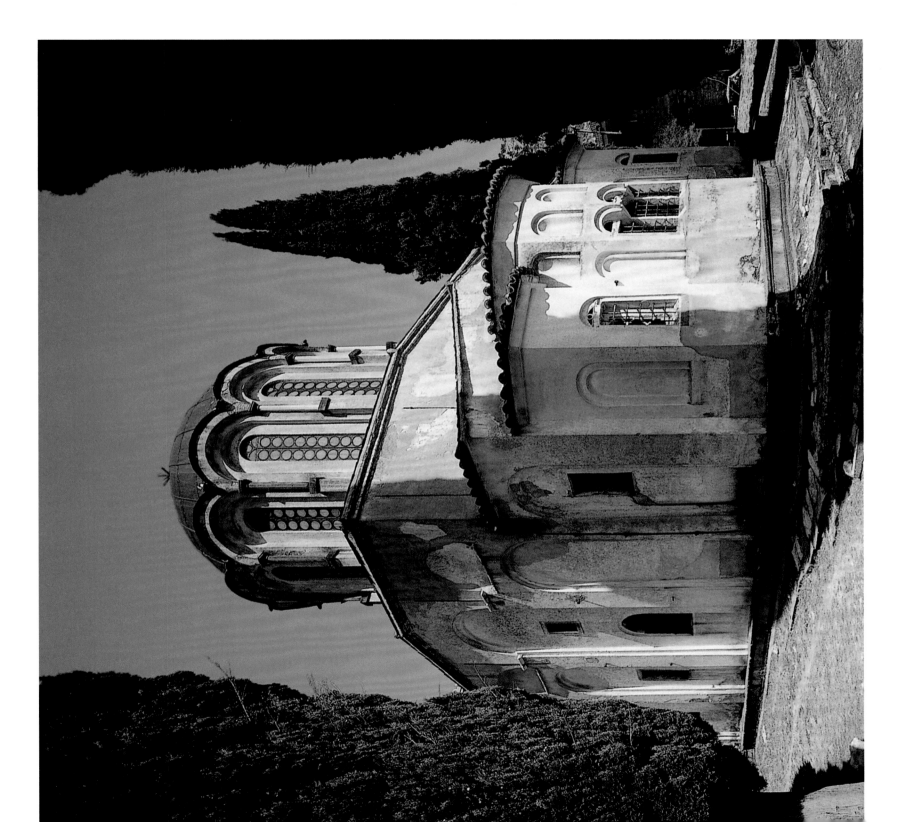

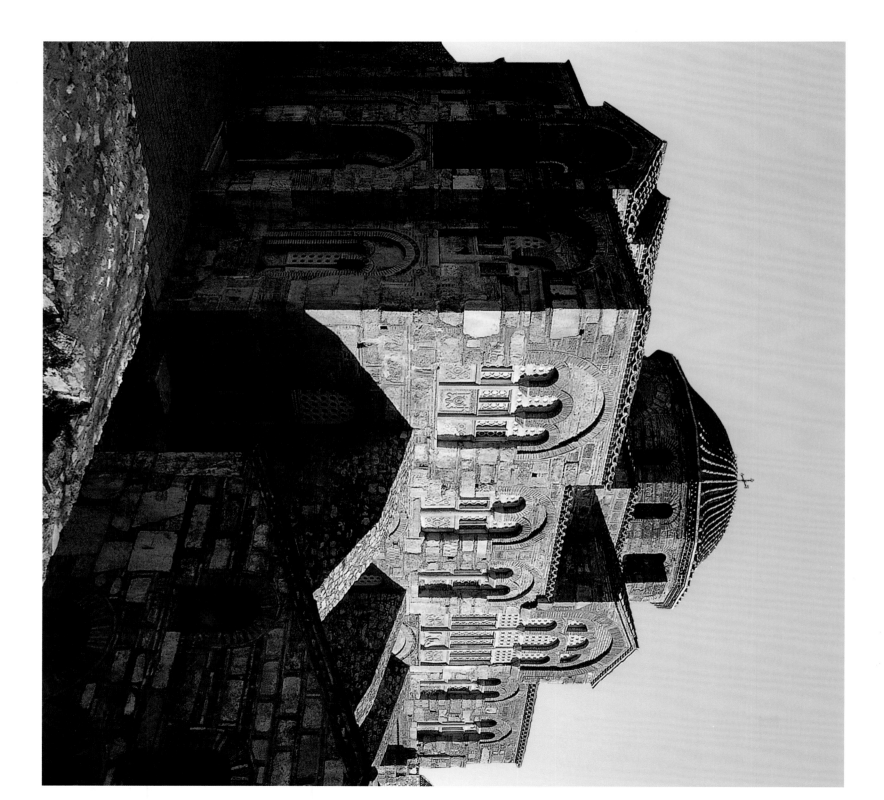

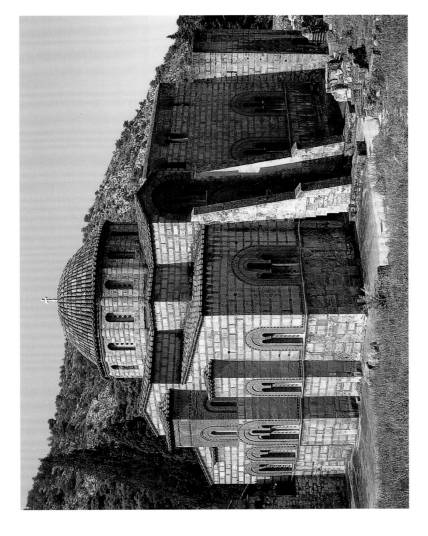

Monastery of Hosios Loukas, 1011. Hosios Loukas, Greece.

Daphni Monastery, eleventh century. Greece.

From the exterior, the Byzantine church presents, as in the past, the form of a rectangle with a choir that juts out from the eastern side; the interior, cut by columns and the four huge pillars that support the central cupola, is in the form of a Greek cross. The choir itself, which from the outside appears to be an addition to the rectangle, is isolated from the rest of the church on the inside; a large enclosure, normally of wood, separates it from the iconostasis, thus named for the sacred images and paintings that adorn it. It is there, at the back of the choir, hidden from the view of the masses, that the priest performs the holy rites. Within the sanctuary, an upper level extends, traditionally reserved for women.

Architects who were familiar with the construction of cupolas knew that in order to support them, it was not necessary to use massive pillars that encumbered the church and deflated its light appearance. They reduced the thickness and often substituted them with columns; consequently, the interiors appear finer. The cupola, which remained the invariable theme of architecture, never seemed to lose its popularity. In the time of Justinian, some buildings already boasted five; that which had been an innovation became the rule. Even that number was not enough, and new parts of the building were sought out where still more cupolas could be installed; sometimes the narthex would be used, divided into compartments which would each hold their own dome. It is for this reason that in some Byzantine churches, twelve tiny domes are grouped around one large one.

However, it was not sufficient to increase the number of domes; modifications to the form were also desired. Viewed from within, that of the Hagia Sophia, which is

Plan of the Monastery of Hosios Loukas, 1011. Hosios Loukas, Greece.

Monastery of Hosios Loukas, view of the interior, 1011. Hosios Loukas, Greece.

connected directly to the body of the construction, produces a very lively impression and in some way draws in the spectator below into its majestic development; on the contrary, from outside, it seems that it does not project out far enough, and that there is something heavy and depressing about the very mass of the church. The new builders, on a quest for elegance, tried to make their cupolas more impressive and projected them boldly into the air. To achieve this result, it was necessary to reject the practice of uniting them as closely to the supports as in the past, and to give them for direct points of support great arches that projected above the pillars and columns. Thus it was conceived to pose between these huge arches and the cupola a rather high, cylindrical drum. Some writers have perceived in that combination an attack on the true principles of architecture; they reproached these new cupolas for not being in organic relation with the rest of the ceiling and for being detached as if to form a separate monument.

If the drum had been introduced into the old model, Byzantine churches would not have had nothing but an undecorated cylindrical wall; it would have been a shocking sight, but people learned how artistically to adorn its shape as well as to make the best use of it. The drum is generally polygonal, and the edges of the angles, with their vertical orientation, express the idea of elevation sought by the artist. The impression of height is better conveyed through long, thin colonnettes that decorate it and through tall, narrow windows that grace it. Curved, horizontal lines of the construction outline the facades and sides of the building. Rarely is there a pediment to mark the end of a roof, for Byzantine architects rarely concealed the true form of their vaults behind the triangular tympanum. Wherever this last plan is commonly found, a Latin influence must undoubtedly be recognised.

In newer Byzantine churches, windows were usually plentiful. Constructed with a round arch, they took on many different shapes, again demonstrating the search for variety and

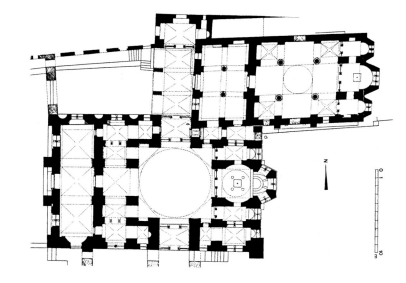

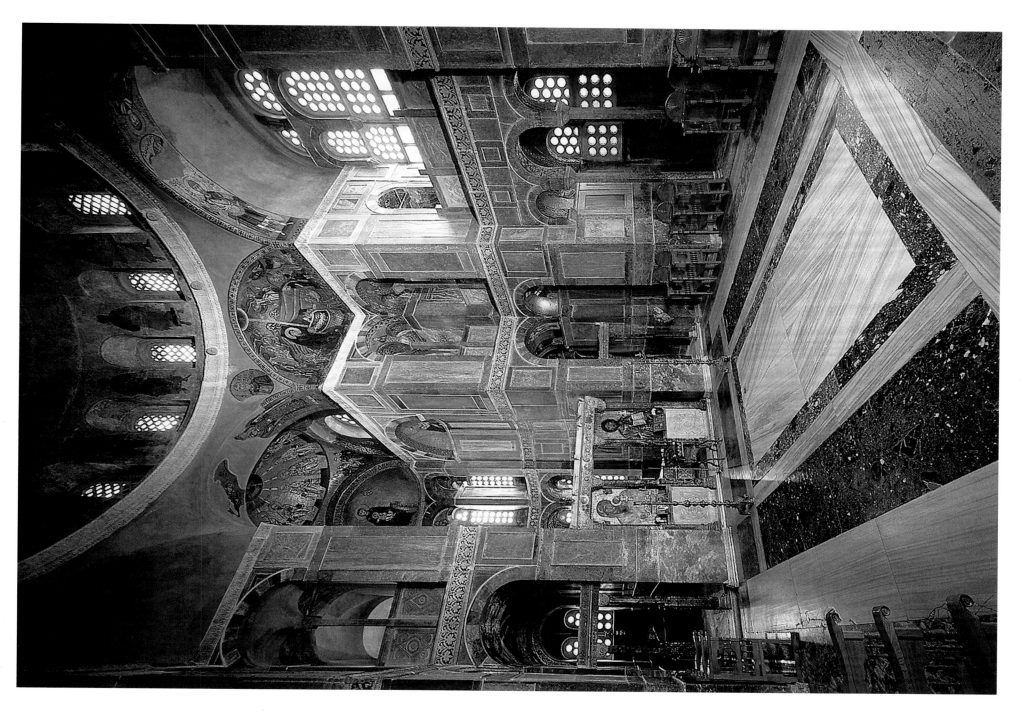

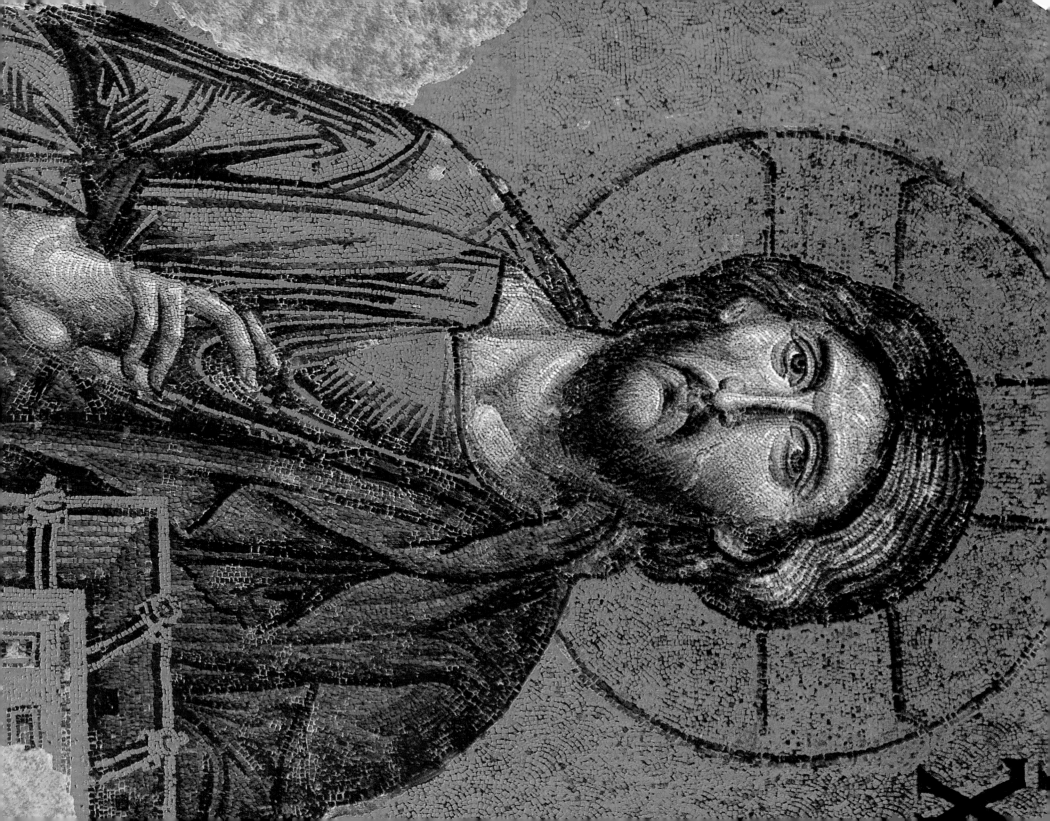

elegance. Here, the bay is divided into twin windows, separated by a colonnette; there, they are trilobate and almost always closed behind slabs of latticed stone.

It is also in the brickwork of the walls that this preoccupation is visible. The builders used stone and brick, but they did not mix them in uniformly alternating rows, and, using this diversity of materials, they learned to create decorative effects that change from one monument or wall to another. To the traditional *opus spicatum* of the Romans, which did not disappear, they added a plethora of new combinations. On the walls of buildings, the bricks are manipulated into a thousand designs, alluring in the ingenious creativity of their arrangements. It is even common to see them arranged into letters and forming inscriptions.

In summation, while the previous century had seen the birth of the major themes of Byzantine architecture, this century was dedicated to refining them. The essential elements and general carpentry of sixth century churches were accepted, but they sought to change the look of the old edifice by rendering it lighter in appearance and more picturesque.

The churches of that period that still exist are far too numerous to even dream of counting. Some, whose dates are certain, can serve as models for the rest.

In Constantinople, one of the most elegant is the Church of Theotokos, built by an individual who lived during the reigns of Leo the Philosopher and of Constantine Porphyrogenitus. Arches supported by columns and large windows open the façade, giving it life and adorning it, while also letting an abundance of light pour into the narthex. The varying designs of alternating brick and stone further enhance the charm of this impression, while above the façade, on the second floor, stand cupolas placed on drums. The apse, in the shape of a pentagon, is pierced at mid-height by arches supported by colonnettes.

In the same city one finds the monastic Church of Christ Pantocretor, built in the first half of the twelfth century by order of Irene, wife of John Komnenos. It is divided, so to speak, into three churches: one contains the tomb of Manuel Komnenos, the second was reserved for the monks, the third for the people. In the sixteenth century, the richness of the marble that decorated it provoked the admiration of Patrus Gillius. Since then, the edifice has suffered, but one can still discern what care had been taken in its construction.

Thessaloniki possesses perhaps the most interesting series of churches from that time. No fewer than three bear mentioning: the Agioi Apostoloi, St. Elias Church, which appears to date from 1012, and the Church of the Virgin, which was consecrated in 1028. All three cathedrals bear great similarities to one another, but the first is the most exquisite. In Greece proper, in the Peloponnesus, churches of the types just examined are numerous, but their history is not well known and many are of a more recent date.

Christ, thirteenth century.
Mosaic.
Hagia Sophia, Istanbul.

Christ in Majesty between the Emperor Constantine IX Monomachos and the Empress Zoe, eleventh century. Mosaic. Hagia Sophia, Istanbul.

2. Mosaics, Painting, and Illuminations

If we pass on from architecture to decoration, similarities between secular and religious art become evident. The mosaics that decorated the imperial bedchamber are reminiscent of those found in the churches. Figures are arranged in the same configurations, standing upright in tranquil positions, around one or two other characters. Still penetrated by the ideas of unity and symmetry that had dominated since the sixth century, Byzantine painting naturally tended to express them in homogenous ways, whether decorating secular buildings or temples. Also, between the celestial and the terrestrial – Christ, Sovereign of the heavens, and the emperor – a parallelism was established that may also be noted during the time of Constantine and has never been forgotten in art.

The mosaic, in such high regard during the preceding centuries, was always very sophisticated. We have seen how it was used in the palace rooms and those of the New Church. In the Hagia Sophia, there was an image of the Virgin carrying the Baby Jesus and accompanied by Constantine and Justinian; the rest of the church was repaired throughout, wherever the need was need was evident. Outside the capital, some important works exist in assorted locations. [See p. 90-91]

In the Hagia Sophia, Christ is depicted in all the glory of his power, seated on a magnificent throne, blessing with one hand, holding in the other an open book that reads: "Peace be to you! I am the light of the world." To his right and left, two medallions frame the heads of the Virgin and the archangel Michael; at his feet, Emperor Leo VI is prostrate, richly dressed and girded with a nimbus diadem. [See p. 96-97]

Even outside of the capital, mosaic art had been developing in certain areas, as shown by the decoration of the monastic church of St. Luke's in Phocis. The cupola is overlaid in mosaics. In the center, the figure of Christ is dominant. All around in a concentric zone are gathered the Virgin, St. John the Baptist, and the four archangels, and below come the sixteen prophets. Several large-scale images also appear in these mosaics, including the washing of the feet, the Anastasis, and the Crucifixion. [See pp. 92, 94, 99]

On the vault of the cupola and the apses, down the length of the walls, immense decorative mosaics unfold. On a background of gold or dark blue, great figures of a majestic character appear. Finally, on the pendentives are represented four scenes from the Gospel: the Annunciation, the Nativity, the Circumcision, and the Baptism. The building had been reconstructed in 1011 upon the foundation of a church built in 944.

At the end of the eleventh century, in the monastic church of Daphni, near Athens, on the pendentives of the cupola are depicted the Annunciation, the Nativity, the Baptism, the Transfiguration, and the Crucifixion. [See p. 103]

The monastery Nea Moni (New Monastery) on the Greek isle of Chios was founded in 1042 by the Byzantine Emperor Constantine IX Monomachos on the spot where three hermits were said to have found an icon of the Virgin. Mosaics decorate the walls and

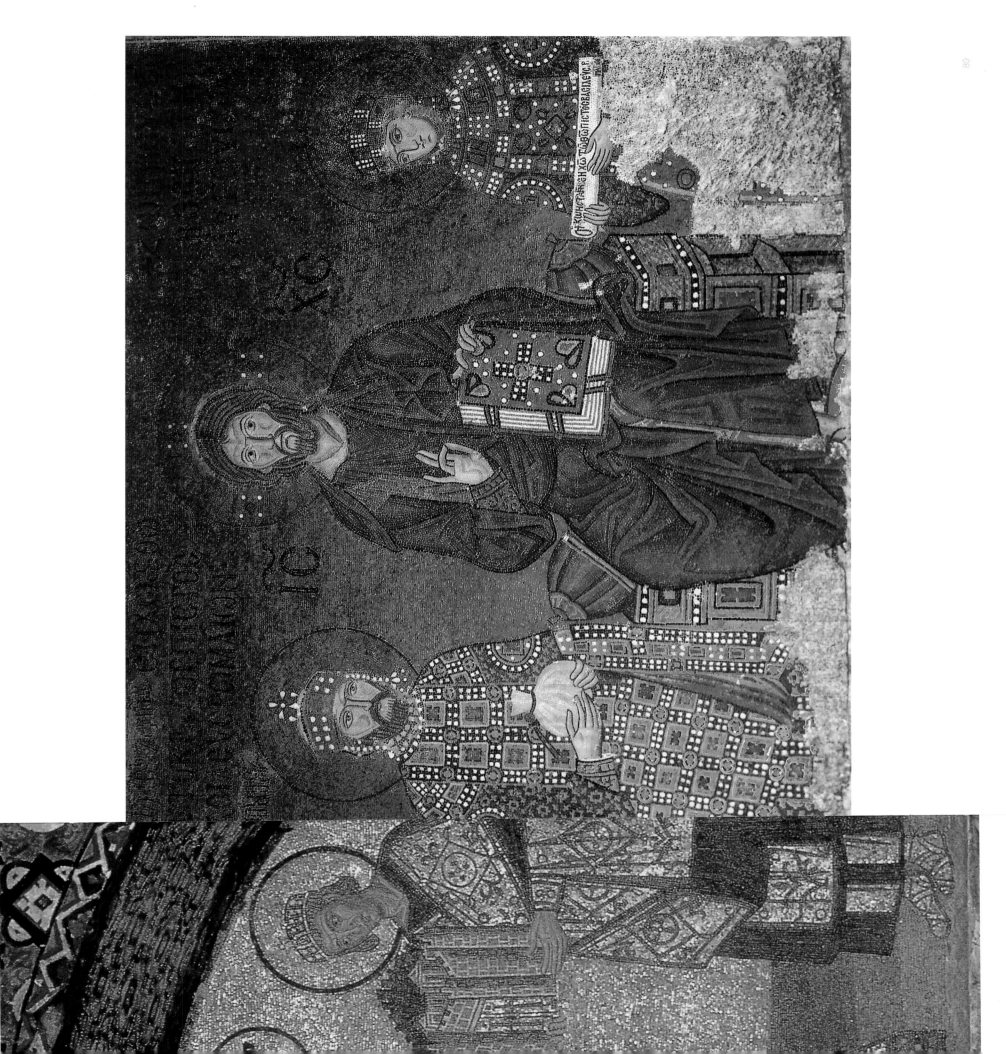

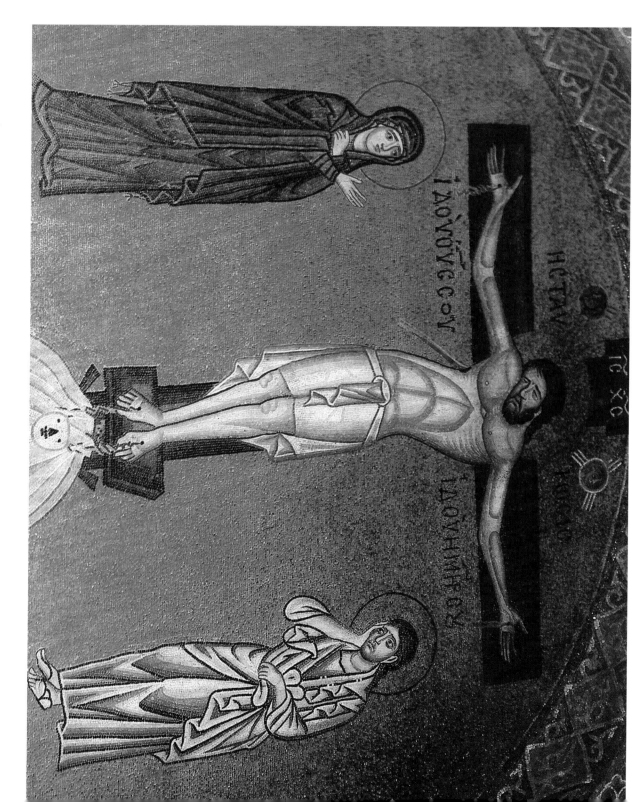

ceilings, a portion of the dome, the nave, and the sanctuary. They are made with natural stones and glass. Among these is a fantastic baptism of Christ. [See p. 95]

Several Eastern and Western churches keep images of the Virgin, which are accredited with origins of miraculous legends; some are attributed to St. Luke, who became the patron of painters during the Middle Ages. They do not lend themselves well to attentive study; they are hardly available to curious onlookers, and they are often covered with patches of reworked silver or gold, which simulates the clothing and hides the greatest part of the painting. In judging them according to the more or less exact reproductions that are available, many could not be attributed with any certainty to a time prior to the thirteenth century. However, long before, the Byzantines were already revering miraculous images of the Virgin. One of those with the most artistic value is now located at Rome, in the Basilica of St. Mary Major; the beauty of the example of the Virgin, the elegance of the arrangement of the drapery merits admiration. In the churches of the convents of Athos, images of the Virgin are preserved, to which have been assigned a very early date, without, however, accrediting St. Luke. There are none that can said with certainty to date to early Antiquity. At St. Mark's in Venice, a painted rendering of the Virgin is found, which tradition holds was stolen from the Greeks in a battle in 1203. The Madonna, who received the name Nicopea (Victorious), is depicted from the waist, holding her son. The rendering is good, and the look given the Virgin by the artist is that which is found consistently in works of the time. The frame of the painting is very elaborate, decorated all in enamel.

The monastery of St. Catherine on the Sinai, in Egypt, has retained to this day numerous icons from this period. It is situated at the foot of Mt. Sinai and was constructed by order of Emperor Justinian between 527 and 565 at the site of the "Burning Bush". One of the most celebrated icons is the Ladder of Divine Ascent, described by John Climacus, a Syrian monk from the sixth or seventh century. His book, thirty chapters in length, is intended to summarise the monastic experience. It is written for monks, and it aims to help them attain, in thirty steps, perfection. [See p. 104]

The most famous icon from this time is the Theotokos (Mary) de Vladimir, also known as the Virgin of Vladimir. It is one of the most revered orthodox icons in Russia. She is considered the patron saint of Russia. The icon was painted in Constantinople at the beginning of the twelfth century. Luke Chrysoberges, patriarch of Constantinople, sent the icon as a gift to the Grand Duke Youry of Kiev around 1131. [See p. 106]

It is believed that the custom of executing small mosaic paintings had been introduced around the tenth or eleventh century. To this effect, fragments of stone or glass were used that were held together with white wax. It was a departure from the rules of the mosaic to bend them to create these miniscule works where the true character of mosaic was lost. However, these miniatures were widely sought after. Some remain in the treasuries of the Eastern churches; the convent of Vatopedi possesses one that depicts the Crucifixion. Others passed into the West. Two are preserved in the Florence Cathedral treasury and reproduce episodes borrowed from the Gospel and the Apocrypha: the Annunciation, the Nativity, the Presentation at the Temple, the Baptism of Christ, the Transfiguration, the Resurrection of Lazarus, the Entry of Jesus into

The Crucifixion, early eleventh century.
Mosaic.
Hosios Loukas, Greece.

The Washing of the Feet, 1100.
Mosaic.
Hosios Loukas, Greece.

Jerusalem, the Crucifixion, the Descent of Christ into Hell, the Ascension, Pentecost, and the Death of the Virgin. There is found, then, a whole series of compositions whose study is interesting from the point of view of the development of Byzantine iconography. At the Louvre Museum, a small mosaic of this genre portrays the Transfiguration; two others belong to the Basilewsky Collection, and show the faces of Samuel and St. Theodore.

Perusing the other miniatures of the time, illuminations, one sees that the painters were classically trained, and that they learned their art well enough to reproduce the positioning and the drapery, not in servile imitation, but with intelligent admiration. They responded thus to the current trend of contemporary society. Popular cantos celebrate beauty with even more graceful expression and display all the charm of Greek poetry.

Nowhere are these qualities more manifest than in two Greek manuscripts, kept at the National Library in Paris. One contains the homilies of St. Gregory of Nazance, which are the work of artists plying their trade under royal protection, and was produced for Basil the Macedonian. The illuminations are numerous, and several are important compositions occupying an entire page. The first portrays the well known figure of Christ, seated on the throne. [See p. 111] The second and third are of a more historical interest: one is of Empress Euddokia, surrounded by her sons Leo and

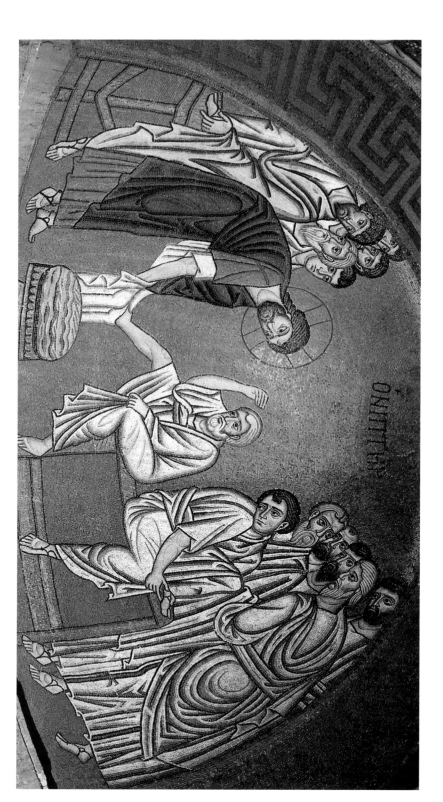

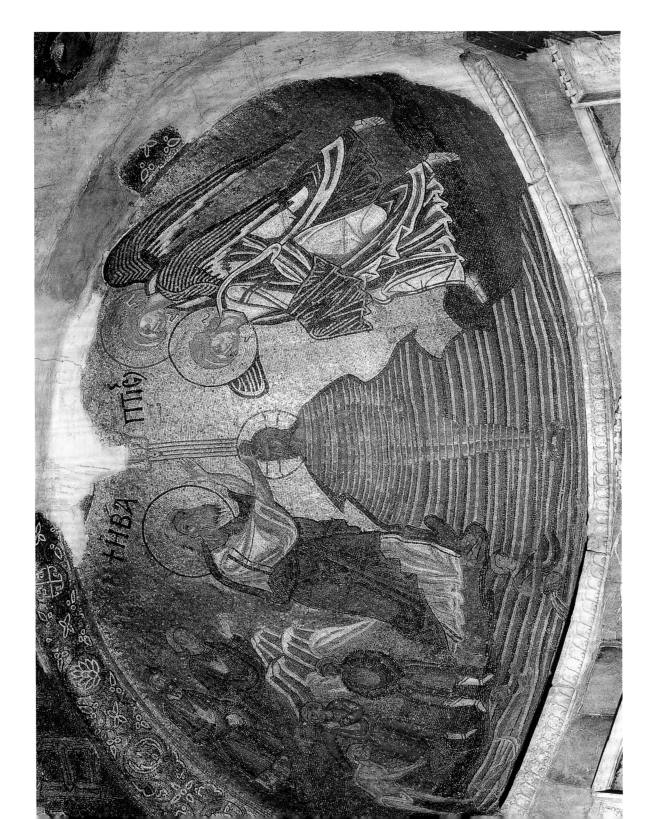

The Baptism of Christ, eleventh century.
Mosaic.
Monastery of Nea Moni, Chios, Greece.

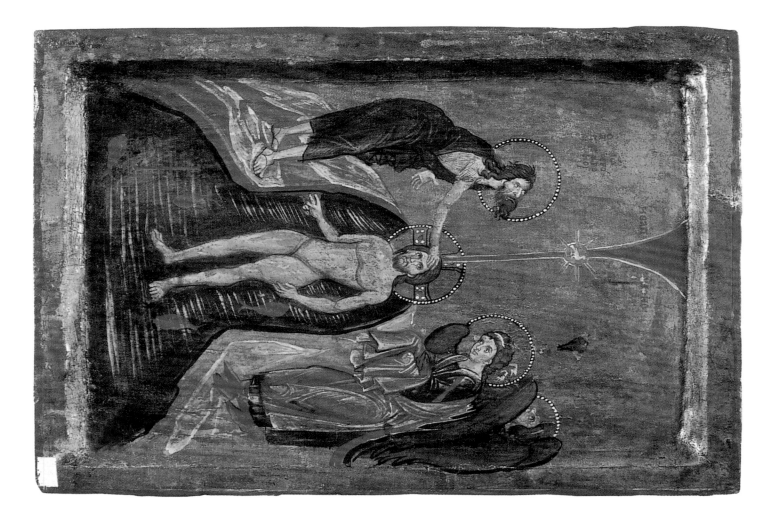

Leo VI Prostrate Before Christ in Majesty, 886-912.
Mosaic.
Hagia Sophia, Istanbul.

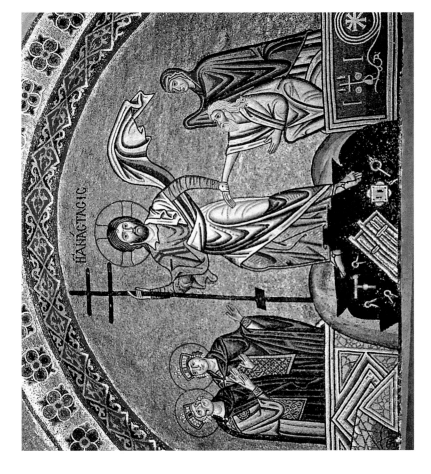

Alexander; the other is of the emperor himself, between the prophet Elijah and the Archangel Gabriel. To reiterate, on the walls in one of the rooms of the palace, Basil had himself depicted in the middle of his family; it is probable that the compositions found here can give some idea of the mosaics that have disappeared, although they differ from them on several points.

One of the most ravishing compositions depicts David guarding his flock while playing the lyre. Nearby, resting a hand on the shoulder of the shepherd, a young goddess, Melody, inspires his song. Her ancient dress leaves uncovered arms and part of her chest, a graceful and firm model; her head is half-inclined, and a soft smile animates the regular beauty of her face. In a second plane, behind a fountain, a woman is hiding and listening to David, only her head visible. In a corner of the painting, a young god is stretched out on the ground, half-naked, his head crowned in leaves; he is the personification of the mountain at Bethlehem. A surrounding countryside spreads out, cold and shadowy. This is a far cry from the mosaics of San Vitale and even further from the compositions that later Byzantine art would repeat. By contrast, it seems that the artist had tried to eliminate everything that recalled grandeur, etiquette, and majestic symmetry in search of grace and life alone, in their most natural forms. Most certainly, if one was unfamiliar with the contents of the manuscript, it would seem that one were regarding an idyll of Theocritus, rather than a Biblical scene. [See p. 112]

Elsewhere, it is Isaiah who prays, a theme that reintroduces a religious feeling. But behind him, Night appears, in the guise of a young woman of a tall and elegant build.

The Baptism of Christ, tenth century.
Icon.
Monastery of St. Catherine, Mount Sinai, Egypt.

The Anastasis, eleventh century.
Mosaic.
Hosios Loukas, Greece.

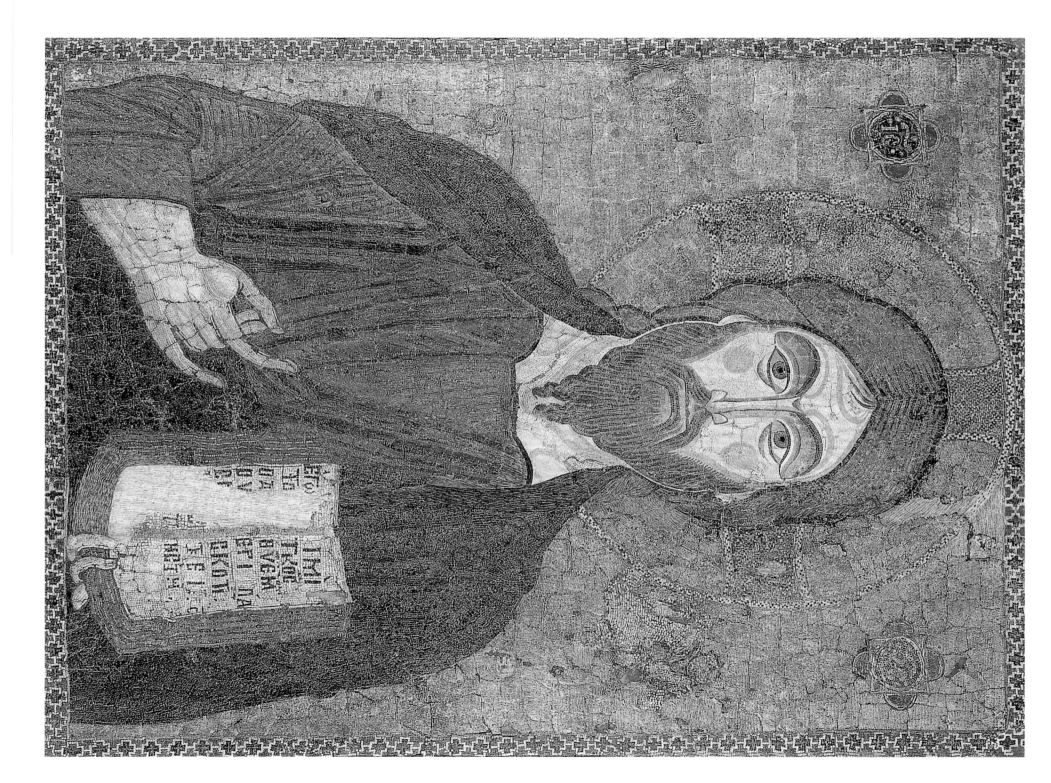

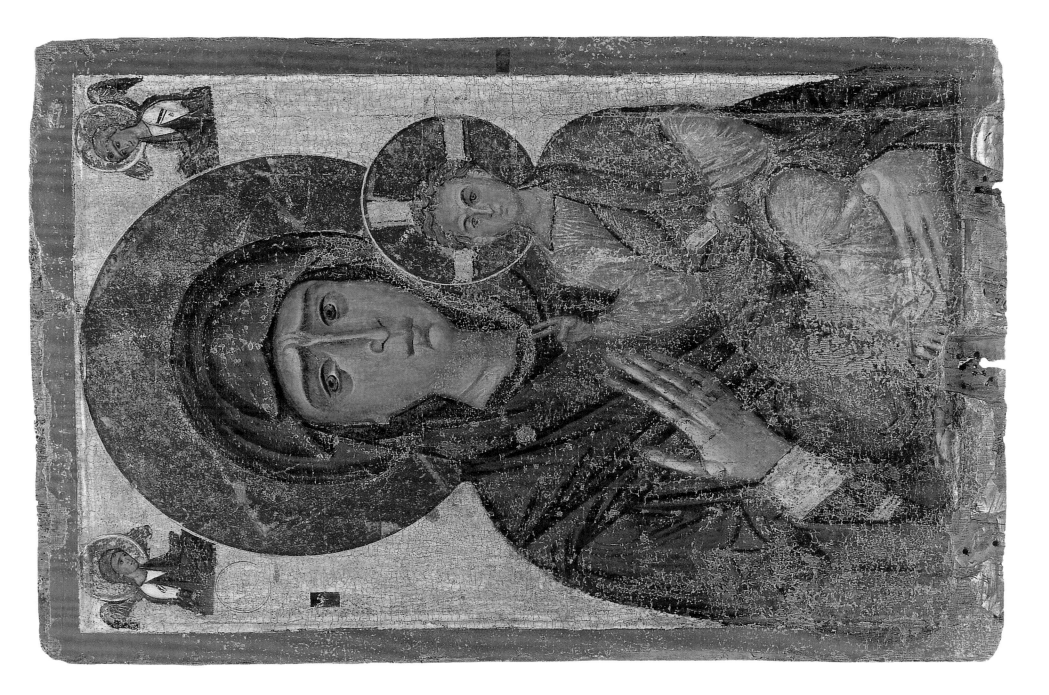

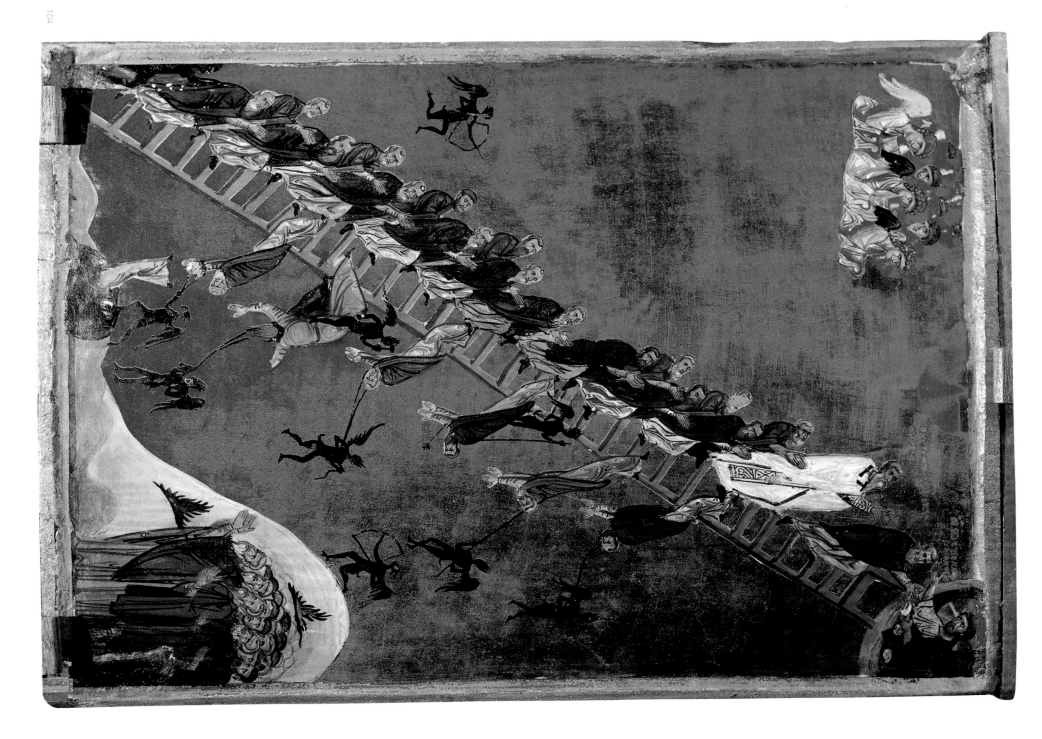

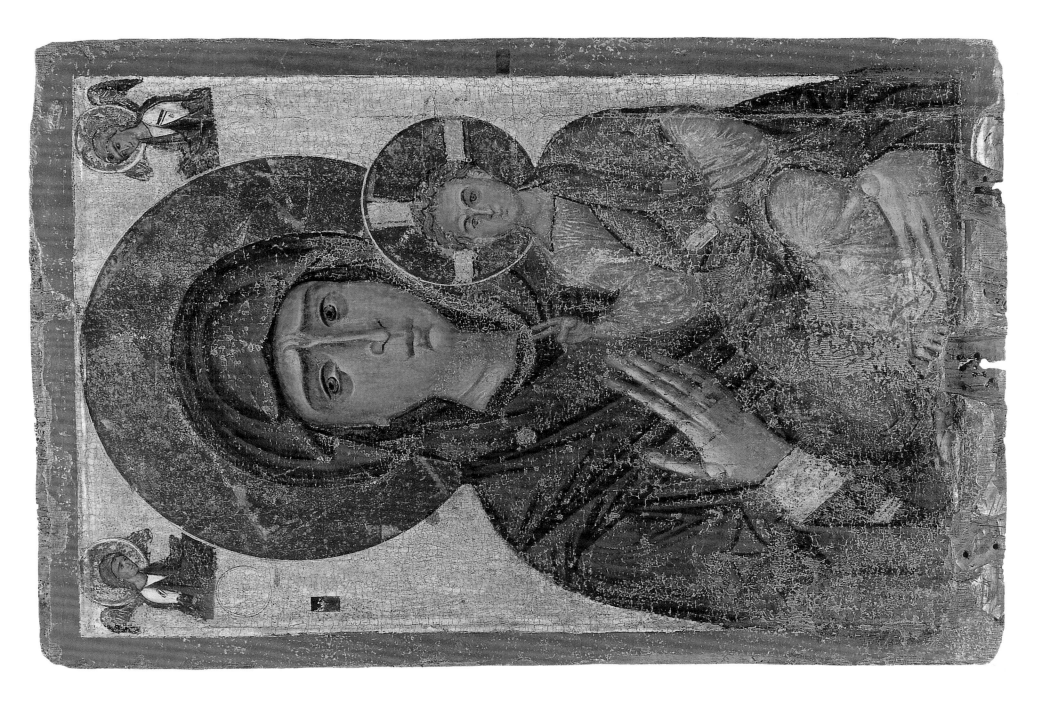

Christ Pantocrator, twelfth century.
Icon.
Bargello Museum, Florence.

Our Lady of Hodegetria, twelfth century.
Icon.
Byzantine Museum, Kastoria, Greece.

The Crucifixion and Saints in medallions, eleventh or twelfth century.
Icon.
Monastery of St. Catherine, Mount Sinai, Egypt.

The Crucifixion, eleventh century.
Daphni Monastery, Greece.

In an odd contrast, around her pagan face, brushing her naked shoulders, a Christian nimbus is forming, while she holds above her head a veil studded with stars, whose light fabric is billowing in the breeze. On the other side, a young child – a wingless Eros – holds a torch and represents the Dawn. [See p. 113]

These compositions, intended for valuable manuscripts, were appreciated by its contemporaries. After being admired, they were imitated, and even the lowliest of artists were producing reproductions of works that the masters of the time had originally conceived.

A manuscript of the Greek Menologue, stored at the Vatican, was produced for Basil II (976–1025). Four hundred illuminations are included, all on backgrounds of gold. Eight painters worked on it, and each one signed his work: Menas, Pantaleon, George, the two Blacherniti, Nestor, Simeon, and Michael the Small. These each have a different level of merit: Labarte considered Pantaleon and Nestor to be the most skillful, but it is the finesse of Simeon that is truly striking. A great variety of subjects were depicted, as they were present at all the celebrations of the year. They sometimes depicted New Testament episodes, sometimes scenes of martyrs or saints praying. This precious manuscript could sincerely be called the breviary of religious art for the Byzantines at the end of the tenth century. [See p. 119]

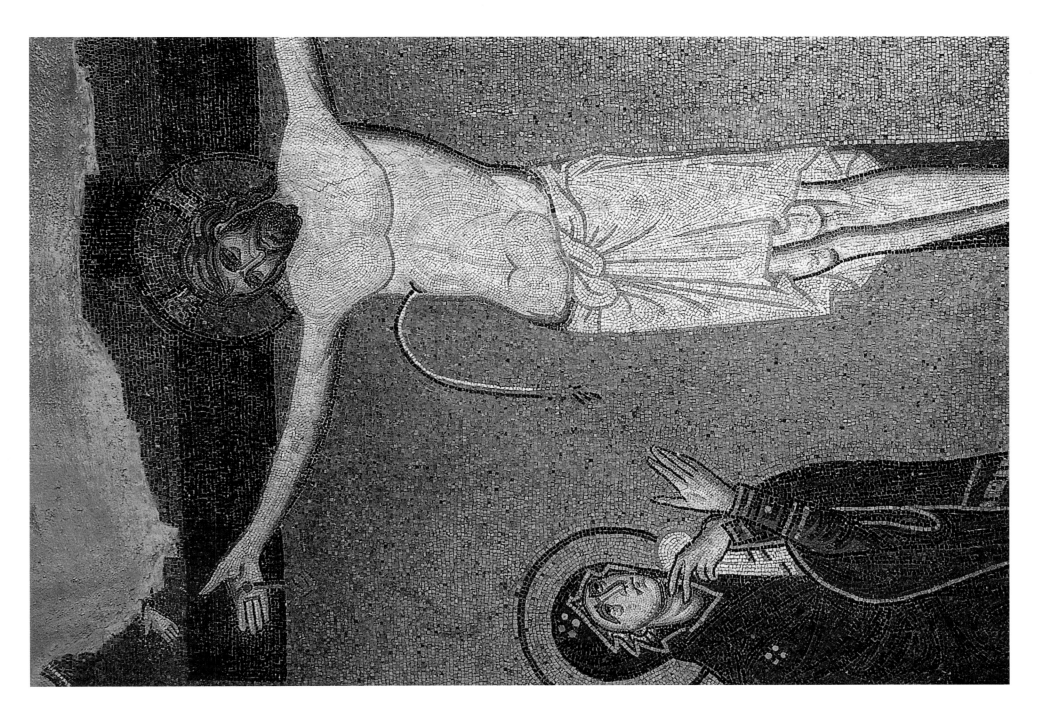

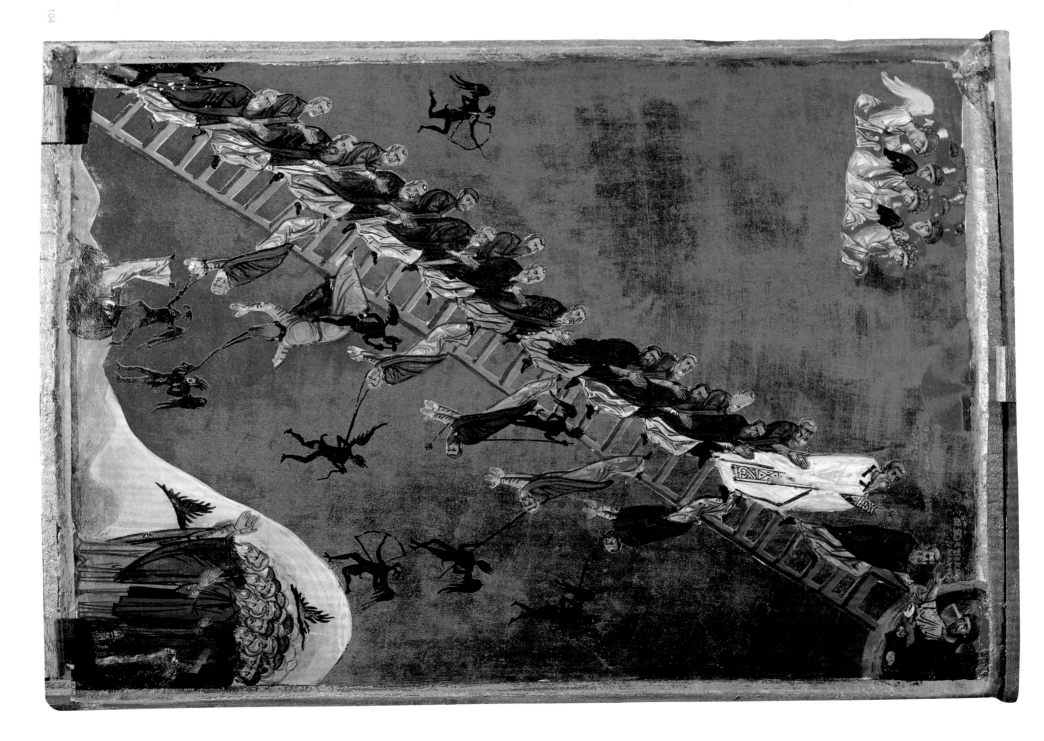

The Ladder of Divine Ascent, twelfth century. Icon, 41 cm. Monastery of St. Catherine, Mount Sinai, Egypt.

Toward the thirteenth century, flaws became more noticeable. In a manuscript from the eleventh century, which contained the sermons for the celebrations of the Virgin, mythological personifications of rivers were still rather frequent and would never actually vanish from Byzantine art. The decoration was always fine, and so, at the beginning of the first sermon, on the golden background of the illumination, animals and birds romp across multicoloured foliage. However, too often, when dealing with the human figure, the rendering becomes clumsy or inaccurate; corporeal proportions were no longer observed; because of a desire for an elegance of mannerism, they were elongated and thinned.

An entire facet of Byzantine art is revealed through these manuscripts' illumination of history. The illustrations show that Byzantine iconography was as well developed then as it would later appear. A subsequent chapter will show that, around the fifteenth century, an artist drafted a painter's manual in which compositions were noted for their many religious subjects. Among these, some are quite old and can only be found in the works of the fifth and sixth centuries; but for many, the standard seem to have been set in the ninth, tenth, and eleventh centuries.

In this way, the illustrations of the homilies of St. Gregory of Naziance and of the Menologue of Basil II are quite intriguing. Several contain an entire series of scenes from the Old and New Testaments, which correspond in part with those that are still today painted on church walls. Comparing the illuminations, whether those of manuscripts, of the Menologue of Basil II or of the corresponding passages in the manual from the fifteenth century, it is striking to find an almost complete identity. Even if these illuminations are nothing more than small copies of the frescoes from the eleventh and twelfth centuries, in their turn, the frescos from the following centuries – thanks to their similarity with the copies – would reconnect wholly with the iconographic system, which had then prevailed.

Among the prototypes of the saints represented in the manuscripts from this time, a thread of the trends that had a place in Byzantine art is notable, and it can be said that some are descended from Antiquity, while others are monastic in nature. The first are holy warriors, ordinarily depicted in the form of Greek ephebes, based on their regular features and their elegant and supple bodies, they seem more akin to youthful athletes of the Panathenian Games. However, in opposition, the ascetic saints, with their scrawny and angular limbs, their crude and wooden traits, recall that among the Church Fathers, more than one condemned beauty. These are of a race all their own; from their foreign appearance, they are recognizable as the family of Simeon Stylites, and in the depths of the most austere monastery, the monks dreamed up these bodies withered by vigils and fasting. Yet holy warriors and ascetic saints appear side by side in the illuminations of the Menologue of Basil, like they do on the walls of Byzantine churches today. Depicting opposing civilisations, they attest, by the strange contrast of their form, to the diversity of the elements that comprise Byzantine art; some demonstrating how powerful the persistence of ancient concepts were, others how great was the influence of monastic thought.

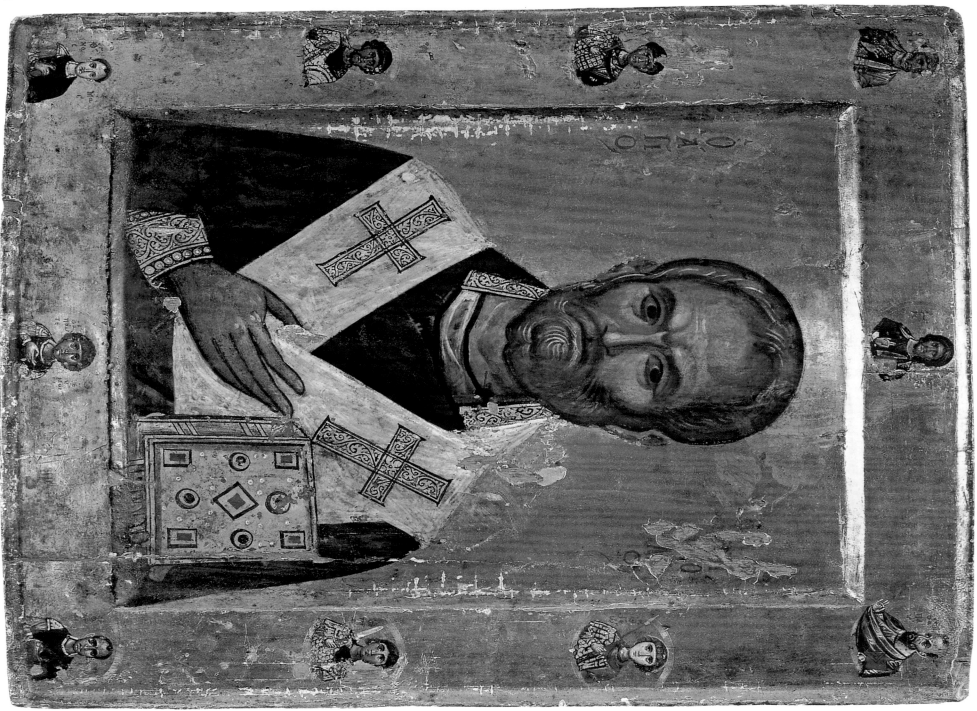

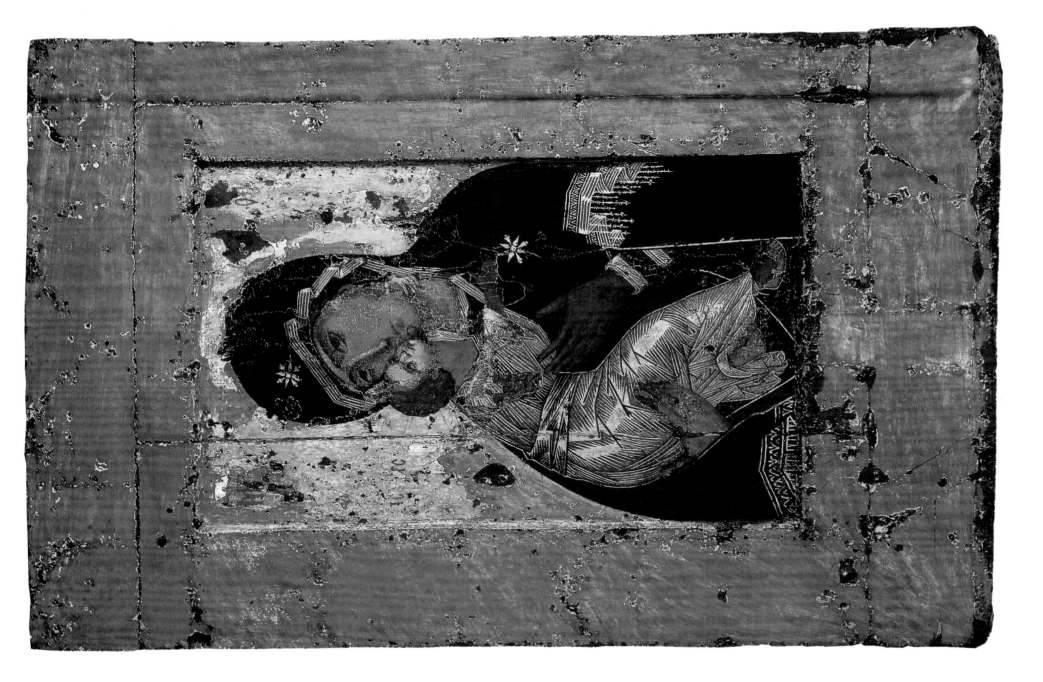

3. Sculpture, Metalworking

The causes in the East for the decadence of great sculpture are indeed well known; ill-viewed by the Church, it had only a precarious existence for many years. It has often been affirmed that it was formally condemned in the 8th century, and the Fathers of the Council of Nicaea sacrificed the art of sculpture over the course of their restoration the veneration of icons. However, in the seventh meeting of that council, when the decisions of the assembly were read, it was a matter of holy images, "let them be made with colours or with stone or with some material, be it as it may." The Greek Church today considers statuary prohibited, but this is founded on tradition rather than on a canonic rule. Islamic influence is perhaps no small contributor to these prohibitions.

The quarrel of the iconoclasts could very well have been fatal to sculpture. When the iconodules triumphed, it is likely that they hardly encouraged sculpture, already so forsaken. Yet this seems to correspond with their adversaries who had accused them of idolatry. Nevertheless these reproaches would particularly affect statues, the works of sculpture that reproduced the very reality of the human form. Bas-relief does not pose this problem, as, to a certain degree, it is more akin to the conditions of painting; because it expresses that same form only with the help of illusion and convention. The Church therefore showed itself to be more flexible on that point; not only would sculpting in ivory be maintained in all its brilliance, but marble and stone sculpture, restricted to bas-relief, did not entirely disappear.

In Ravenna, in the church of Santa Maria in Porto, there is a bas-relief that, according to legend, is supposed to have arrived miraculously in Italy from Greece around the year 1100. The sigils that indicate the name of the Virgin as well as the style of the work leave no doubt as to the origin of the sculpture; it must have been brought back at the time of the Crusades. The Virgin is orant, her head is regular and beautiful, and the overall effect shows a character of remarkable grandeur. The execution is simple and quite pleasing, though it occasionally lacks softness in the drapery. This work, lost in the depths of a foreign sanctuary, framed in a modern border of poor taste, strikes the visitor; it seems to be exiled from a world where the taste for beauty is preserved and united with religious sentiment. Apart from that, one recognises a model, used repeatedly by artists, the likes of which Byzantine sculpture has left adequate examples.

Very often, marble or stone sculpture was limited to the rendering of animals or ornamental designs. Numerous Byzantine flagstones that portray eagles, lions, or panthers striking down does are found in the East. Many are crudely rendered and from a decadent time. They have the particular characteristic of frequently imitating motifs that eastern art had been repeating from a very distant past, and which continued frequently to appear on fabrics woven in Asia during the Middle Ages.

To judge accurately the potential of Byzantine sculpture, one must look to the ivories. Many were brought back to Europe at the time of the Crusades or in the following centuries and are kept in the treasuries of churches, in museums, and in private collections. They attest to the fact that from the eighth to the thirteenth

Bust of St. Nicolas and Saints in medallions, tenth or eleventh century. Icon. Monastery of St. Catherine, Mount Sinai, Egypt.

The Virgin of Vladimir, early twelfth century. Painting on wood, 78 x 55 cm. State Tretiakov Gallery, Moscow.

The Annunciation, late twelfth century. Monastery of St. Catherine, Mount Sinai, Egypt.

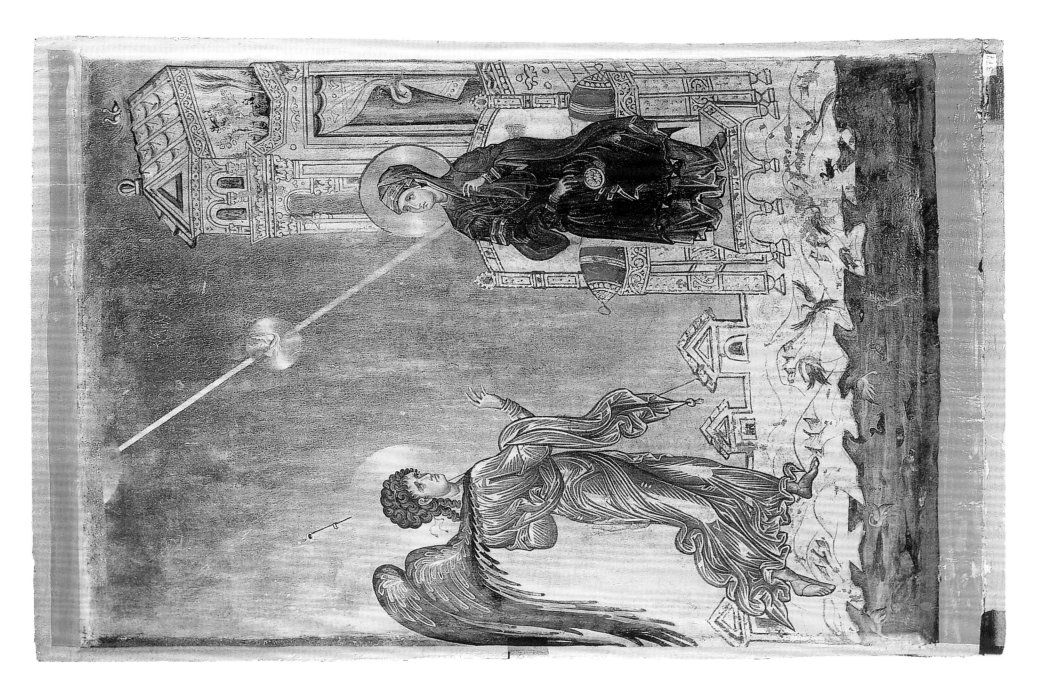

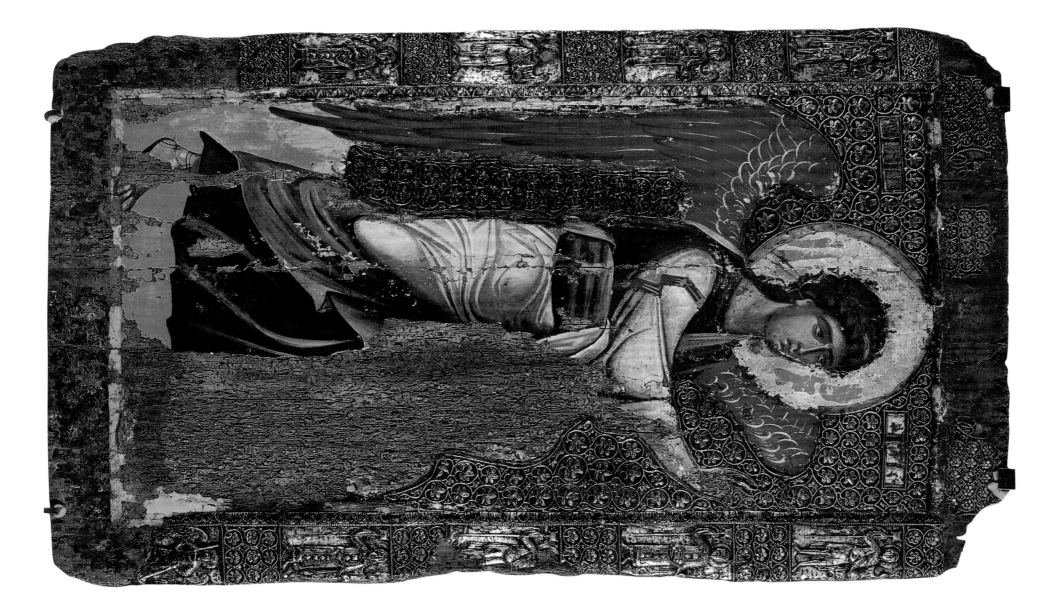

centuries, the development of that branch of sculpture corresponded with the development of manuscript painting; they demonstrate the same qualities at first, and later the same flaws.

One triptych, now at the Cabinet des Médailles in Paris, is from a slightly more recent date, and some changes in the style can already be noticed. Some attribute this to the eleventh or twelfth century, others to the end of the thirteenth century only; it seems more likely that it dates from the late eleventh to the early twelfth century. At the center of the triptych is a depiction of the Crucifixion. The Virgin and St. John are standing to the sides of the cross; lower, near the pedestal, are Constantine and Helena, in the form of tiny figures, only half the size of the others. At the very top, above the arms of the cross, hover two angels. The lateral panels are occupied by ten medallions, framing the heads of saints. The artists had not yet imagined placing on the cross an emaciated Christ whose limbs are twisted by convulsions of agony; on the contrary, the half-nude body is of fairly exact proportions and sufficiently accurate detail. The traditions of the school of the ninth and tenth centuries had therefore not yet been abandoned at this work's conception; however, the great elegance of the figures of the Virgin and St. John already approaches mannerism, and the proportions are too elongated. These trends are also noteworthy in another ivory depicting the Ascension of Christ. The composition and the execution are no longer

The Archangel Gabriel, early twelfth century.
Icon, height: 111 cm.
St. Clement's (Church of the Virgin Peribleptos), Ohrid, Macedonia.

Christ Enthroned, Homilies of St. Gregory of Naziance, 867-886.
Manuscript.
French National Library, Paris.

David Playing the Lyre, 867-886.
Manuscript.
French National Library, Paris.

Isaiah's Prayer, Homilies of St. Gregory of Naziance, 867-886.
Manuscript, 36 x 26 cm.
French National Library, Paris.

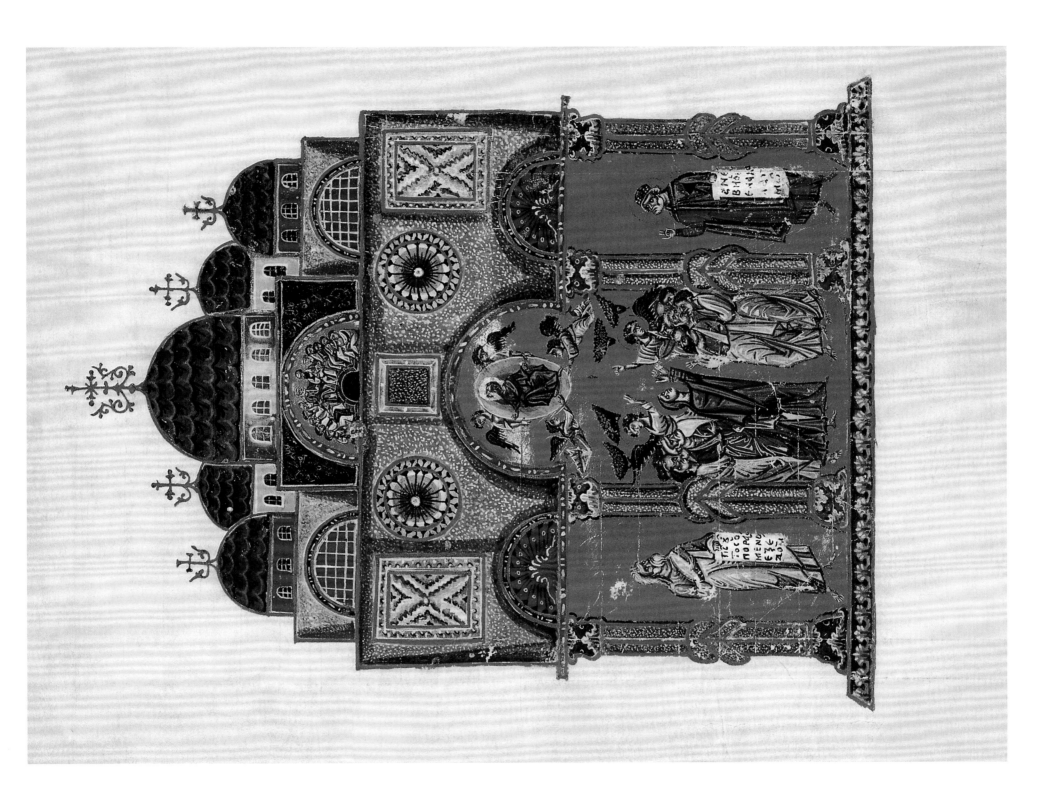

so full or so natural; the details are too elaborate, and the delicacy of the work is excessive. But these flaws are dissimulated by the overall grace, and the figures of the two angels flying and supporting the halo of Christ are of a finer style.

Another ivory at the Cabinet des Médailles dates from the tenth century. On a richly decorated pedestal, Christ is standing, dressed in ancient garments, whose arrangement still conserves the large, supple folds of the masters. The figure maintains accurate proportions and, under the draped clothing, a well-rendered and living body can be seen. The head, framed by long, curly locks of blond hair, is remarkable for its beauty and grandeur. Christ is crowning the Emperor Romanos and the Empress Eudokia, who are at his sides; but, due to a pedestal under his feet, he towers over them, and the whole of the scene presents a pyramidal arrangement and a very pleasing effect. These figures bear a striking contrast to the depiction of Christ; stiff in their richly embroidered clothing, they betray the conventional attitudes that Byzantine etiquette required. Their heads are veritable portraits: Romanos is soft and smooth-faced as a eunich, in spite of his courageous air, while the well-crafted traits of Eudokia display an intelligent beauty that affirms what we know of her in history. [See p. 118]

Among the ivories from that era, many served as the binding of precious manuscripts, but this system of decoration was applied to objects of all genres, as well as domestic altars, like the one that is kept at the Christian museum at the Vatican, or to sacred containers, like those found in Cortona and in Sens. The one in Cortona has the advantage of bearing a date: it was given to a monastery by one of the clerks of the Hagia Sophia during the reign of Nikephoros Phokas (963-969). The one at Sens, commonly called "la Sainte Châsse" provides a long series of bas-reliefs that show scenes from the stories of David and Joseph. One also finds there the eastern patterns that have already been indicated on the flagstones of that era. [See p. 124]

Works in ivory were not reserved exclusively for churches. Although most of the ivory works that are known are decorated by religious subjects, one can nevertheless cite some examples that are not of that character. The Basilewsky Collection, so rich in artefacts from the Middle Ages, possesses several containers of this genre; featured upon the most important vessels are sculpted warriors, some of whom wear Asian dress. People supposed that this indicated a souvenir of victory brought back from the Euphrates by Basil the Macedonian in 872. Though it is difficult to admit such a precise date, at the very least one must recognise that it is a work from the ninth or tenth century.

The Cabinet des Médailles in the French National Library and the Louvre Museum possesses a certain number of Byzantine cameos. All are decorated with religious subjects. One of the most beautiful shows Christ between two warrior saints, St. George and St. Demetrius. [See p. 125]

Thus, while the art of carving fine stone seemed to have been lost in the West, in the East it endured. However, if Labarte is to be believed, it would have disappeared immediately following the period studied here. "Byzantine cameos," he states, "are almost

The Vision of Ezekiel, 867-886. Manuscript. French National Library, Paris.

The Ascension. Homilies of James Kokkinobaphos, twelfth century. Manuscript, 23 x 16.5 cm. French National Library, Paris.

St. Mark, eleventh century. Manuscript, 24 x 18.5 cm. Österreichische Nationalbibliothek, Vienna.

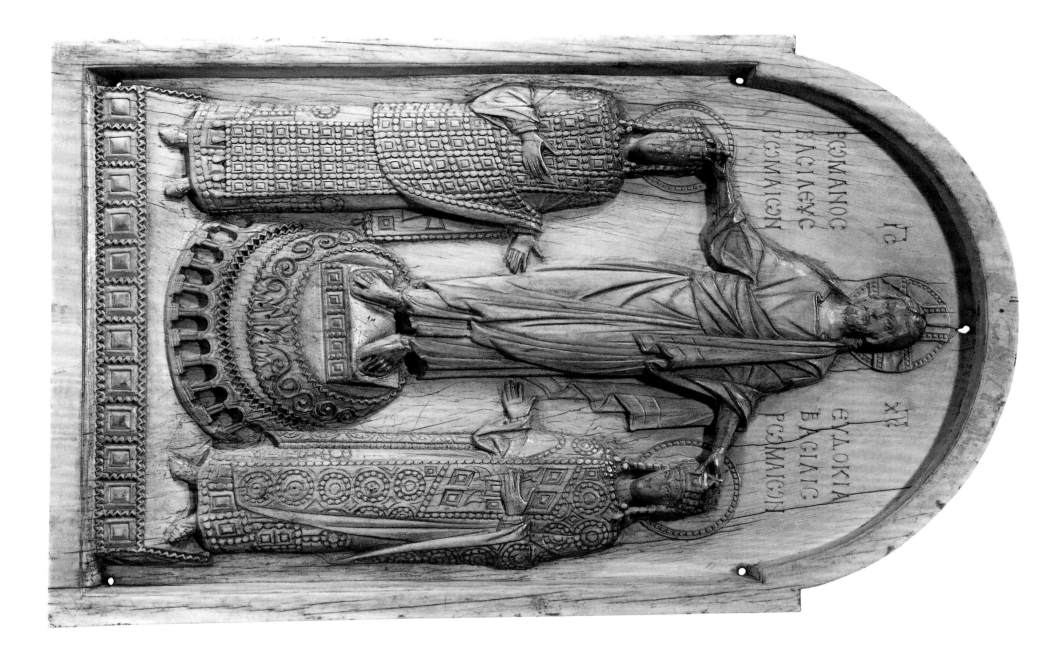

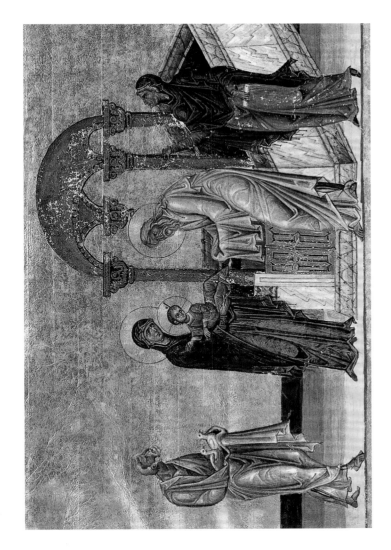

all from prior to the eleventh century; there are some from the era when the decadence of Byzantine art began; we know of none from a later date." This chronology may be somewhat too strict.

The Byzantines also excelled at the art of casting bronze, and their writers sometimes discuss works of this genre. Constantine Porphyrogenitus describes in detail the fountains that Basil the Macedonian had had erected in the atrium of the new church; the bronze is married with marble, and the overall effect must have been pleasing and picturesque. "One of these fountains," he writes, "is in Saharan stone. From the center of the base rises a pine cone pierced with holes. Above, on the cornice that encircles the basin, are placed cocks, goats, and rams in cast bronze that spout water through pipes."

The early founders of the Greek Empire primarily owed their reputation to the doors that they created for churches. The bronze door of the Hagia Sophia in Constantinople, older even that the era we are studying, survives to this day. Moreover, its decoration is rather simple and consists of crosses, fig leaves, and ornamental patterns. In the tenth century, the Emperor Constantine Porphyrogenitus commissioned silver doors with images of Christ and the Virgin for the chrysotriclinium of the palace. In the eleventh century, the activity of Byzantine workshops is evident today through a whole series of important works, commissioned by the Italians. The great Italian cities had trading posts in the East; some, such as Venice and Amalfi, had political and commercial relations with Byzantium. The family of Count Mauro shone among the leading families of Amalfi: two of its members were particularly famous, Maurus and his son Pantaleo. Both sustained relations with Constantinople: they owned a rich house there and received the titles of patrician and consul. Pantaleo played a political role and supported the cause of the Greek emperors against the Normans. In 1066, he gave to the Amalfi

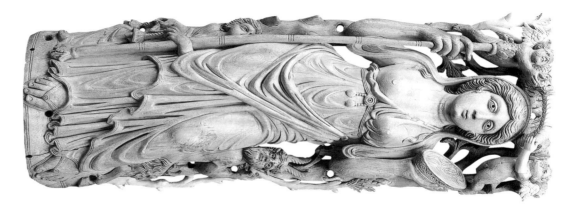

Ariadne and Her Retinue, early sixth century.
Ivory, 40 x 14 cm.
Musée National du Moyen Age - Thermes et Hôtel de Cluny, Paris.

Virgin with the Infant Enthroned, tenth century.
Ivory, height: 18.6 cm.
Petit Palais, Paris.

Cathedral its bronze doors, created at Constantinople, on which are depicted Christ, the Virgin, St. Peter, and St. Andrew in the four main center compartments. When Leo, the abbot of Monte Cassino, saw them, he was so moved that he sent the measurements for the doors of his church to Constantinople. Pantaleo again contributed to that expense, but the doors of Monte Cassino did not show any figures; instead, it bore inscriptions enumerating the possessions of the Abby. In 1076, Pantaleo gave to the sanctuary of Monte Sant'Angelo sul Gargano some doors whose decoration is much more interesting to the history of art; those of the church of San Salvatore di Bireto in Atrani, donated in 1087 thanks to the generosity of his son, who shared his name. In his turn, Robert Guiscard, after having seized Salerno (1077), offered to its cathedral doors of the same origin. There, the figures of Robert Guiscard, his wife, and the Protosebastos Landulf Botromiles, whom an inscription names as the founder of the church, are at the sides of St. Matthew.

These works are covered rapidly in order to arrive at the most important, the doors of St. Paul Outside The Walls in Rome. Here again, the inscriptions make known with certainty their date and origin. They were commissioned by the abbot of the church, Hildebrand, the future Pope Gregory the VII, and were cast at Constantinople in 1070 by an artist named Stauracios; Pantaleo took care of the costs. Although they disappeared in 1823 during the great fire that devastated St. Paul Outside The Walls, they survived, despite being quite battered. They were not put back in their former location, but rather set up in one of the vestibules of the church. [See p. 132]

The subjects that are treated have already been seen many times: events from the life of Christ, scenes of martyrs, figures of prophets and saints and inscriptions filling up to fifty-four compartments. The style bears traces of the research that distinguished the works at the end of the eleventh century from those of the ninth and tenth centuries: proportion is not observed closely enough, and the figures are elongated. But what most draws the attention here, as in the majority of these works, is the technique itself that was used. They are not bas-reliefs, but damascened bronze plaques are present. On the back of the metal, the artists drew the inverted features of the figures, and the folds of the clothing; then, in the grooves thus rendered, he inserted filaments of silver and gold. Their heads, feet, and hands were done in enamel. Unfortunately, this decoration, so rich and elaborate, has suffered greatly; long before the fire of 1823, the precious materials had attracted the greed of thieves.

The works just examined are closer to metalwork than to sculpture. The art of creating works out of precious metals, already well developed before the eighth century, had always been equally appreciated. It was applied to secular furnishings as well as objects of religious worship: churches, imperial palaces, and the houses of the wealthy were overflowing with pieces of metalwork. Nothing is more perishable than such works, for the value of the materials of which they are composed compromises their durability. Too many successive conquests have devastated the Byzantine Empire for most of these works of art to escape the avarice of conquerors. Fortunately, among the conquerors, there would occasionally be one who had long admired the works of the Byzantine metal smith and even previously

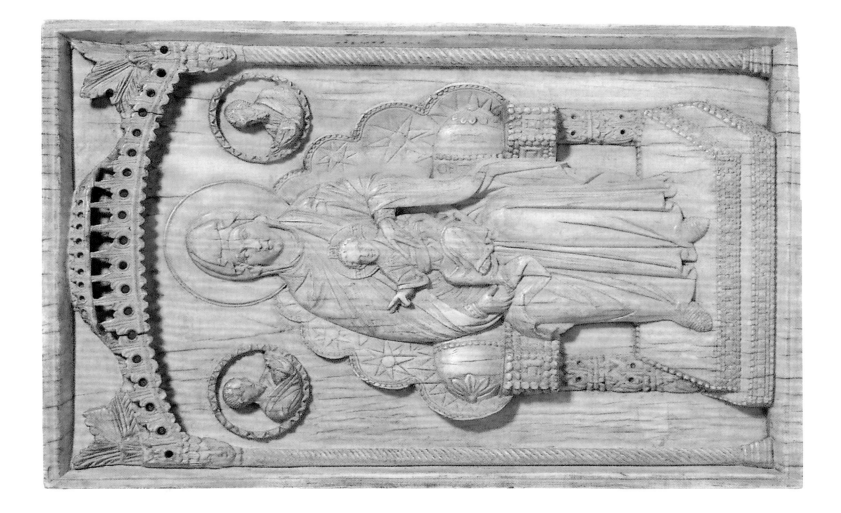

The Pala d'Oro, twelfth to thirteenth century.
Gold, silver, and precious stones, height: 212 cm; length: 334 cm.
Treasury of St. Mark's, Venice.

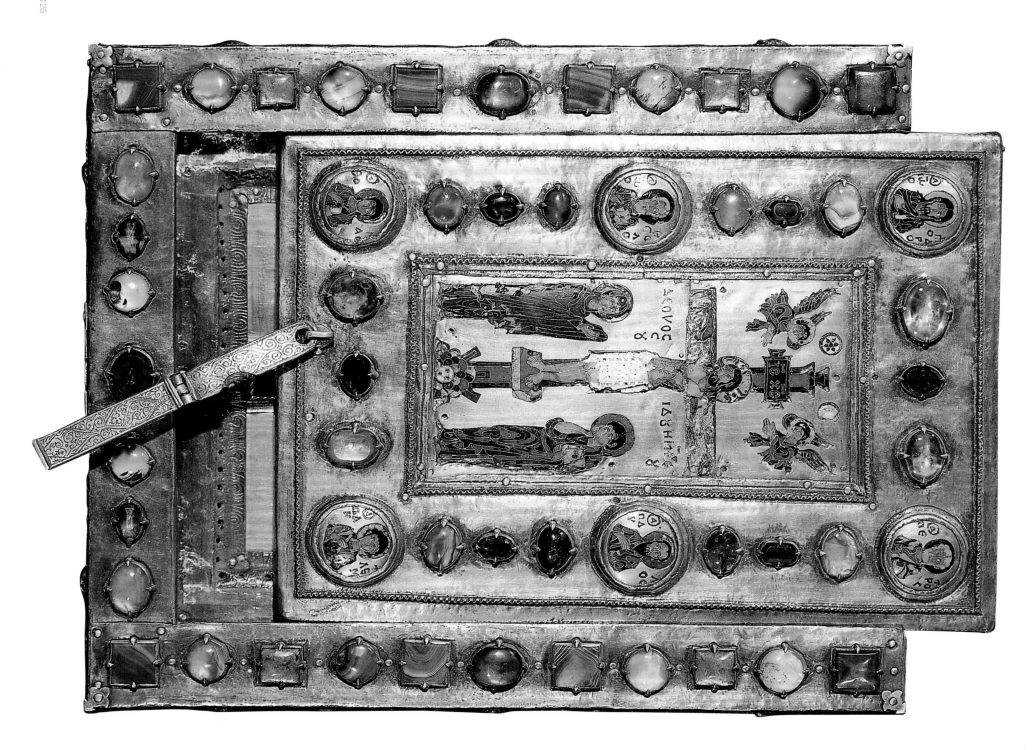

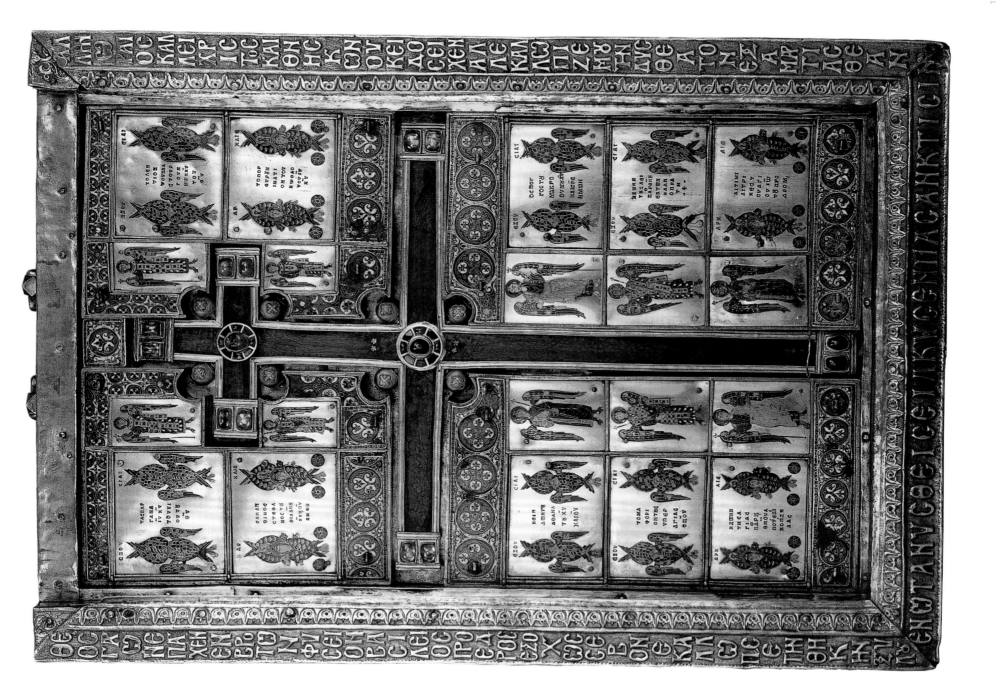

stands apart for its beauty and richness: the celebrated Pala d'Oro, which now serves as the retable of the high altar at St. Mark's. [See p. 122-123]

The Pala d'Oro has been the object of many descriptions, but also of heated debates. This is not a homogeneous work, a whole, executed all at once—it is composed of parts that differ by date and style. On this point, most scholars are in agreement, but they cease to agree when it comes to determining the age of the various sections.

The whole of the Pala d'Oro is in the form of a rectangle whose base is approximately 3.15 metres and whose height is approximately 2.10 metres. It folds over itself, framed by wide borders, loaded with fine stones and chiseled medallions, and featuring eighty-three pictures or enamel figures that stand out against a gold background and are all isolated, whether by small columns or pilasters adorned with pearls and fine stones. The tympana of the arches that arch between the pictures or the figures and all the fields that can be seen between the enamels are covered with a copious amount of precious stones, pearls of great value (thirteen hundred thirty-nine stones and more than twelve hundred pearls), and tiny enamel medallions that all together create an amazing luster and a richness that cannot be found in any other metalwork monument.

The frame and spaces left open between the enamel figures have often been restored and are in many places in the Italian style. The enamels, with very few exceptions, are definitely Byzantine. They are split into two groups, or rather into two superposed section. In the upper, the center is formed by a large medallion, from which the Archangel Michael stands out in full length. The two sides are made up of six compositions: Christ's Entry into Jerusalem, the Crucifixion, Christ's Descent into Hell, the Ascension, Pentecost, and the Dormition of the Virgin.

The lower section, roughly twice the height, shows in the center the image of Christ seated on a throne. Four small medallions house the Evangelists around him. To the sides, above, and below, numerous figures of angels and saints attend the Savior and form the celestial court. Finally, in the upper and side borders, scenes of the Evangelists and episodes from the life of St. Mark unfold.

By the style and the finesse of execution, these enamels inspire all that has already been said of other Byzantine works, though they are not of the same value. It is evident that multiple artists have worked on them, and they were not contemporaries. According to an ancient tradition, which several passages of old Venetian chroniclers confirm, the Doge Orseolo was supposed to have had brought a magnificent altar front from Constantinople in 976, which was subsequently set up on the altar itself and became the Pala d'Oro. Moving to the inscriptions on the monument itself, this transformation could be attributed to the Doge Ordelafo Faliero, and he also could have added new plaques to those that already existed (1105). Finally, in 1209 and in 1345, the Pala was again restored and enhanced with new gems. The intervention of Ordelafo Faliero is confirmed by other testimony. Below the medallion of Christ is the Virgin; she is surrounded, on one side, by the Empress Irene, wife of Alexis Komnenos, who lived at the end of the eleventh century and the beginning of the

The Crucifixion, eleventh to twelfth century.
Icon, height: 24 cm.
Treasury of St. Mark's Basilica, Venice.

Reliquary of the True Cross, mid-tenth century.
Gold, silver, and precious stones, height: 48 cm.
Limbourg Cathedral Treasury, Limbourg.

Lapis Lazuli Icon, twelfth century.
Lapis lazuli, gold, pearls and precious stones, height: 8.3 cm.
Louvre Museum, Department of Decorative Arts, Paris.

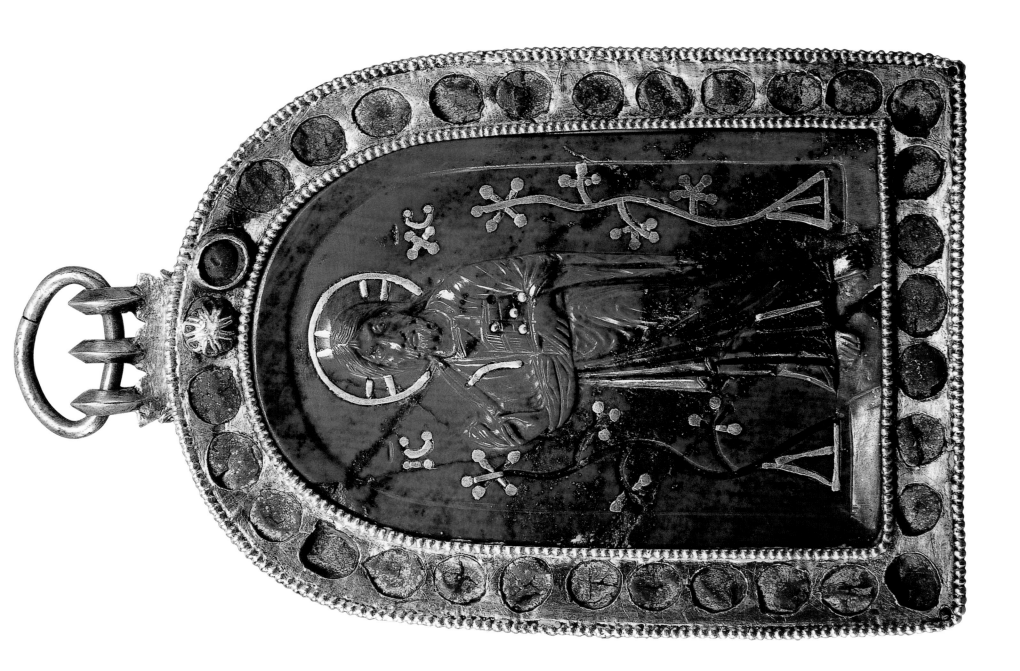

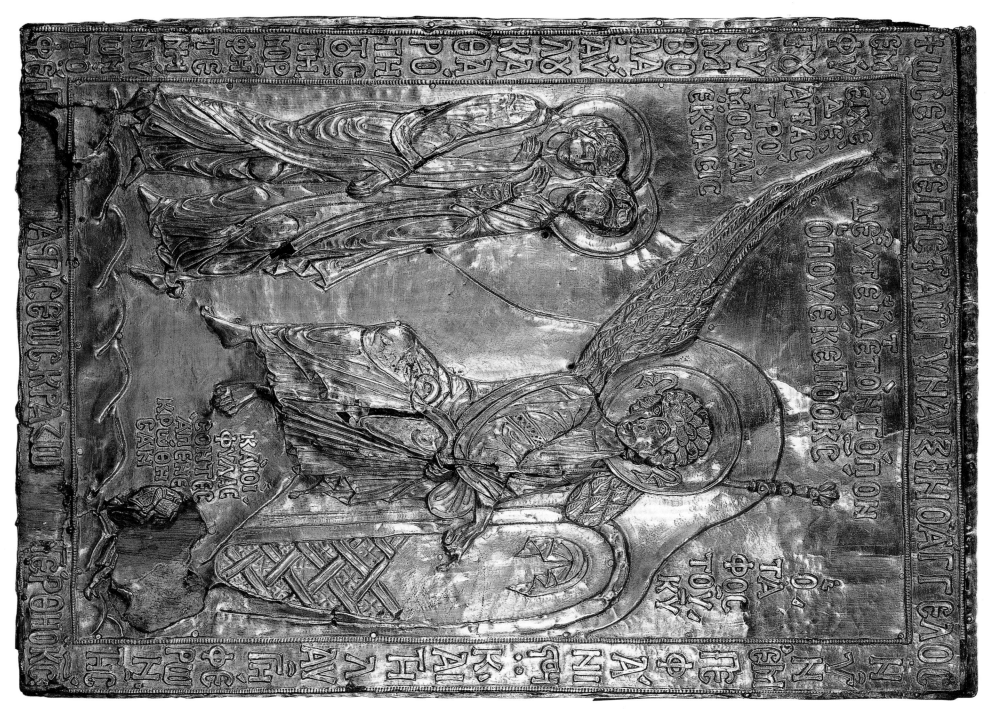

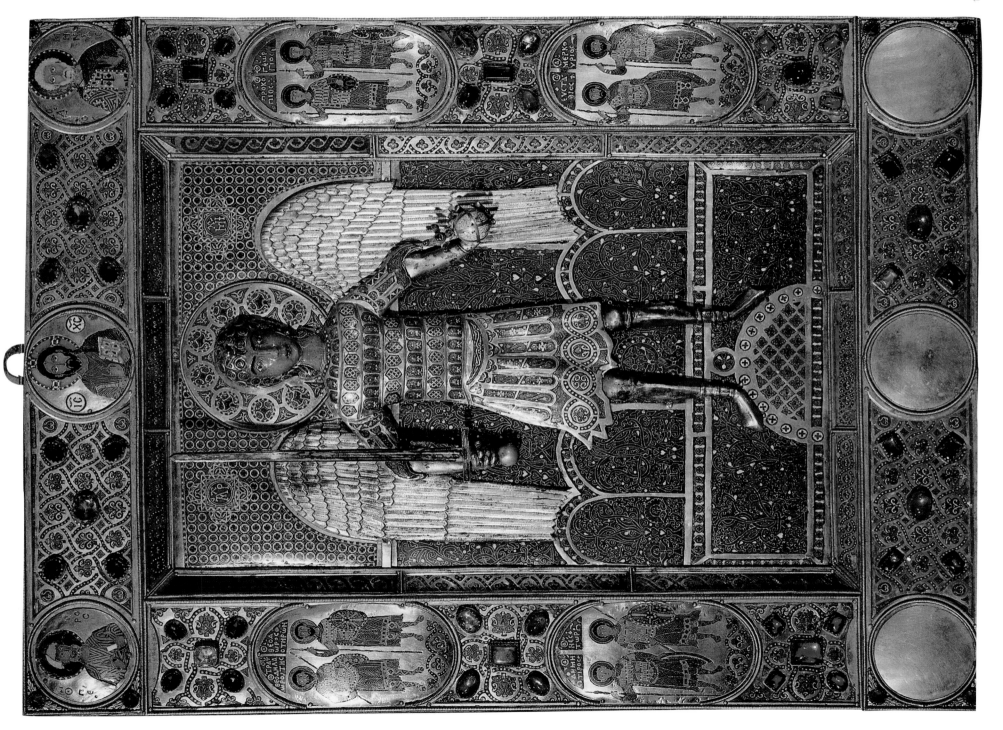

twelfth, and on the other side, by Ordelafo Faliero himself, dressed in the style of the high dignitaries of the Byzantine court.

The details that have been given concerning this masterpiece of Byzantine metalwork make it unnecessary to dwell on other monuments of this genre kept in the treasury of St. Mark's. Once again, Venice has only preserved but a part of that which it formerly possessed; in several other churches there used to be Byzantine retables that have since disappeared. Elsewhere, although so many precious works are not found together in one place, beautiful pieces of Byzantine metalwork nevertheless merit rapt attention. For example, the reliquary of Limburg is of great interest, as its era and provenance are known with certainty. A Greek inscription indicates in fact that it was completed on the order of the Emperors Constantine and Romanos, which is to say between 948 and 959. The reliquary is in the form of a container; the center of the cover and the interior of the box are decorated in enamels, whose frames are adorned with pearls and precious stones. The most beautiful are those on the cover. Seated on a throne, Christ is surrounded by the Virgin, St. John the Baptist, and two angels. The twelve Apostles are spread out in lines above and below. "The diverse figures on this reliquary," says one of the archaeologists who has studied it most, "are noble and handsome. In keeping with the character of the art of that time, their attitude is serious; it seems rather harsh and stiff; but, on examining the figures up close, one can see a delicacy in the forms that recall the works of Antiquity. The flow of the drapery could rival that of classical execution." Unfortunately, a rendering, no matter how exact, would not be able to give a fair idea of these works, because it loses the colouration that gives it its charm. [See p. 127]

One could also mention the reliquary of the stone of Christ's sepulcher kept at the Louvre Museum. This reliquary had been acquired by St. Louis after the sack of Constantinople by the crusaders in 1204. It shows the tastes of Byzantine metalworkers in the twelfth century. The subject is borrowed from the Gospel; seated near the tomb of Christ, an angel announces to the saintly women that the Savior is risen. [See p. 130]

The crown said to be of St. Stephan I, kept in Budapest, is less ancient, as indicated by the figures of Michael Doukas (1071-1078) and his brother Constantine, both reproduced on the enamel plaques. Images of Christ, the archangels, and various saints decorate the perimeter. Subjects of the same genre, combined with more developed compositions are shown on a Byzantine reliquary also kept in Hungary, in the city of Gran. France also possesses a certain number of Byzantine enamels, but of less importance or a more uncertain date.

From this sampling of arts from that era, one can draw a general impression. In the majority of their works, whatever the material or importance, the Greeks demonstrated their ideas of taste and elegance. Between the figures in the mosaics and miniatures, and those that decorate enamels or fabrics, one can discern no difference in style at all. The procedures alone vary, but the images are conceived with the same thought, and the skill of both groups is often equally great. Is this not characteristic of truly artistic eras?

Reliquary, Stone from Christ's Sepulcher, twelfth century.
Gilded silver, height: 42.6 cm.
Louvre Museum, Department of Decorative Arts, Paris.

The Archangel Michael, eleventh century.
Icon, 46 cm.
St. Mark's Museum, Venice.

Bronze door of the Basilica of St. Paul Outside The Walls (detail), 1070.
Bronze.
Rome.

B. Byzantine Influences in the West

During the Middle Ages, the East and the West were never isolated from one another. Well before the Crusades, their contact was frequent. Byzantium exercised a powerful attraction for the western imagination; the princes of France, Germany, and Italy constantly sent ambassadors there. Countless pilgrims departed for the Holy Land, often visiting Constantinople; in their turn, Greek monks would come and settle in the West. They could be found, not merely in the south of Italy, but in Rome, France, and Germany. It was above all through trade that a rapport was established whose effects the development of civilisation must have felt. In France, during the Merovingian era, there were small Syrian colonies even in the center at Orléans. Each year, in western ports, many vessels would set sail for Constantinople, Thessaloniki, and Alexandria, to acquire products from the East. International travel was even more common when the Crusades established permanent Latin settlements in eastern countries.

Among those Greeks who came to the West, there were some artists to whom the testimony of several chroniclers bears witness. And it was not only spices, but also decorative objects that merchants and travelers brought back from the East. These artistic works were closely studied; often, they were imitated or used as inspiration for western art. Following Byzantine art along all of its forays in the West would be a long and difficult task; as it is impossible to dedicate more than a few pages to it here, only the most important and best-established facts will be mentioned.

Votive Crown of Emperor Leo VI, 886-912.
Gold, cloisonné enamel and pearls, height: 3.5 cm; diameter: 13 cm. Treasury of St. Mark's, Venice.

Paten with Christ Giving a Blessing, eleventh century.
Alabaster, gold, and silver, diameter: 34 cm. Treasury of St. Mark's, Venice.

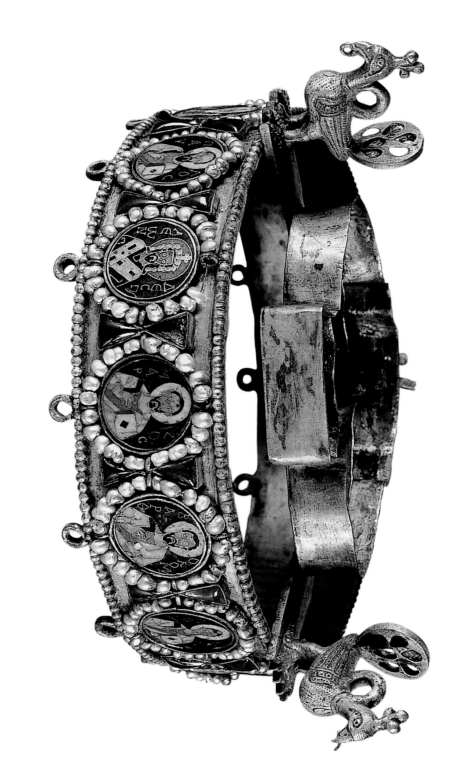

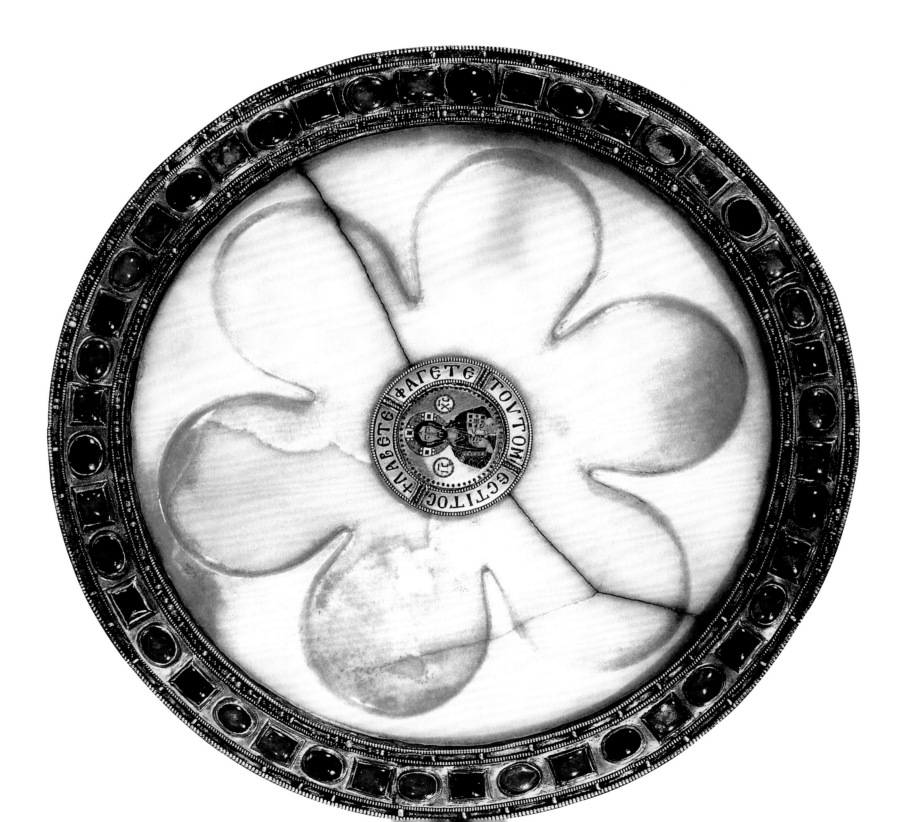

Leopards and Centaurs, twelfth or thirteenth century.
Mosaic.
Chamber of Roger II, Palace of Roger II of Sicily, Palermo.

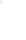

138

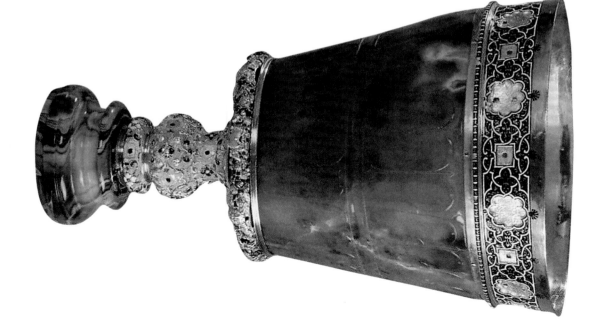

Chalice of Romanos II, 959-963.
Sard, height: 28.5 cm.
St. Mark's Museum, Venice.

Vessel, tenth to eleventh century.
Sard, enamelled gold, height: 24.6 cm.
Louvre Museum, Department of
Decorative Arts, Paris.

Shroud of St. Germain d'Auxerre, tenth
to eleventh century.
Silk, height: 160 cm.
Museum of Saint-Germain Abbey,
Auxerre, France.

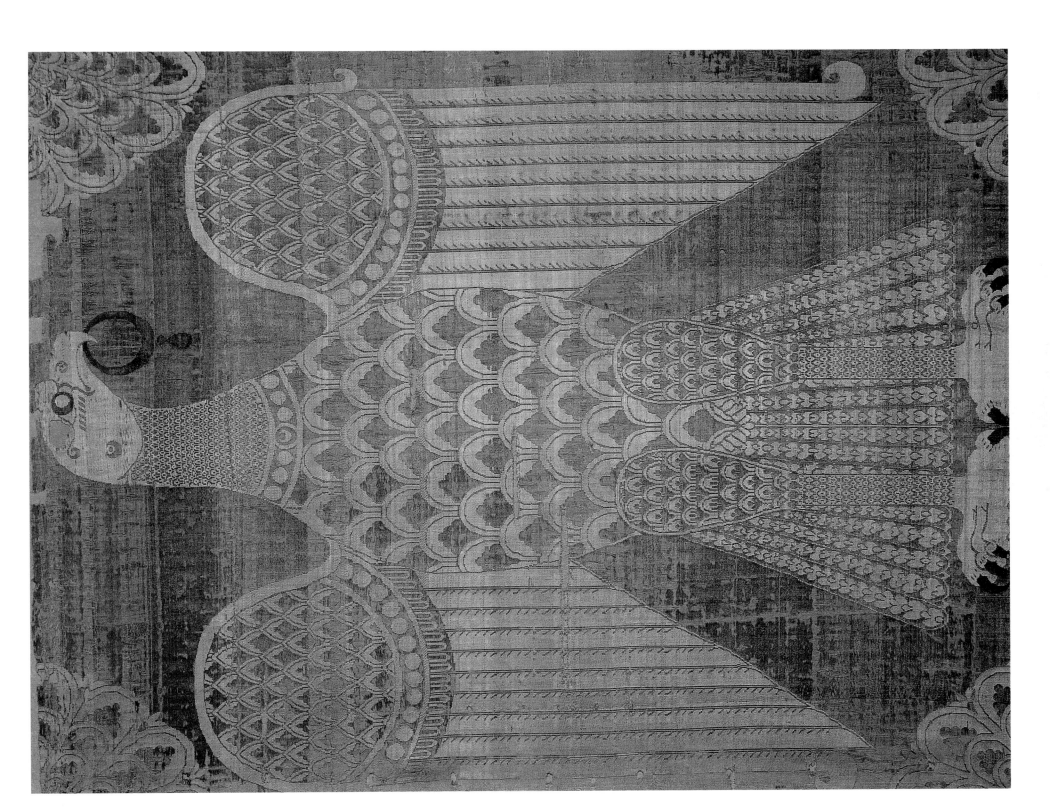

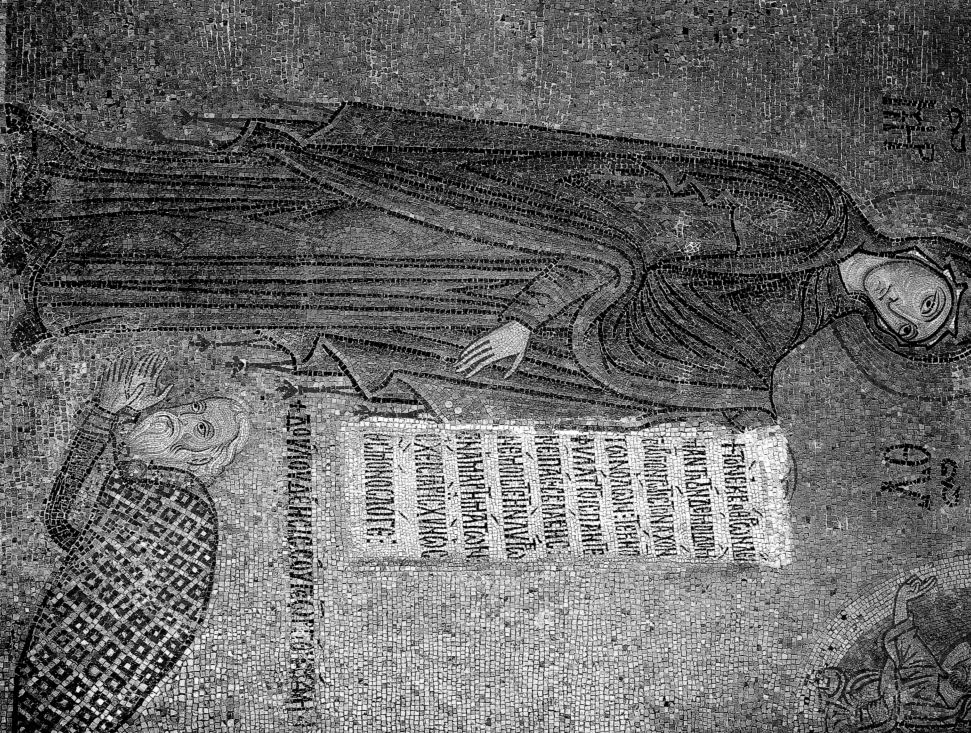

The role played by Byzantium in the development of the arts in Italy has been the object of many discussions. Some have expanded it and others have restrained it with equal exaggeration. To arrive at several general conclusions, which are at the same time as precise as possible, it is necessary to distinguish several regions within the country. Italian art in the Middle Ages did not develop with uniformity. Italy had been divided into a mass of cities and states that differed greatly in their political and artistic conditions. In certain provinces, Greek domination was long maintained; elsewhere, it disappeared quite early. While the activity in some cities was geared toward the East, others only had less direct and more infrequent contact with the Empire of Constantinople. It is therefore logical to study individuals whose destinies have been diverse; so in many places Byzantine art enjoyed a rather long supremacy, while elsewhere its influence had been weaker and more ephemeral.

In the south of Italy, the role played by Byzantium is evident. Throughout many centuries, a large part of that territory was linked to the Empire of Constantinople by religion, administration, and even language. The former Magna Graecia still deserved that name. Even the quarrel of the iconoclasts, which split away the rest of Italy from the East, fortified Hellenism in the south; the iconodules took refuge there in great numbers and the Greek emperors did not concern themselves with them. There was, in those provinces, a veritable Greek colonisation and a colonisation that was in part monastic. In Calabria alone, the names of ninety-seven monasteries of the order of St. Basil are known, which were founded during that era. This region was the center of the Neo-Hellenistic civilisation. Byzantium was well-loved there, and when the Normans arrived, they were vigorously resisted in many places. Robert Guiscard besieged Taranto and Santa Severina with no small amount of difficulty; even with violence, he was unable to pry the peoples from Hellenism. More than a century would pass before the Latin rites would replace Orthodox. In certain places in the twelfth century, the Greek language was still used, including in Sicily. In other provinces, Byzantine culture, although less strongly rooted than in those two regions, was nonetheless still very strong. "Is there a need to be reminded what the Normans themselves, after the conquest, during the first period of their domination over the south of Italy, borrowed from Greco-Byzantine civilisation? Not only did they adopt Greek as one of the official languages of their chancellery, because it was the language of a portion of their subjects, but their architecture remained entirely Byzantine until around 1125. The first coins that they struck in Apulia and Otranto imitate those of the Eastern Empire. The new style of dress, characterised by a long, oriental-style mantel and a sort of Phrygian cap, that the entire East adopted around 1090, just before the First Crusade, in place of the short attire that prevailed until that time, owed them its first introduction. And it is nothing more than Greek fashion." The Norman princes founded as many Greek monasteries as Latin. At court, they had as many Byzantine poets, historians, and theologians as there were at the imperial court. It was not until around the thirteenth century that kings and Church undertook to extirpate by force the Eastern element.

Until then, in the provinces that formed their kingdom, a brilliant civilisation developed, entirely imbued with Hellenism. Yet art is not the same everywhere. In Sicily, where Islamic domination succeeded the Eastern emperors and preceded the Normans by more

The Great Admiral George of Antioch at the Feet of the Virgin, 1149.
Mosaic.
La Martorana, Palermo.

Christ Pantocrator, c. 1148.
Mosaic.
Cefalù Cathedral, Sicily.

Christ Pantocrator, 1148.
Mosaic.
Cefalù Cathedral, Sicily.

than two centuries, Byzantine and Arabic art lived side by side and sometimes blended, while at the same time western influences crept in. As for the architecture, the shapes of the Greek church combine in a myriad of edifices with those of the Latin basilica, and at times the cupola appeared on pendentives, as at St. John of the Hermits (outside the walls of Palermo, twelfth century), the Martorana (Palermo, twelfth century), and the chapel of San Cataldo (same city, twelfth century).

Roger II, who took the workers from the Greek fabric manufacturers, also commissioned Byzantines to decorate the walls of his Sicilian churches. It was undoubtedly they who created the beautiful mosaics of the Cefalù Cathedral (1148). Around Christ, placed at the back of the apse, are grouped the figures of the Virgin, the prophets, and the saints.

[See p. 143]

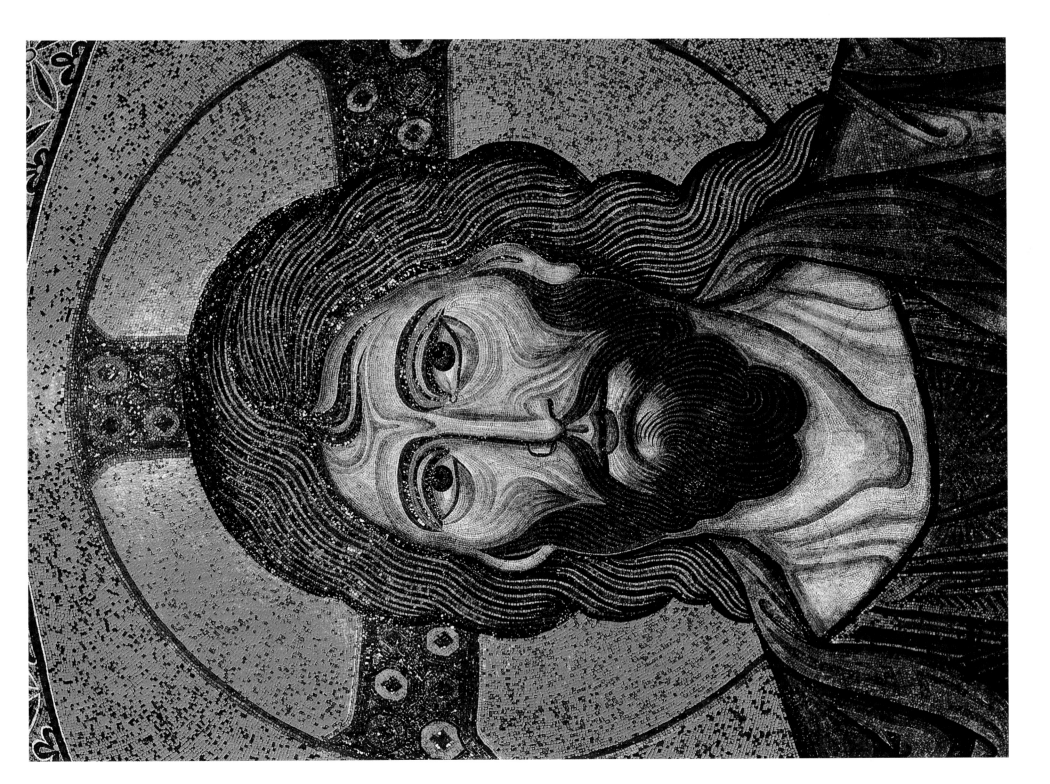

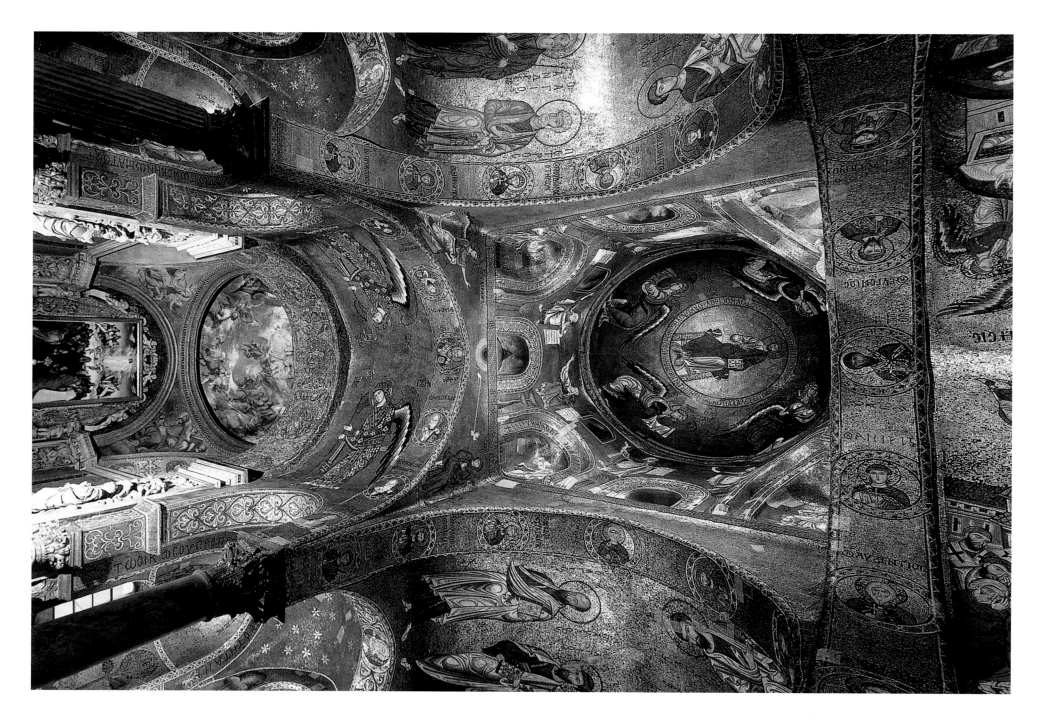

INMISIT·DNS·SOPOREA·INA
DAM·ET·VLT·EVA·DE·COSTIS
EIVS

At Palermo, the mosaics of the Palatine Chapel, consecrated around 1143, date from the reign of Roger II and his successors. At the sides of the saintly figures, who, as at Cefalù, occupy the apse, the rest of the church is decorated with scenes from the Old and New Testaments. By strange contrast, Arabic art dominates the ceiling, displaying its figures and Kufic inscriptions. [See p. 145].

During the same era, one of the officers of Roger II, the Greek Admiral George of Antioch, was having a church built and decorated that was named after him, Santa Maria dell'Ammiraglio (now the Martorana). The old building has been greatly modified, yet some of the mosaics that were there still exist. One of them provides one of the earliest dated examples of the Death of the Virgin. At another site in the church, George of Antioch had himself depicted prostrate at the feet of the Madonna, while nearby is an image of Christ crowning Roger. [See p. 140].

View of the Dome, 1149.
Mosaic.
La Martorana, Palermo.

The Creation of Eve, 1130-1143.
Mosaic.
Palatine Chapel, Palermo.

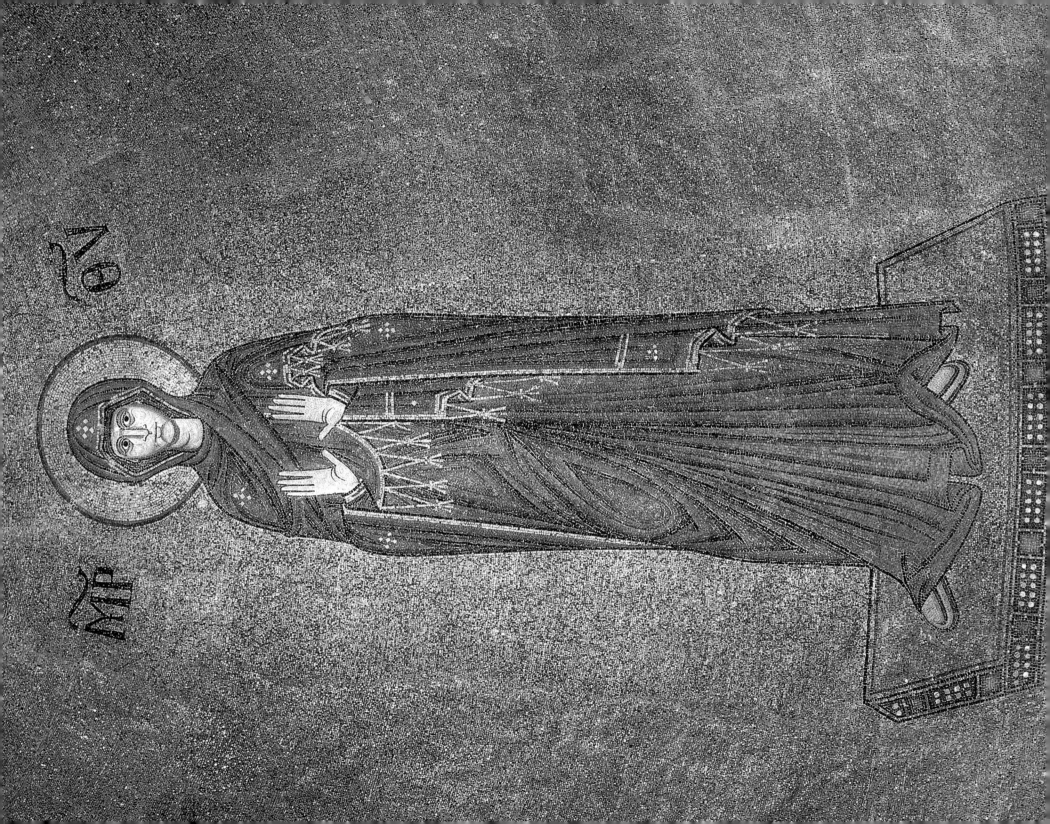

Madonna Standing, late twelfth century.
Mosaic.
Cathedral of Santa Maria Assunta,
Torcello.

Orant Virgin, 1140.
Church of Santa Maria e San Donato,
Murano.

Monreale Cathedral, 1175-1190.
Mosaic.
Monreale, Sicily.

These works from the first half of the twelfth century are often remarkably well-executed, their composition well conceived, the design precise, and the colour scheme brilliant. Nothing gave a better idea of the school of Byzantine mosaic that was then flourishing and whose products were so rare in the East. But in the second half of that century, there appear already to be some signs of decadence. The mosaics of the Monreale Cathedral (completed around 1182) cannot compare to those at Cefalù; then again, they display a more robust development. In the apse is a decoration that is analogous to the aforementioned at Cefalù and Palermo. Down the length of the naves and the lateral apses several series of subjects play out: scenes from the Old Testament, scenes from the Gospel, and finally episodes from the histories of St. Peter and St. Paul.

It would not be correct to attribute to Greek hands all the mosaics from the Norman era. Only the mosaic art of the Cefalù Cathedral and the Martorana seem to belong only to the Byzantine tradition in their entirety. Some Italian students must already have been working at the Palatine Chapel, and their productions became more evident and important at Monreale Cathedral. [See p. 142]

Italy's other extreme, Venice, is a Greek city. Its prosperity increased at the same rate that neighboring Ravenna declined. Depopulated by Justinian II, ruined by the avarice of the exarchs, the capital of Byzantine Italy had already been stripped of its former splendour when, in the middle of the eighth century, it fell to Lombard hands, soon to pass into those of the Pope. However, Venice managed to maintain its independence from the Lombards and the French. The nominal suzerainty of the Greek emperors of which Venice feigned recognition determined Venice's fortune. Granted a plethora of privileges, Venice increased its trade colonies on the coasts of the Mediterranean and soon controlled the largest area of trade between the East and the West. But, along with the Empire's products, Venetian merchants brought Byzantine civilisation to their homeland. Everything was reminiscent of Greece — the dress, the customs, the ceremonial of the court of the doges and the titles *hypatos* and *protospathaire*, with which the Venetians adorned the imperial court. Some of the luxury industries at which Venice would soon excel were borrowed from the East, such as the arts of glass and crystal work, and tanning leather.

Therefore, for several centuries, Venetian monuments often echoed those that had been erected at Constantinople. When the Doge Pietro Orseolo ordered the construction of the breathtaking Church of St. Mark in 976, although the ground was not consecrated until 1085, he did not, according to any documented proof, use Greek-born architects. It is certain, however, that those who constructed this monument, whatever their point of origin, were practicing Byzantine architecture in its purest form. Even the materials, marble, and columns which appear throughout the structure were obtained from the East. However, even in Venice, the Greek standard did not dominate exclusively; In the surrounding region, at Murano, Torcello and Grado, Latin forms reappear at the time when St. Mark's was being built; in secular buildings as in the churches, the two styles are combined, blending their layouts and ornamentation.

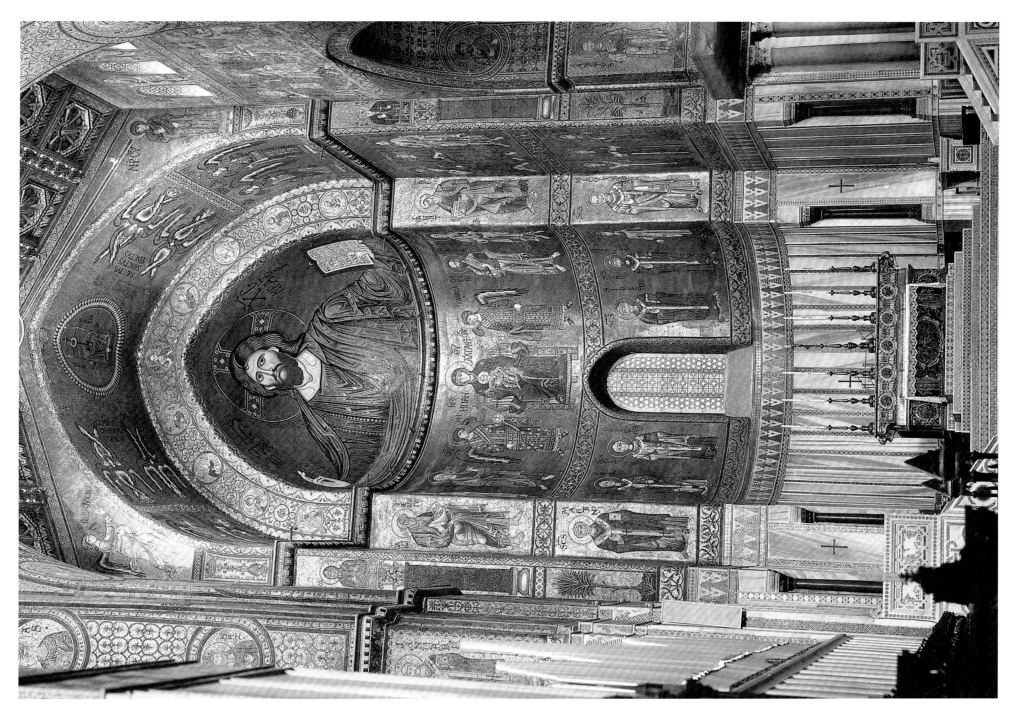

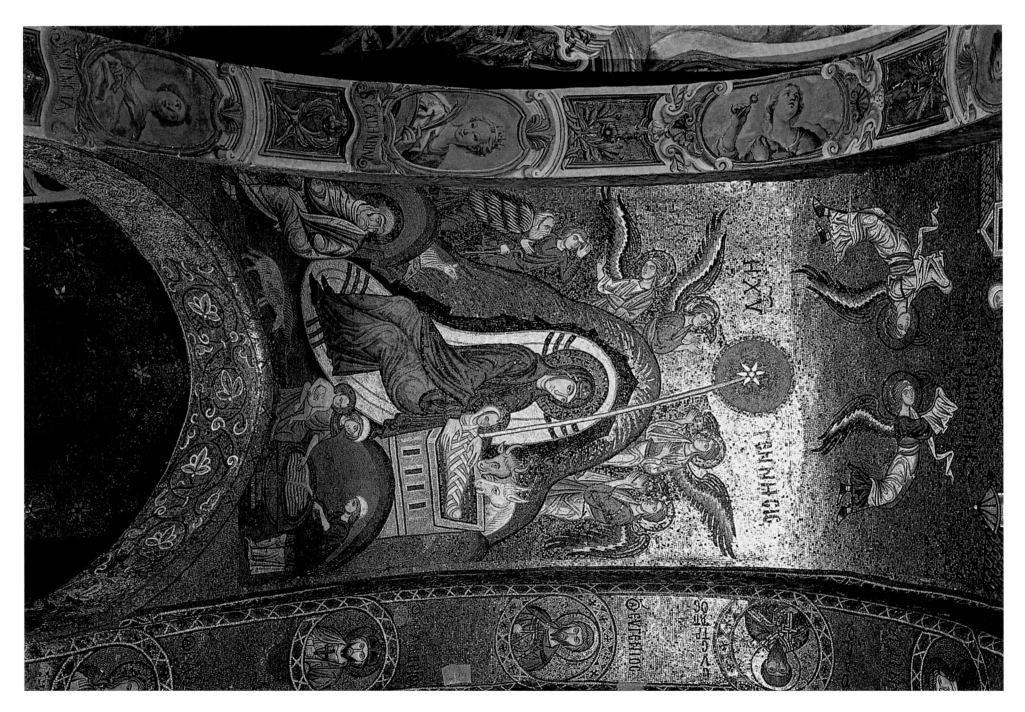

When it comes to decorating their monuments, it is again to the East that the Venetians turn. The enamels of the Pala d'Oro are Byzantine; the same is true for some of the beautiful pieces in the Treasury. One of the doors of the church must have been produced at Constantinople; two others appear Venetian, but are obviously imitations of the foreign model. The Greek artists established in Venice formed a corporation in the eleventh century. It was they, everything indicates, who began to create the mosaics of St. Mark's, and for many years local artists from that school conserved the style. [See p. 152–153; 155]

Their influence was not restricted by the walls of the city. At the Church of Murano, the Virgin who decorates the apse is the purest of Byzantine art (twelfth century). [See p. 147] Nearby, at Torcello, the majority of the mosaics still hold to that style (eleventh and twelfth centuries): on the central apse the Virgin and the Apostles, on the west wall, the Final Judgment, and on one lateral apse, Christ surrounded by archangels. (In that composition, however, there are clear traces of Italian collaboration.) [See p. 146]

In the twelfth and thirteenth centuries, mosaic art was unveiled in Rome with new brilliance. This renewal originated with the Greek masters who had been called to Monte Cassino in the previous century by the Abbot Didier. Their works are plentiful – the decorations of the apses of Santa Maria in Transtevere, Santa Francesca Romana and San Clemente date from that time period. The artists who produced them are not mere copy-cats. Though they borrowed from the East some samples and compositions, they add personal touches. They had not forgotten the artistic patrimony, and they conserve or revive the models of the Roman works from the fourth, fifth, and sixth centuries in their ornamentation. Through these examples, Byzantine influence, though modified, was preserved in Rome up to the very time it passed down to Giotto. Pietro Cavallini, who completed the decoration of the apse at Santa Maria in Transtevere around 1291, remained loyal to the Byzantine tradition, although he blended it with new elements. From this technique of combination and the preservation of rich traditions, Cavallini releases the character that is presented in his beautiful scenes from the life of the Virgin. One senses, "the influence of Greek style, but with more grace and a much better Italian method", and already, all the charm of the Renaissance begins to be revealed.

During this renaissance of which Tuscany was the center, what was the role of the Byzantine masters? Vasari wrote that the Florentine magistrates called Greek artists into their city to revive painting, which had been lost to them. For many years, people were satisfied to repeat this statement, without noting how uncertain and often erroneous the authority of Vasari proved to be. Precise and sagacious research has done justice to this legend. In the documents of the time, there is no trace of this colony of foreigners; it has, however, been established that painting was far from the state of abandon that Vasari believed it to be, and that, in the center of Italy, many artists had preceded Cimabue or Giotto. Without a doubt, in their far-from-perfect works, one can point out many traits that resemble Greek pieces; the Italians departed little by little from these Byzantine traditions that had been more or less widespread in the previous era. The Italians owed to Byzantine artistry a more accurate sense of execution and style, but already from among their best work, they were clearing the way for more

The Nativity, 1149.
Mosaic.
La Martorana, Palermo.

The Ascension of Christ, thirteenth century.
Mosaic.
St. Mark's Basilica, Venice.

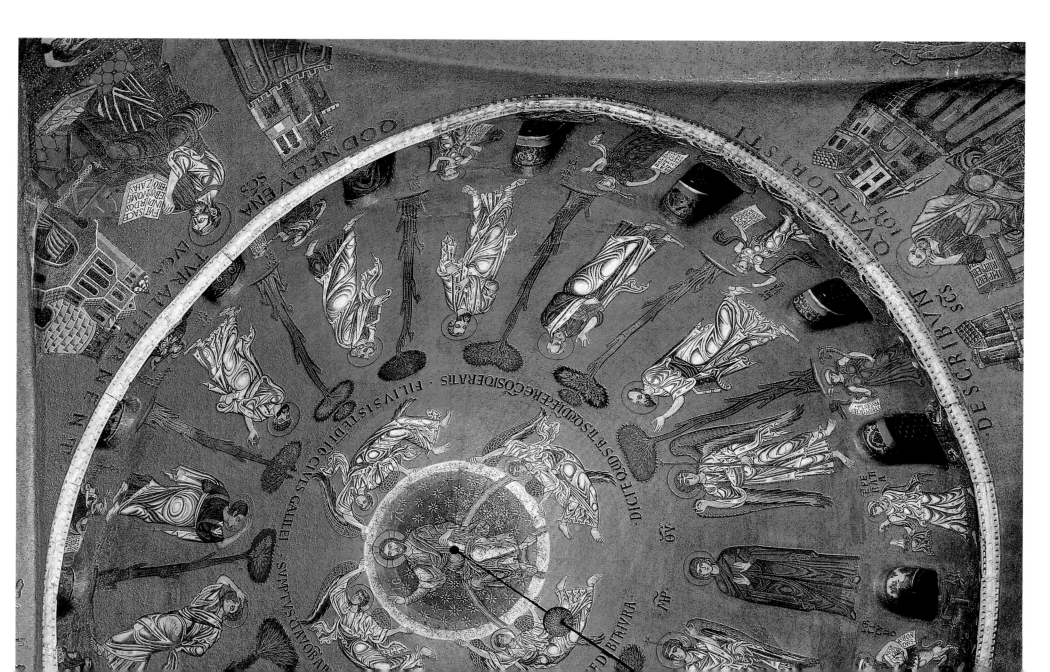

Genesis Cupola, c. 1120.
Mosaic.
St. Mark's Basilica, Venice.

original masters. Artists who came in from outside the province were not the driving force behind the Florentine renaissance. Giotto did not acquire his talent from the Greek school; on the contrary, he managed to release influence that his predecessors had often tried to set free. Here, everything supports Italy's claims, and the new art that was expressed with so much brilliance is truly Italy's own. The masters of this period discovered how to introduce a personal sense of life and truth that was continually weakening among the Byzantines, and, while the latter distanced themselves from nature, the former returned to it and applied to it their skill.

In Germany, from the tenth to the thirteenth centuries, traces of Christian art in the East were also found. In 972, the son of Otto the Great, the future Otto II (the Red), married a Greek princess, Theophanu. With her on the throne, it has often been said that Byzantine artists came to Germany and initiated the Germans in the knowledge of their style and processes. Though the importance of this event has sometimes been exaggerated, it was nevertheless real, and German scholars themselves recognise it. Foreign influence is above all noticeable in paintings, enamels, and pieces of metalwork from the time. Among the monuments where it is most visible, it suffices to mention the Evangeliarium given by the prince and his wife to the Abbey at Echternach (Library of Gotha), several monuments from the time of Henri II (Library of Bamberg and Munich, National Library of Paris), and the splendid golden altar that the Emperor had presented to the Church of Basle (Musée de Cluny). Moreover, at the beginning of the following century, the presence of Greek artists in Germany was again attested to by one certain fact: Meinwerk, Bishop of Paderborn (1009-1036), used Byzantine craftsmen for the construction of a church dedicated to St. Bartholemew. Throughout the eleventh century, these eastern traces were more or less apparent, and the monk Theophilus, who wrote his *Schedula Diversarum Artium* around that time or at the beginning of the twelfth century, mentions more than once the methods of the Greeks.

In the Rhine Valley, an entire region, centered around Cologne, resorted to the use of the cupola. Did the architects who erected them associate them, through some unknown tradition, to those who had built Cathedral of Aix-la-Chapelle at the time of Charlemagne? Whatever the merit that one attributes to that explanation, it couldn't possibly suffice, as the churches of the Rhine of that style do not have the same plan as that at Aix and, again this time, it is quite difficult not to judge the East. The very history of Cologne is disposed to it. "Mistress of the commerce of the Rhine, outpost of Venice, great bazaar of the North, it had not awaited the Crusades to enter into relations with the East. The peoples and customs of the Levant had taken up residence there." But, in Germany as in France, from the thirteenth century on, these foreign traces tended to fade away.

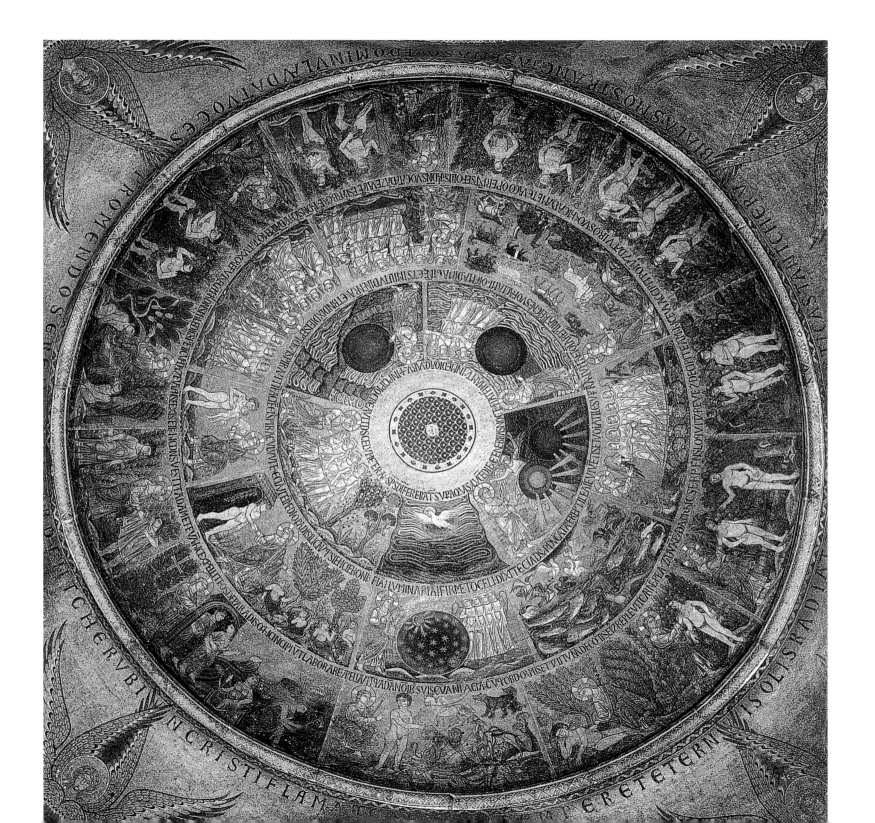

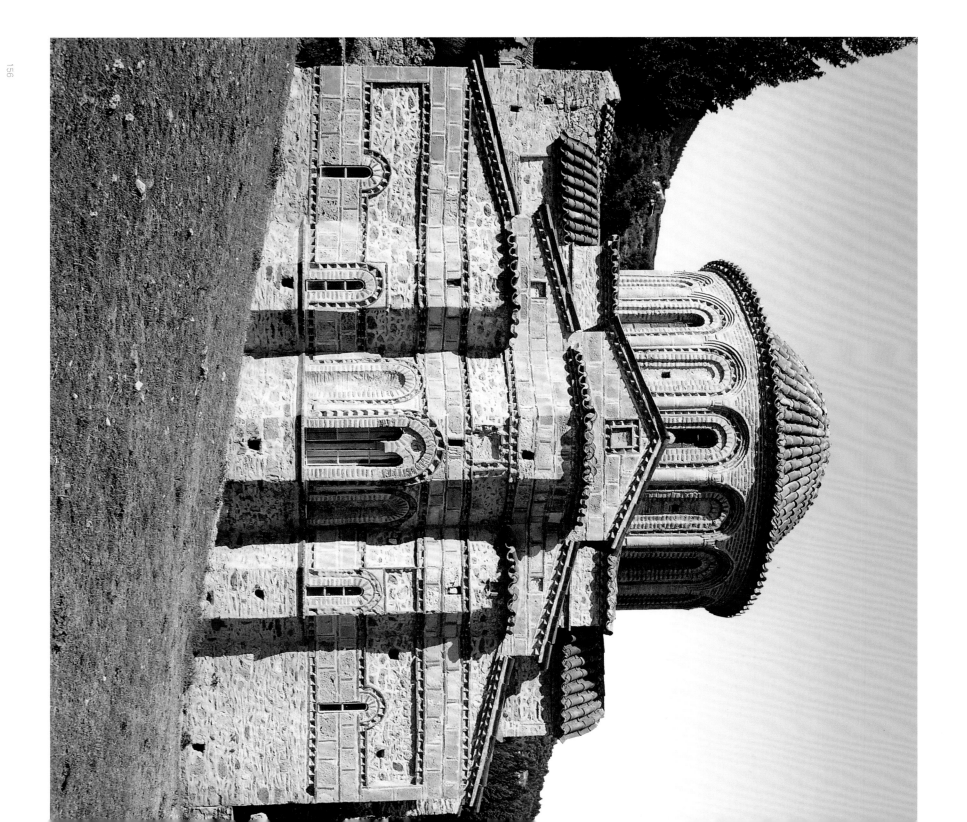

III. Late Byzantine Art (1204-1453)

A. Art under the Eastern Roman Empire (1204-1261)

In the eleventh century, a whole series of grave events precipitated the decadent dissolution of the Byzantine Empire and consequently led to the weakening of the arts. The Macedonian family disappeared, and it was only with difficulty and after much trouble that a new dynasty, that of the Komnenoi, managed to secure for itself the possession of power. In Asia, new invaders, the Seljuk Turks, were making rapid progress. Then the Crusades began, and the Latin West rushed down to the Greek East. Byzantine historians are not of the opinion that the West came as defenders and see in the crusaders adversaries rather than allies. Though they sometimes exaggerate, it is nevertheless fair to recognise that the Latins were not at all concerned with the interests of the Empire, and that they contributed rather to disorganizing and razing it. Moreover, religious dissidence between people of the West and people of the East impeded a lasting union. At the time of the First Crusade, not a half-century had passed since the Church of Constantinople had crossed out from its diptychs the name of the Pope and the Roman legates had declared at the altar of the Hagia Sophia a sentence of excommunication against the patriarch Michael Cerularius (1054).

In spite of this antipathy between the two halves of Christendom, there was some rapprochement, although of this, Greek civilisation would never gain the advantage. All profits were for the West, where new artistic influences led the culture to blossom around the religious tradition. At Jerusalem, a sort of fusion may have taken place among elements of diverse origins. The court of Godfrey de Bouillon's successors had, in some respects, a Greco-Roman physiognomy; Byzantine artists would find themselves side by side with artists from the West; often they would work together and borrow from each other reciprocally.

When the crusaders besieged Jerusalem, most Christian buildings had disappeared or were left in ruins. Up to the moment that the city was taken in 1187, they were increasing the number of churches and monasteries. These constructions were the work of Latin masters and bear no resemblance to the system of architecture that was in use in the Byzantine Empire in the eleventh century; if some traits cause one to recall certain eastern edifices, they are those models that, in the fifth and sixth centuries, were raised in Syria, but modified and transformed in the West. Between the churches of the Holy Land, which date from the Crusades, and those that, during the same era, were built on the banks of the Seine, there is no discernable difference. But, as for monuments decorated in the Latin style, architects often called upon the Greeks. One, named Ephrem, while under the reign of Amalric I, created the mosaics of the Church of the Nativity in Bethlehem in 1169 by the order of Manuel Komnenos. By the time they were completed, they formed the length of the outer wall in a whole series of subjects that corresponded to those one still sees today in Eastern churches. Unfortunately, of this decoration, Greek in style and composition, today only fragments remain: a few figures of angels, two or three scenes borrowed from the Gospels, some depictions relating to

Church of St. Theodore, 1290-1295. Mystras, Greece.

the history of the Councils, and ornamental patterns. The mosaics in Bethlehem were not isolated incidents of this kind of art. The Greek monk Phokas, visiting Jerusalem in 1177, reported that he had seen mosaics in other churches, and those of the Holy Sepulcher, of which only minimal debris now remains, still existed in large part in the seventeenth century.

This collaboration between the Greeks and the Latins can also be found in other works. To cite just one example, the artistic cooperation is significant on an ivory produced in Palestine for the Princess Melisende. The style of dress was at times Latin, at times Greek, and the two styles were blended.

Would this alliance have grown closer, could the Kingdom of Jerusalem have served as a center for an art both mixed and original? Its duration was too short; and, soon after, the capital itself became the target of the Crusades.

In 1203, when the Latins arrived before Constantinople, the splendour of that city, where for so many centuries monuments had accumulated and pressed against each other, left them in awe. "And yet you can know that those who had never seen Constantinople stared at it; because they could not have believed that there could be in all the world a city so rich, when they saw those high walls and those rich towers by which it was entirely surrounded, and those rich palaces and high churches, of which there were so many that none could believe it, had he not seen it with his own eyes, and the length and expanse of the city; that among all the rest was sovereign. And know that

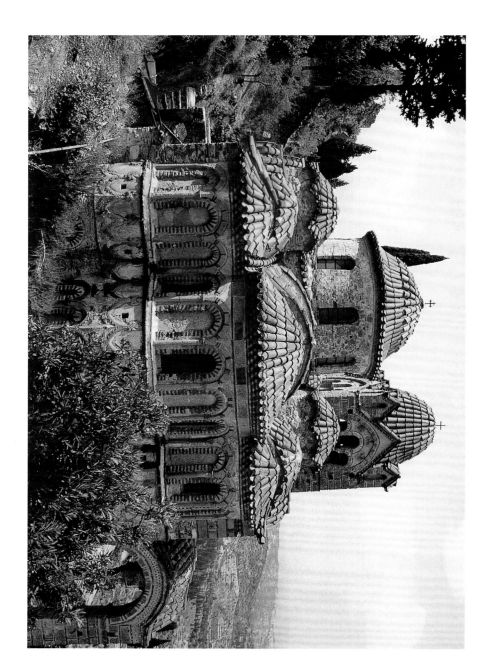

The Pantanassa, early fifteenth century. Fresco. Mystras, Greece.

John VI Cantacuzenus at the Council of Constantinople 1351, 1370-1375. Manuscript, 33.5 cm. French National Library, Paris.

Church of Agioi Apostoloi, early fourteenth century. Thessaloniki, Greece.

Plan of the Church of Agioi Apostoloi, early fourteenth century. Thessaloniki, Greece.

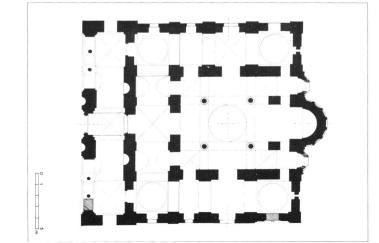

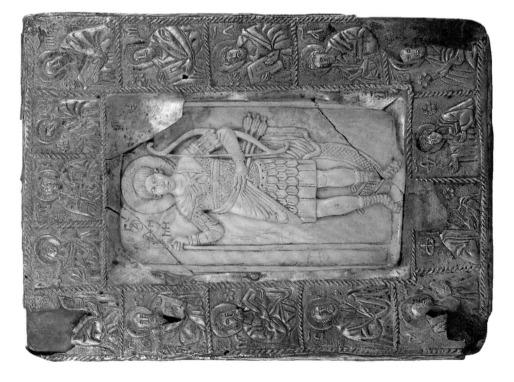

there not a man was so bold that his flesh did not tremble." But soon, the disasters began; a series of fires consumed a part of the city. "The barons of the army were greatly saddened by it, and felt great pity to see those beautiful churches and rich palaces crumble into ruin, and those great market streets burned up in a blazing fire," and, in one fell swoop, "more houses were burned than existed in the three largest cities in all the Kingdom of France."

Matters became worse when the crusaders finally took the city. All those marvels that were hoarded in the treasuries of the palaces and churches were pillaged. At the Hagia Sophia, the altar, adorned with enamels and precious stones, was smashed to pieces over which the soldiers fought; the ambo and the iconostasis were robbed of their gold and silver surfaces. The mercenaries led mules into the church that they would load up with holy plunder, while, on the patriarch's throne, a *debauchee* sang and danced. Even the images of Christ and the Saints were not immune; they were used as stepladders. The conquerors did not stop there; the imperial tombs at Agioi Apostoloi were despoiled for their riches. Finally, the ancient masterpieces, stolen from throughout the Greek world to bejewel Constantinople, knew no clemency before the avarice of the crusaders. Bronze statues were thrown into the furnace and recast into heavy coins. Much was lost in this disaster. The Byzantines themselves lost the models by which they had been many times inspired, and whose sight had so contributed to maintain the cult of beauty. One Greek who described these savage depredations, Nicetas Choniata, lamented the ruin of those

Icon of St. Demetrios, late thirteenth to early fourteenth century. Soapstone, silver, height: 10.4 cm. Louvre Museum, Department of Decorative Arts, Paris.

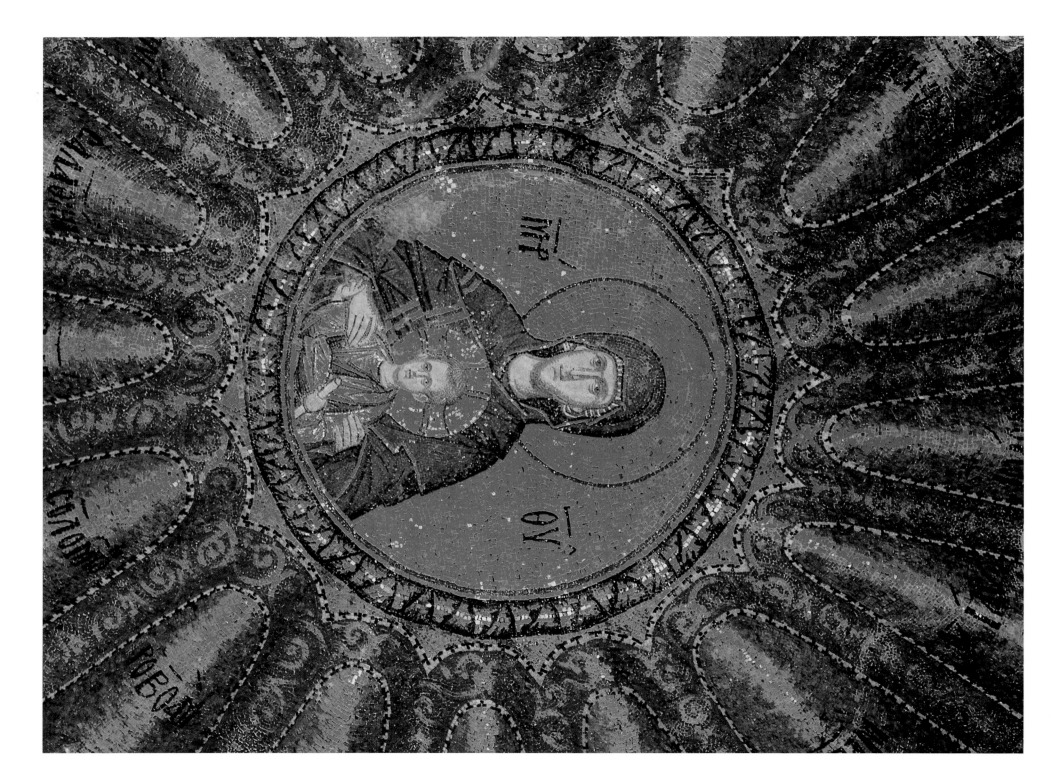

The Dormition of the Virgin, 1265-1270.
Fresco.
Sopocani Monastery, Serbia.

Virgin and Child, 1315-1321.
Mosaic.
Kariye Camii (former Chora Church),
Istanbul.

*The Virgin and Joseph being censused
before the Governor Quirinius*, 1316-1321.
Mosaic.
Kariye Camii (former Chora Church),
Istanbul.

B. Art under the Palaiologoi (1261–1453)

In the midst of adversity and ruin, it was difficult to discern how the arts might find new life. The time of great creations had passed; tradition and imitation would soon dominate. The Crusades, reaching their end, had brought no fruitful influence to Eastern art. Almost no traces are visible, save a scarce few in architecture. These would still be limited to certain territories where Latin settlements remained, such as Greece and the islands. There, not only were western-style constructions common, but even in buildings of Greek origin, foreign elements were often brought together. For example at Mystras, a Latin bell tower stands next to Byzantine cupolas. For this study, these bastard combinations inspire only secondary interest; they did not give rise to a new school, and everywhere that artistic culture conserves some vigor, architects remain loyal to the ancient models.

It is at Mystras, capital of the Despotate of Morea, that Byzantine art rivaled the artistic production of Constantinople during the fourteenth century. It was the secondary city of the Empire and the last great center of study with the philosopher Gemistus Pletho at its head. The city attracted intellectuals and artists. It amassed an impressive quantity of religious buildings, among them: the Pantanassa and the Church of Saint Theodore [See p. 158 and 156]

The Nativity, late fourteenth century.
Fresco.
Peribleptos Church, Mystras, Greece.

In Constantinople, from the thirteenth to fifteenth centuries, the emperors protected the arts. Most of them, loyal to the examples from the past, embellished their palaces and built monasteries and churches, but their efforts were only a partial success, and nothing from that time could compare to the magnificent development of the arts in the ninth and tenth centuries. If one consulted only the illuminations of a few manuscripts, it would even seem that painting had fallen into an extreme decadence. In many of the illuminations from the thirteenth, fourteenth, and fifteenth centuries, "The drawing is mediocre, a black line belies the contours; though the faces have conserved a passable likeness and are sometimes delicately finished, the extremities are hard and neglected, the drapery is hard and angular."

In 1408, Manuel Palaiologos made a gift to the monastery of St. Denis of a manuscript of Dionysius the Areopagite, now at the Louvre. On one of the first pages is a representation of the emperor, accompanied by his wife and children. Imprisoned in the heavy, metallic-looking clothing, fixed oddly to platforms, the characters no longer have movement or life. Only the meticulously rendered heads still conserve some expression. But it would not be an accurate judgment to base all the miniaturists of the time on that strange composition. Others knew better how to arrange their subjects. In a manuscript from the late fourteenth century, Emperor John Cantacuzenus is at the center of his court: bishops, generals, and government officials surround his throne and have not lost the gift of movement.

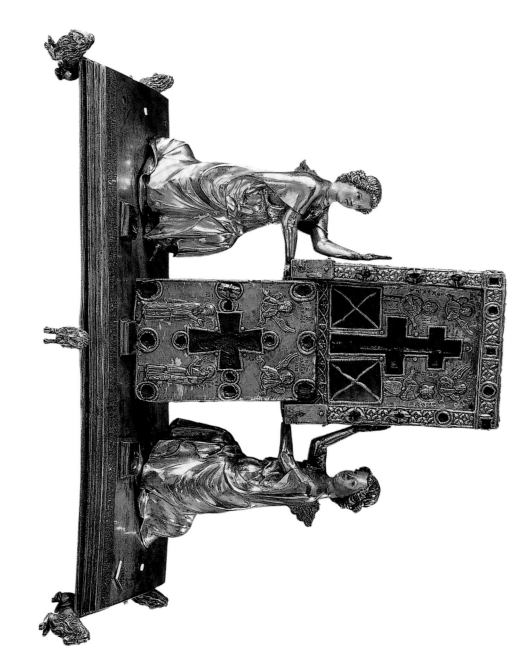

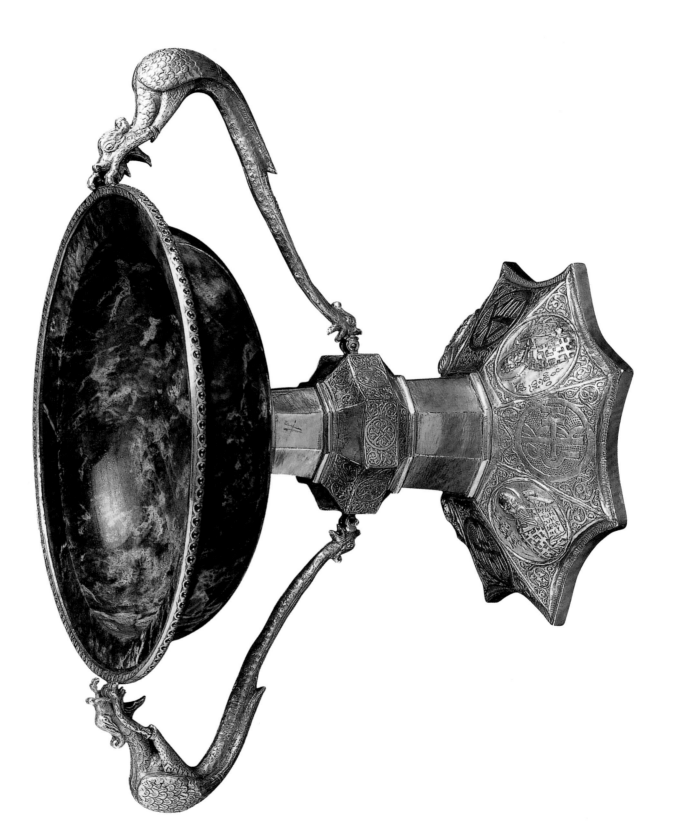

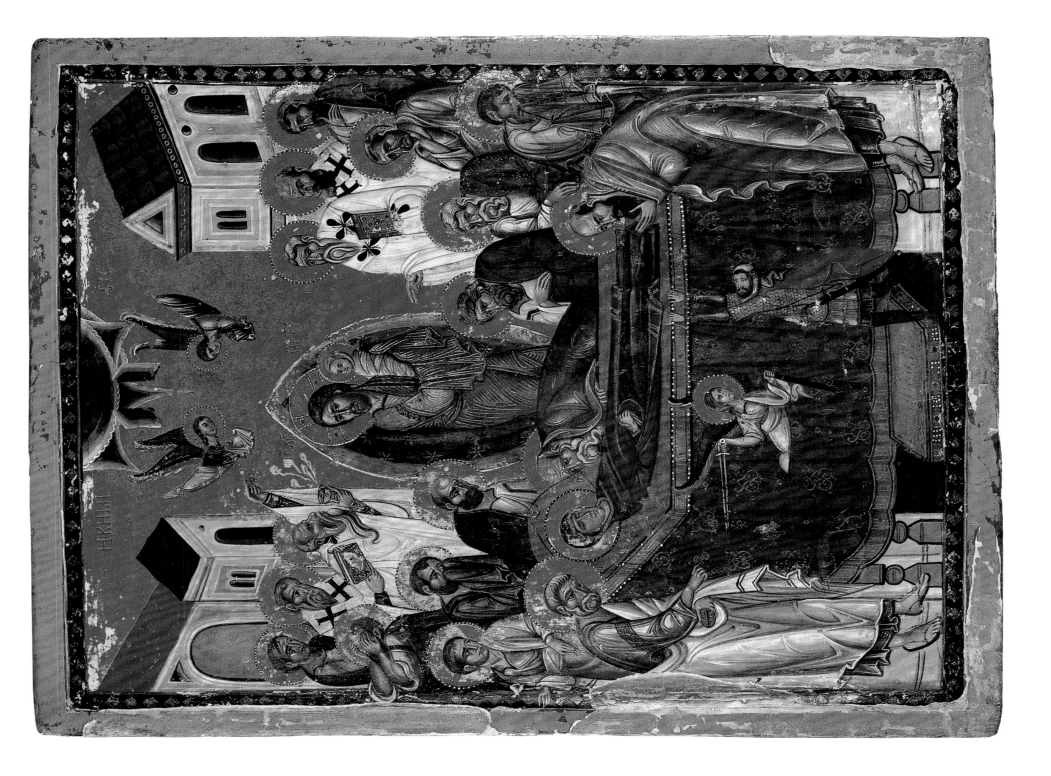

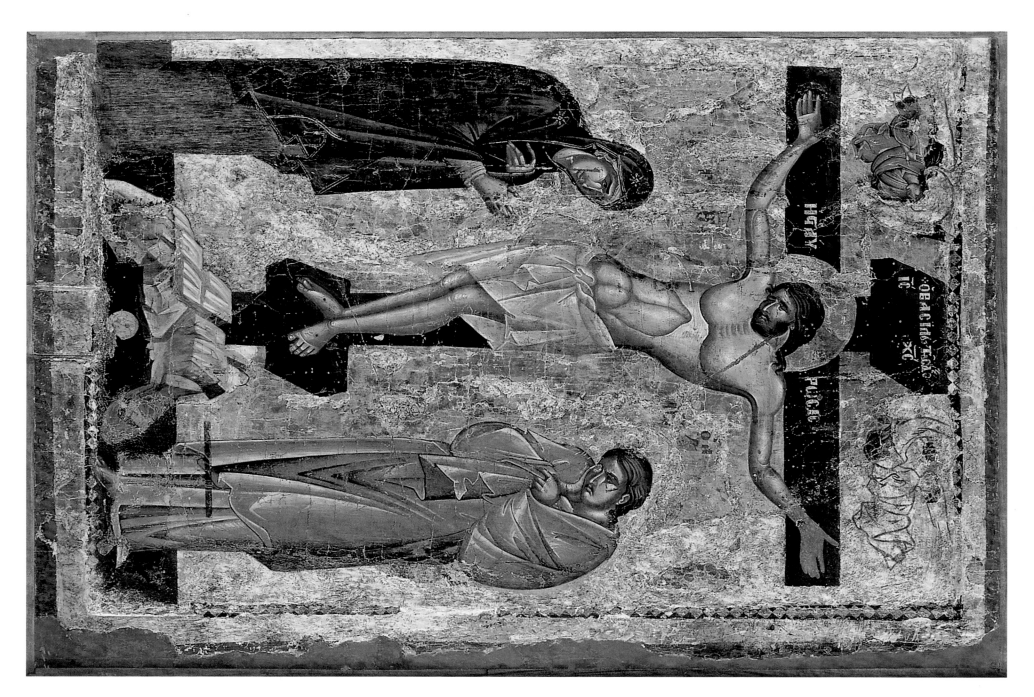

Elsewhere, (fourteenth century) a banquet is depicted. At a table are seated three young men and a young woman, whose rich headpiece frames her black hair. "This tiny drawing equals, in grace, spirit, and vivacity, what our skilled designers can do today."

Still elsewhere, from the fifteenth century, is a Byzantine lord leaving on the hunt, preceded by his servants and dogs; the scene is charming and full of life. Perhaps these artists felt more eloquent when they had to work with subjects that gave them no reason to contend with their empire's intimidating religious tradition. Though art no longer held the same general value as in previous centuries, meritorious works could still be found.

In great decorative painting, it even seems that there had been an attempt at a renaissance that did bear some fruit. In Constantinople artists were working who had some talent. The proof of this can be seen in Chora Church (Kariye Camii). The church was restored, during the reign of Andronikos II (1282–1328), by the great scholar Theodore Metochites, who had it decorated in mosaics, one of which shows him kneeling before Christ. In the narthex and the interior are portrayed the miracles of Christ and numerous figures of saints. The workmanship of these mosaics is so remarkable that they have been compared to works of the Giotto school. [See pp. 162–5 and 168–9] In the fourteenth century, John Palaiologos was still having mosaic work

The Great Admiral Apokaukos, Manuscript of Hippocrates, 1342. Manuscript, height: 41,5 cm. French National Library, Paris.

The Dormition of the Virgin, 1250-1300. Icon, height: 44 cm. Monastery of St. Catherine, Mount Sinai, Egypt.

The Crucifixion, fourteenth century. Icon. St. Clement's (Church of the Virgin Peribleptos), Ohrid, Macedonia.

The Archangel St. Michael, fourteenth century. Icon, 32.8 x 24.5 cm. Museo Civico, Pisa.

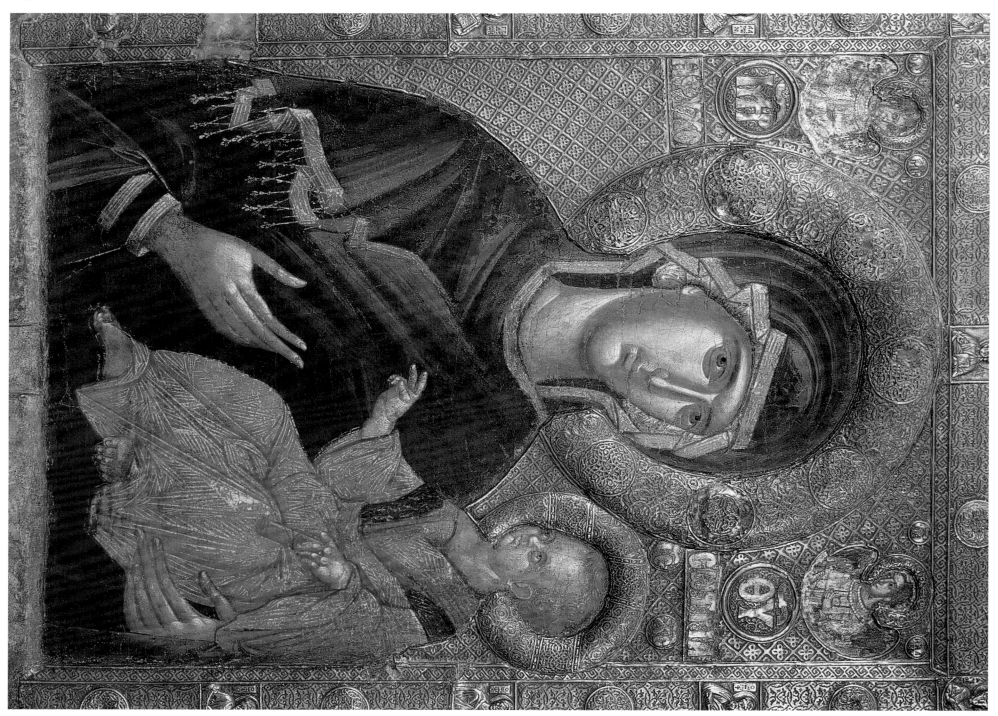

Virgin and Child, fourteenth century. Icon. National Museum, Ohrid, Macedonia.

The Nuns of the Abbey of Bonne-Espérance, fourteenth century. Manuscript, 25 x 18 cm. Bodleian Library, Oxford.

Jesus, fourteenth century. Cloth. Byzantine Museum, Athens.

The Entry into Jerusalem, the Crucifixion, the Anastasis, the Pentecost, Dormition of the Virgin, fourteenth century. Portative mosaic, 27 cm. Bargello Museum, Florence.

done at the Hagia Sophia, as his face can be found mingling within more ancient works restored through his own effort. In metalwork, the sumptuous icon of the Holy Face of Genoa constitutes the most stunning masterpiece of the era. [See p. 188]

However, as the years passed, the future became more threatening, and already all the prophetic signs of the fall of the Empire were beginning to be evident. At the beginning of the fifteenth century, Constantinople had already faded from its former glory. To the fires of 1204 were added those that marked the re-entry of the Greeks, in 1261. The Great Palace had been abandoned, and even to maintain the Hagia Sophia, the necessary funds could not be found.

One curious document permits an image of Constantinople at the beginning of the fifteenth century. In 1403, a Castillian ambassador, Ruy Gonzalès de Clavijo, made a visit; the account of his journey was recorded. The city had not been restored after all the disasters it had suffered, the population had diminished and the ruins were numerous. "As big and as great a countenance as the city has ... it nevertheless is sparsely populated... In Constantinople there are grand buildings, houses, monasteries, churches, of which the majority are fallen into ruin; but it clearly seems that, when this city was in its youth, it must have been one of the most remarkable in the world. And it is said that today there are still 3,000 churches, both large and small."

The ambassador covered the main churches; he noted the curiosities, above all the mosaics that decorated them. Outside the Hagia Sophia remained the colossal statue of

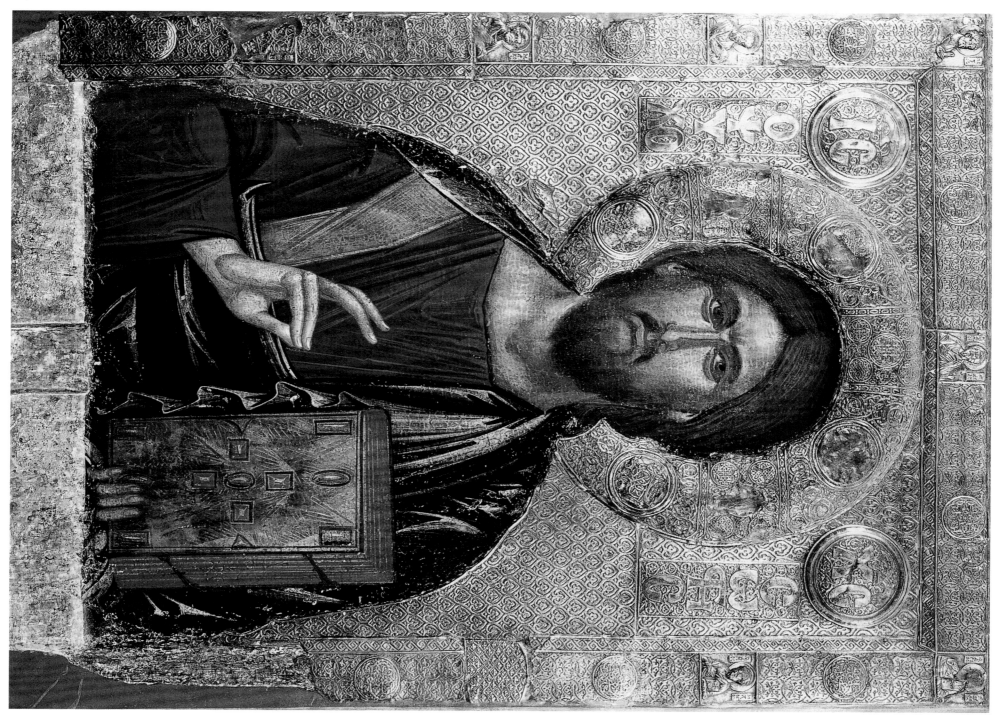

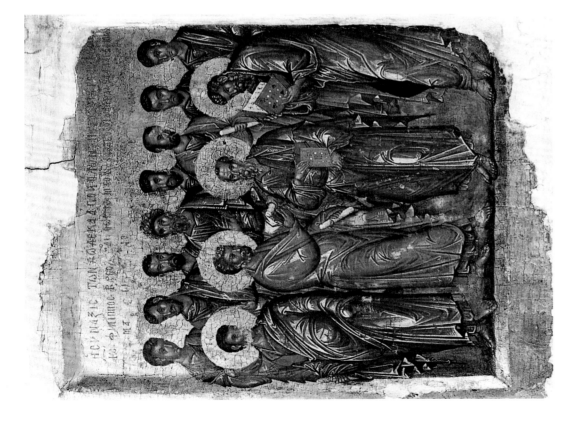

Justinian; on the cupola, and in the galleries of the church, mosaics glowed. At St. John in Hebdomon, "there was a very rich figure of St. John, excellent for a mosaic work; together with that door, a high dome adorned with beautiful images and figures in mosaic." Sometimes the traveler pointed out the subjects treated by the artists. Thus at St. Marie of the River (modern-day St. Ozana Church), "There was a great number of figures, and among them, an image of St. Mary, and opposite, to one side, an image of an emperor, and to the other side an image of an empress, and, at the feet of the image of St. Mary, are depicted thirty castles and towns with the name of each written in Greek. And it was said of them that the aforementioned cities and castles were in the domain of the aforementioned church, given to it by an emperor who was its patron, who had a Roman name and was there interred." In the cloister, "There was depicted the branch of Jesse, the lineage of whom the Virgin St. Mary was descended. It was a mosaic work, so marvelously rich and artistically worked that he who has seen it has never seen another so marvelous." On the interior of the church, "The ceiling was all of mosaic work, and on the walls one could see depicted in mosaic the beauties of the sacred history, from the time that the angel Gabriel greeted the Virgin, to the birth of Jesus Christ Our Lord; then as he went throughout the world with his disciples, and all the rest of his blessed life up to his crucifixion."

183

Icon of Christ, early fourteenth century. Painting on wood. St. Clement's (Church of the Virgin Peribleptos), Ohrid, Macedonia.

The Assembly of the Apostles, early fourteenth century. Icon, 38 x 34 cm. Museum of Fine Arts, Moscow.

At St. George, "The body of the church is very high and all covered in mosaic, and one can see there the representation of Jesus Christ Our Lord as he rose up to heaven," then God the Father, and the Pentecost.

In 1422, a Florentine, Bondelmonti, also described the appearance of Constantinople and its monuments. He described it as ruined and worthy of pity. When he spoke of the expanse of the city, of the Great Palace, it was in the past tense and of things that had disappeared. After having lauded the antique splendour of the Hagia Sophia, he added, with evident exaggeration: "Now, there is nothing left but the archway, because everything has been destroyed and laid to waste." This district, the most beautiful in the city, was in ruin.

In 1453, the Turks besieged Constantinople. Soon the most beautiful churches were converted into mosques; nearly everywhere, paintings and mosaics were destroyed or covered over in calcimine.

The Annunciation, early fourteenth century.
Icon, 38 x 24 cm.
Macedonian National Museum, Skopje, Macedonia.

Ecclesiastical Calendar for the Month of February, fifteenth century.
Icon.
Monastery of St. Catherine, Mount Sinai, Egypt.

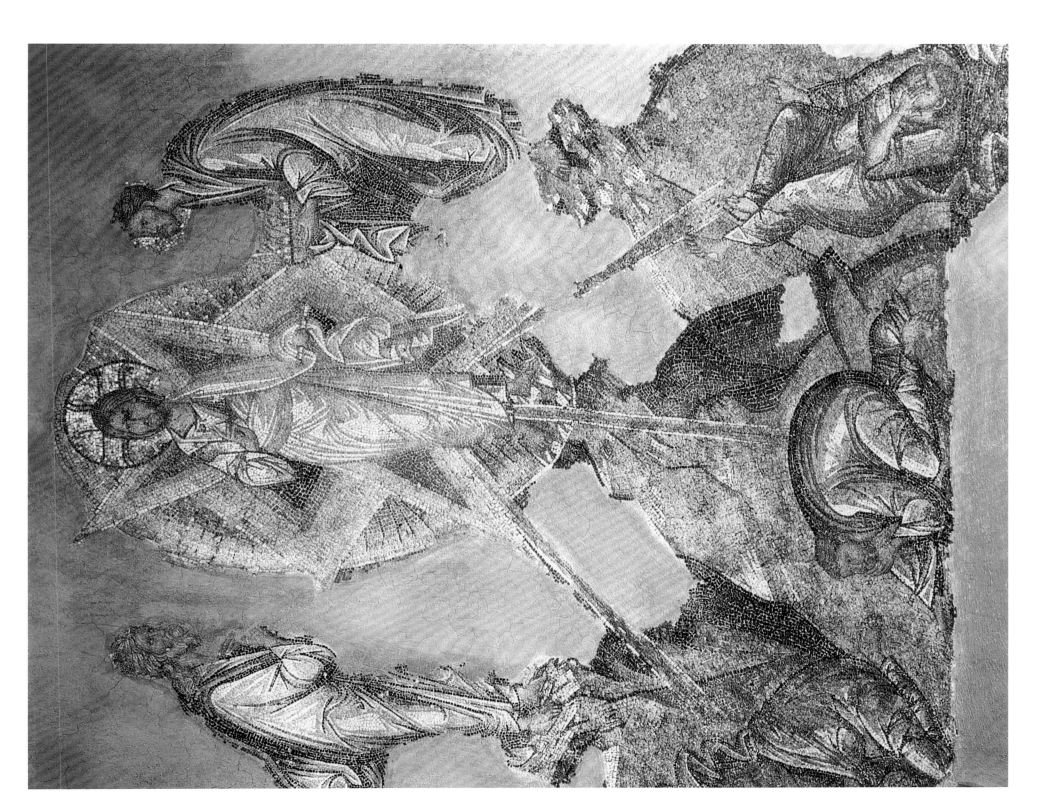

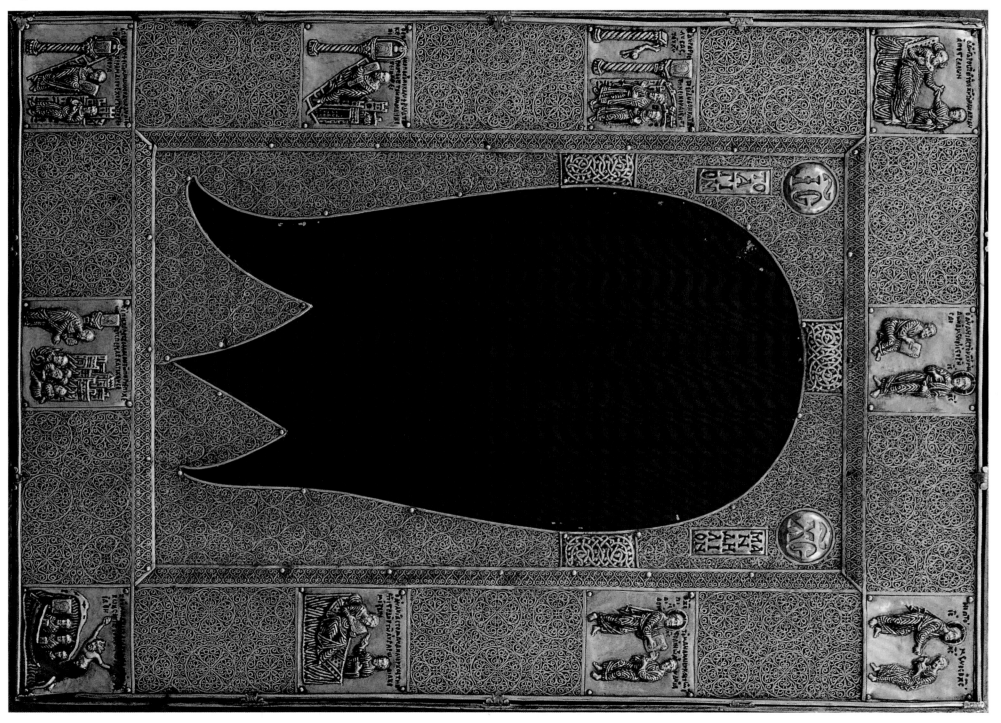

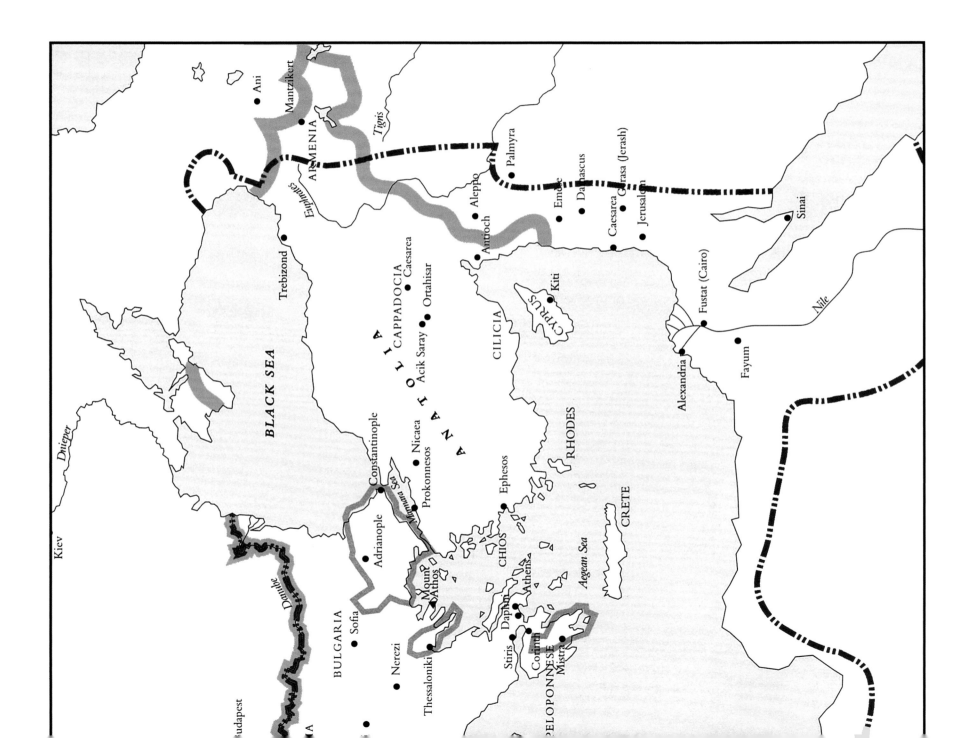

Glossary

Altarpiece (or altar piece):
Panel or collection of panels made of marble, stone, stucco, or wood, usually painted or adorned in decorative patterns, placed vertically behind the altar of a church.

Anastasis:
Resurrection. Wrongly called "the descent of Christ into limbo", this scene originated in the Byzantine Empire in the early seventh century. Having managed to break down the gates of hell, Christ resuscitates Adam and Eve, and more generally, the souls of the righteous from hell.

Apocrypha:
Adjective of Greek origin meaning "hidden away", designating all the inauthenticated writings imitating the books of the Old and New Testaments.

Apse:
The termination at the sanctuary end of a church, generally semicircular in plan but sometimes square or polygonal.

Baptistery:
Small building erected near a basilica or cathedral for the administration of baptisms.

Beautiful Gates:
Central Gates of an iconostasis.

Byzantine:
The word Byzantine comes from Byzantium, the former name of the capital of the Roman Empire, Constantinople. This term was not used until the seventeenth century; it was created to create a distinction between the history of the Roman Empire in Antiquity and the history of the Eastern Roman Empire which, since that time, has been considered Medieval Greek History.

Byzantine Empire:
From the year 396, at the death of Theodosius I, the Roman Empire was divided into two parts: the Western Roman Empire, which dissolved in 476, and the Eastern Roman Empire, or Byzantine Empire, which lasted until 1453.

Byzantium:
Ancient Greek city, capital of Thrace, situated at the mouth of the Bosphorus in a part of modern-day Istanbul. The city had been rebuilt by Constantine and, renamed Constantinople in 300 AD, became the capital of the Roman Empire, then of the Eastern Roman Empire.

Cameo:
Fine stone sculpted in relief to emphasise its diversely coloured layers.

Canon:
Normative text defining the dogmatic and disciplinary rules of a church, its teachings, or its principles. For example, the canons established during the councils of 692 and 787, the teachings promoted by icons, as well as the criteria for judging the liturgical quality of an image in accordance with spiritual practices of the Orthodox Church. A collection of hymns and liturgical texts.

Chalcedon:
See Council.

Council:
Special assembly of the bishops of a region (local council) or of an entire Church (ecumenical council) in order to resolve a doctrinal, canonical, or pastoral problem. There had been only seven ecumenical councils before the Great Schism of 1054 between the Eastern Orthodox and the Roman Catholic Churches. This refers to the First Council of Nicaea in 325, the First Council of Constantinople in 381, the Council of Ephesus in 431, the Council of Chalcedon in 451, the Second Council of Constantinople in 553, the Third Council of Constantinople in 680, and the Second Council of Nicaea in 787. Those that took place after the Schism, organised by either of the two churches, are not considered ecumenical.

Diptych:
A diptych is a painting or sculpture composed of two panels, fixed or mobile, that face each other and in which the subjects face and complete each other. Originally, diptychs were the tablets on which imperial decrees were engraved. Throughout the duration of the Empire, imperial diptychs, consular diptychs, or those of important imperial officials were offered to celebrate events such as the new year.

Dormition:
Representation of the Virgin Mary on her deathbed, surrounded by the Apostles and Christ entrusting his Mother's soul to the angels.

Epistyle:
Ancient term used to describe an architrave.

Forum:
For the Romans, the Forum was the public place where the citizens would gather to barter and discuss political and economic affairs.

Hagiographic Compendium:
Collection of images recounting the life of a saint.

Hagiography:
Laudatory writings describing the lives of the saints.

Hierarch:
Title bestowed on certain high dignitaries of the Eastern Church, which is to say the bishops.

Holy Face:
According to legend, King Abgarus of Edessa, suffering from leprosy, is said to have sent one of his servants to seek out Christ in the hopes of being cured. Christ had him procure a cloth on which were then imprinted the features of his face. This miraculous print is considered by the Orthodox Church to be the first icon to come directly from the source, legitimizing all others.

Holy Mandylion (Image of Edessa):
Fabric on which the image of the face of Christ was miraculously imprinted and was able to be sent to Abgarus, King of Edessa (see Holy Face).

Iconoclasm:
Doctrine dating back to the seventh and eighth centuries which attempted to suppress the veneration of images in the Byzantine Empire. Two iconoclastic strikes, embodied by the destruction of icons, took place over the course of the periods from 730 to 787, then from 815 to 843. The veneration of icons was restored by an ecclesiastical council the 11 of March, 843, the first Sunday of Lent, a date since celebrated as the Day of Orthodoxy.

Iconoclast:
Literally "a breaker of images", also called iconophobe, one who combats images. In this case, iconoclasts are not opposed to all types of images, only to anthropomorphic representations of God.

Iconoclastic Strike:
See Iconoclasm.

Iconodule:
Advocate or defender of images. During the iconoclastic strikes, iconodules were also called iconophiles, or more generally the Orthodox, opposed to the iconoclasts and [therefore] considered heretics.

Iconograph:
Name given to a painter of icons.

Iconostasis:
Dividing wall, made up of three parts and decorated with icons, that separates the nave from the sanctuary in an Orthodox church. From the fifteenth century, these were sculpted of wood and then gilded.

Menologue:
Calendar enhanced with icons and biographies of saints organised according to the order of the liturgical year.

Missorium:
Missorium is the Latin term commonly employed by historians and art historians to indicate large ceremonial silver dishes of late Antiquity.

Mosaic:
An assemblage of small, multicolour cubes or fragments of diverse materials (stone, marble, enamel, glass, metal, wood) forming decorative patterns adorning the surface of a floor, wall, ceiling, or the surface of an object.

Palaiologos:
Name of one of the Byzantine aristocratic families that recaptured Constantinople in 1261. Michael VIII Palaiologos established an imperial dynasty that reigned for two centuries (1261-1453).

Pantocrator :
Representation of Christ in majesty.

Patriarch:
Honorific title bestowed on a primate of the principal Orthodox churches.

Schism:
From the Greek word *skhisma*, meaning "division", this term signifies the separation of a grup of believers from the dominant religion. The Great Schism of the west in 1054 separated the Church into East and West, over a conflict between the patriarchate of Constantinople and Pope Leo IX.

Theotokos :
Litterally "the Mother of God", referring to the Virgin Mary, who gave birth to Christ in his human form (Council of Ephesus); the Council of Constantinople in 553 also honored her with the title "Perpetual Virgin".

Triptych:
A triptych consists of three panels, two of which can be folded over the one in the middle.

Virgin:
In association with such words as Orant (in prayer), Hodegetria, Eleousa, and others, virgin refers to various icons of the Blessed Virgin Mary named for a place of consecration or a particular image of the Mother of God.

Eleousa: Virgin of Tenderness. Her head is inclined towards the Christ Child, cheek against cheek, in a gesture of tenderness.

Hodegetria : Virgin who Shows the Way, in reference to a sacred icon of the monastery of Hodegos.

Bibliography

BECKWITH, J. *The Art of Constantinople: An Introduction to Byzantine Art.* London: Phaidon, 1961.

COCHE DE LA FERTE, Étienne. *L'art de Byzance.* Paris: Citadelles & Mazenod, 1981.

DIEHL, C. *Manuel de l'art byzantin.* Paris: Picard, 1925.

KITZINGER, E. *Byzantine Art in the Making.* London: Harvard University Press, 1977.

KITZINGER, E. *The Mosaics of Monreale.* Palermo: S.F. Flaccovio, 1960.

KONDAKOV, N.P. *Icons.* London: Sirrocco Publishers, 2006.

KRAUTHEIMER, Richard and Slobodan CURCIC. *Early Christian and Byzantine Architecture.* New Haven and London: Yale University Press, Pelican History of Art, 1986.

MAC DONALD, W. *Early Christian and Byzantine Architecture.* New York: George Braziller, 1962.

MAINSTONE, Rowland J. *Hagia Sophia.* London: Thames & Hudson, 1988.

MANGO, C. *The Art of The Byzantine Empire, 312–1453.* Toronto: University of Toronto Press, 1986.

MANGO, Cyril. *Byzantine Architecture.* New York: Electa, 1976.

MATHEWS, Thomas F. *The Art of Byzantium.* London: Calmann and King, 1998.

NESBITT, J.W. *Byzantium : The Light in the Age of Darkness.* New York: Ariadne Galleries, 1988.

OAKESHOTT, W. *The Mosaic of Rome from the Third to the Fourteenth Centuries.* London: Thames Hudson, 1967.

PAOLUCCI, A. *Ravenna.* London: Hacker Art Books, 1978.

RICE, David Talbot. *Art of the Byzantine Era.* London: Thames & Hudson, 1963.

RODLEY, Lyn. *Byzantine Art and Architecture: An Introduction.* Cambridge: Cambridge University Press, 1994.

VAN MILLINGEN, A. *Byzantine Churches in Constantinople: Their History and Architecture.* London: Hesperides Press, 1912.

VOLBACH, W. F. *Art byzantin.* Paris: A. Lévy, 1933.

WEITZMANN, K. *The Classical Heritage in Byzantium and Near Eastern Art.* London: Gower Publishing Co., 1981.

List of Illustrations

A

Anastasis, 1315–1321 — 162

The Anastasis, eleventh century — 99

The Annunciation, early fourteenth century — 184

The Annunciation, late twelfth century — 109

Aquamanile, seventh century — 68

Arch of Constantine, 312–315 — 6

The Archangel Gabriel, early twelfth century — 110

The Archangel Michael, eleventh century — 131

The Archangel St. Michael, fourteenth century — 177

Ariadne and Her Retinue, early sixth century — 120

The Ascension of Christ, thirteenth century — 152

The Ascension, Homilies of James Kokkinobaphos, twelfth century — 115

The Assembly of the Apostles, early fourteenth century — 183

B

The Baptism of Christ, eleventh century — 95

The Baptism of Christ, tenth century — 98

Baptistry of Neon, 458 — 11

Basilica of San Vitale, 527–548 — 26

Basilica of San Vitale, interior view, 527–548 — 28

Basilica of San Vitale, north wall, 527–548 — 45

Bell, seventh century — 69

Bronze door of the Basilica of St. Paul Outside The Walls (detail), 1070 — 132

Bust of Arcadius Wearing the Imperial Diadem, early fifth century — 8

Bust of St. Nicolas and Saints in medallions, tenth or eleventh century — 106

Bust portrait of Eutropius, late fifth century — 50

C

Cameo of St. Demetrios, eleventh century — 125

Chalice belonging to the Despot Manuel Cantacuzenus Palaiologos of Mistra, 1349–1380 — 173

Chalice of Romanos II, 959–963 — 138

Chludov Psalter, Christ on the Cross, Iconoclasts Destroying an Icon of Christ, ninth century — 70

Christ Crowning Romanos IV and Eudokia, 945–949 — 118

Christ Enthroned, Homilies of St. Gregory of Naziance, 867–886 — 111

Christ in Majesty between the Emperor Constantine IX Monomachos and the Empress Zoe, eleventh century — 89

Christ in Majesty Giving a Blessing, fourth century — 10

Christ Pantocrator, 1148 — 143

Christ Pantocrator, c. 1148 — 142

Christ Pantocrator, sixth century — 40

Christ Pantocrator, twelfth century — 100

Christ Restoring the Lazx, fourth or fifth century — 52–53

Christ, thirteenth century — 86

Church of Agioi Apostoloi, early fourteenth century — 160

Church of St. Theodore, 1290–1295 — 156

Codex Purpureus Rossanensis (Rossano Gospels), The Entry into Jerusalem, sixth century — 49

Codex Purpureus Rossanensis (Rossano Gospels), the Judgement of Pilate, sixth century — 42

The Creation of Eve, 1130–1143 — 145

The Cross of Emperor Justin II, c. 575 — 61

The Crucifixion and Saints in medallions, eleventh or twelfth century — 102

The Crucifixion, early eleventh century — 92

D

The Crucifixion, early ninth century 77
The Crucifixion, eleventh century 103
The Crucifixion, eleventh to twelfth century 126
The Crucifixion, fourteenth century 176

Daphni Monastery, eleventh century 83
David Playing the Lyre, 867–886 112
Dioscorides, Princess Anicia Juliana, De Materia Medica, 512 47
Diptych of the Consul Anastasius, 517 56
The Dormition of the Virgin, 1250–1300 175
The Dormition of the Virgin, 1265–1270 166–167

E/G

Ecclesiastical Calendar for the Month of February, fifteenth century 185
The Entry into Jerusalem, the Crucifixion, the Anastasis, the Pentecost, Dormition of the Virgin, fourteenth century 181
Galla Placidia Mausoleum, fifth century 34
Genesis Cupola, c. 1120 155
Genesis, Rebecca and Eliezer, sixth century 43
The Good Shepherd (detail), fifth century 13
The Good Shepherd and the Starry Sky, fifth century 12
The Great Admiral Apokaukos, Manuscript of Hippocrates, 1342 174
The Great Admiral George of Antioch at the Feet of the Virgin, 1149 140
Great Palace Mosaic, late fifth to early sixth century 16
Griffon on a medallion, eighth to ninth century 72

H

Hagia Irene, eighth century 73
Hagia Sophia, interior view facing west, 537 23
Hagia Sophia, interior view, 537 188
Hagia Sophia, southern view, 537 20
Hercules and the Nemean Lion (missorium), sixth century 67

I/J

Icon of Christ, early fourteenth century 182
Icon of St. Demetrios, late thirteenth to early fourteenth century 161
Icon of the Holy Face, 1384 78
Icon of the Triumph of Orthodoxy, late fourteenth century 113
Isaiah's Prayer, Homilies of St. Gregory of Naziance, 867–886 180
Jesus, fourteenth century 60
Jewelry from the Mersinsky Treasure, sixth or seventh century 159
John VI Cantacuzenus at the Council of Constantinople 1351, 1370–1375 36

L/M

The Ladder of Divine Ascent, twelfth century 104
Lapis Lazuli Icon, twelfth century 129
Leo VI Prostrate Before Christ in Majesty, 886–912 96–97
Leopards and Centaurs, twelfth or thirteenth century 136–137
Madonna Standing, late twelfth century 146
St. Mark, eleventh century 117
Mary with the Baby Jesus between Constantine and Justinian, eleventh century 90–91
Missorium of Theodosius I, 387–388 64
Monastery of Hosios Loukas, 1011 82
Monastery of Hosios Loukas, view of the interior, 1011 85
Monastery of Nea Moni, 1042 81
Monastery of St. Catherine, 527–565 31
Monreale Cathedral, 1175–1190 149

N/O

The Nativity, 1149 — 150
The Nativity, late fourteenth century — 170–171
The Nuns of the Abbey of Bonne-Espérance, fourteenth century — 179
Orant Virgin, 1140 — 147
Our Lady of Hodegetria, twelfth century — 101

P

The Pala d'Oro, twelfth to thirteenth century — 122–123
The Pantanassa, early fifteenth century — 158
Panel of a Diptych of the Consul Areobindus, 506 — 62
Paten with Christ Giving a Blessing, eleventh century — 135
Plan of the Church of Agioi Apostoloi, early fourteenth century — 160
Plan of the Hagia Sophia, sectional view, 537 — 20
Plan of the Monastery of Hosios Loukas, 1011 — 84
Plan of the Monastery of Nea Moni, 1042 — 80
Plaque of St. Simeon Stylites, sixth century — 66
The Presentation at the Temple, Menologue of Basil II, early eleventh century — 119
Presentation of the Virgin at the Temple, 1315–1321 — 165
Procession of Martyrs, 493–526 — 32–33

Q/R

Quadriga, from the reliquary of Charlemagne at Aix-la-Chapelle, eighth century — 74
Rabbula Gospels, the Ascension, 586 — 48
Rabbula Gospels, the Crucifixion and the Resurrection, 586 — 48
Reliquary of the True Cross, mid-tenth century — 127
Reliquary of the True Cross, thirteenth century — 172
Reliquary, Stone from Christ's Sepulcher, twelfth century — 130

S/T

Sarcophagus with Stylistic Decoration, c. 500 — 55
Sarcophagus, reputedly of Archbishop Theodorus, late fifth to early sixth century — 55
Sarcophagus, reputedly of St Barbatian, 425–450 — 55
Shroud of St. Germain d'Auxerre, tenth to eleventh century — 139
St. Apollinare, sixth century — 39
St. Demetrios, seventh century — 46
St. Peter, sixth century — 41
The Tetrarchs: Diocletian, Maximian, Constantius Chlorus, and Galerius, fourth century — 14
Theodora and Her Retinue, c. 546 — 37
Theodore Metochites kneeling before Christ, 1316–1321 — 164
Theodosian Walls, 412–413 — 19
Theodosius Receiving Tribute from the Barbarians, detail from the base of the Obelisk of Theodosius, 390–393 — 54
Throne of Bishop Maximianus, 546–554 — 58
The Transfiguration, fourteenth century — 187
The Triumphant Emperor, Barberini ivory, early sixth century — 57
Triumph of Two Emperors (cover), Hunting Lions, and Phoenix (sides), early eleventh century — 124

U/V/W

Urn, known as "La Sainte Châsse", twelfth to thirteenth century — 124
Vase from Emesa, late sixth century, early seventh century — 63
Vessel, tenth to eleventh century — 138
View of the dome, 1149 — 144
Virgin and Child, 1315–1321 — 168
Virgin and Child, fourteenth century — 178
The Virgin and Joseph being censused before the Governor Quirinius, 1316–1321 — 169
The Virgin of Vladimir, early twelfth century — 107
Virgin with the Infant Enthroned, tenth century — 121
The Vision of Ezekiel, 867–886 — 114
Votive Crown of Emperor Leo VI, 886–912 — 184
The Washing of the Feet, 1100 — 94
The Wedding at Cana, 1310 — 186